OKAVANGO
AFRICA'S LAST EDEN

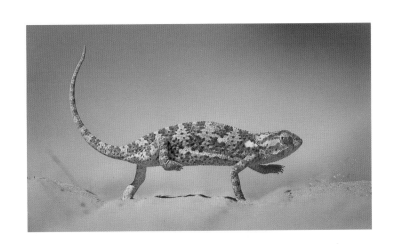

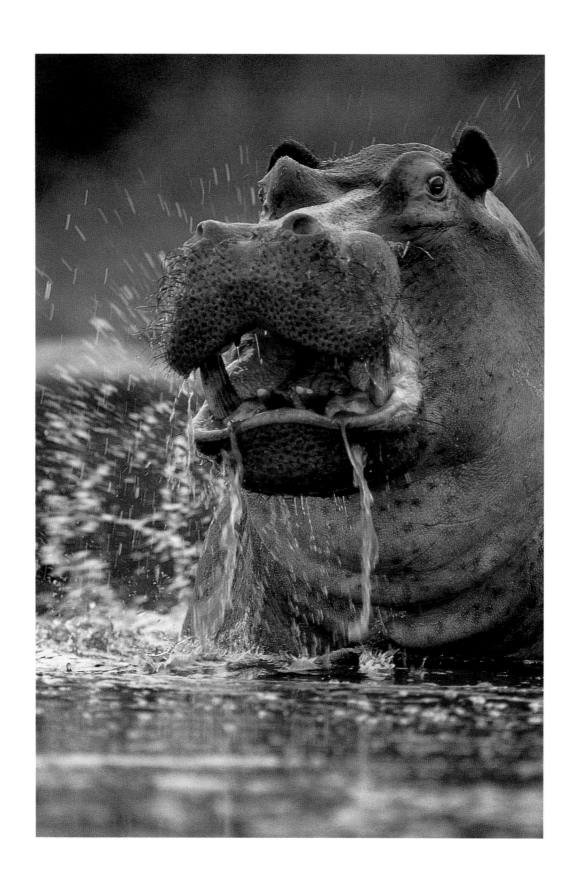

OKAVANGO

AFRICA'S LAST EDEN

Frans Lanting

Edited by Christine Eckstrom

CHRONICLE BOOKS

in association with

CALLAWAY EDITIONS

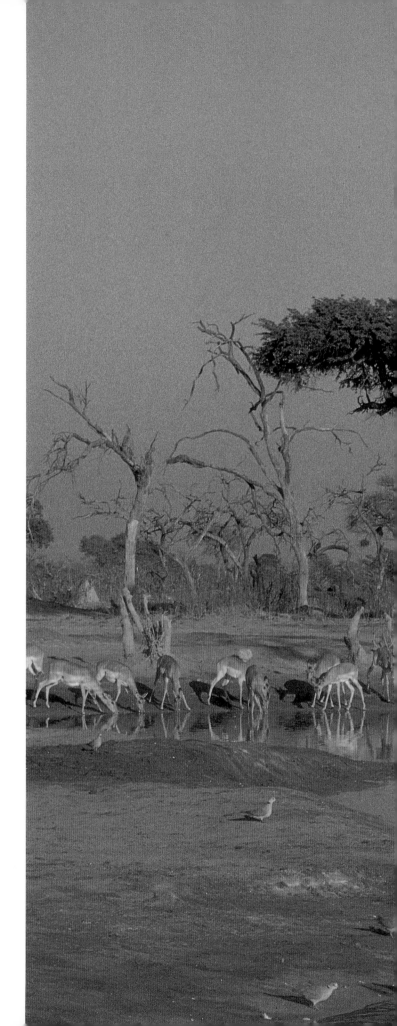

In time, and with water, everything changes.

Leonardo da Vinci

For Chris

First published in the United States
by Chronicle Books in 1993.
Produced by Callaway Editions, Inc.
Copyright ©1993 by Callaway Editions, Inc.
Text and photographs copyright © 1993
by Frans Lanting.
Photographs on pages 2, 34–35, 41, 46–47, 58,
66–67, 112, 125, and 139 reproduced with the kind
permission of the National Geographic Society.
Copyright ©1990 by the National Geographic Society.

Library of Congress Cataloging-in-Publication Data
Lanting, Frans.
Okavango: Africa's last eden / Frans Lanting ;
edited by Christine Eckstrom.

 p. cm.
ISBN 0-8118-1182-4
1. Natural history—Botswana—Okavango River
Delta. 2. Okavango River Delta (Botswana).
3. Natural history—Botswana—Okavango River
Delta—Pictorial works. I. Eckstrom, Christine K.
II. Title.
QH195.B6L36 1993
508.6883—dc20 93-10296
 CIP

Distributed in Canada by
Raincoast Books
8680 Cambie Street
Vancouver, B.C.
V6P 6M9

10 9 8 7 6 5 4 3 2

Chronicle Books
85 Second Street
San Francisco, CA 94105
www.chroniclebooks.com

Printed and bound in Korea.
First edition.

Page 1: Chameleon on hot sand, Makgadikgadi.
Page 2: Hippopotamus, Linyanti.
Pages 4–5: Elephants and impalas at a Savute
water hole.
Pages 6–7: Heart of the Okavango Delta.
Page 9: Elephant mother and calf, Chobe.
Page 10: Greater flamingos, Sua Pan.

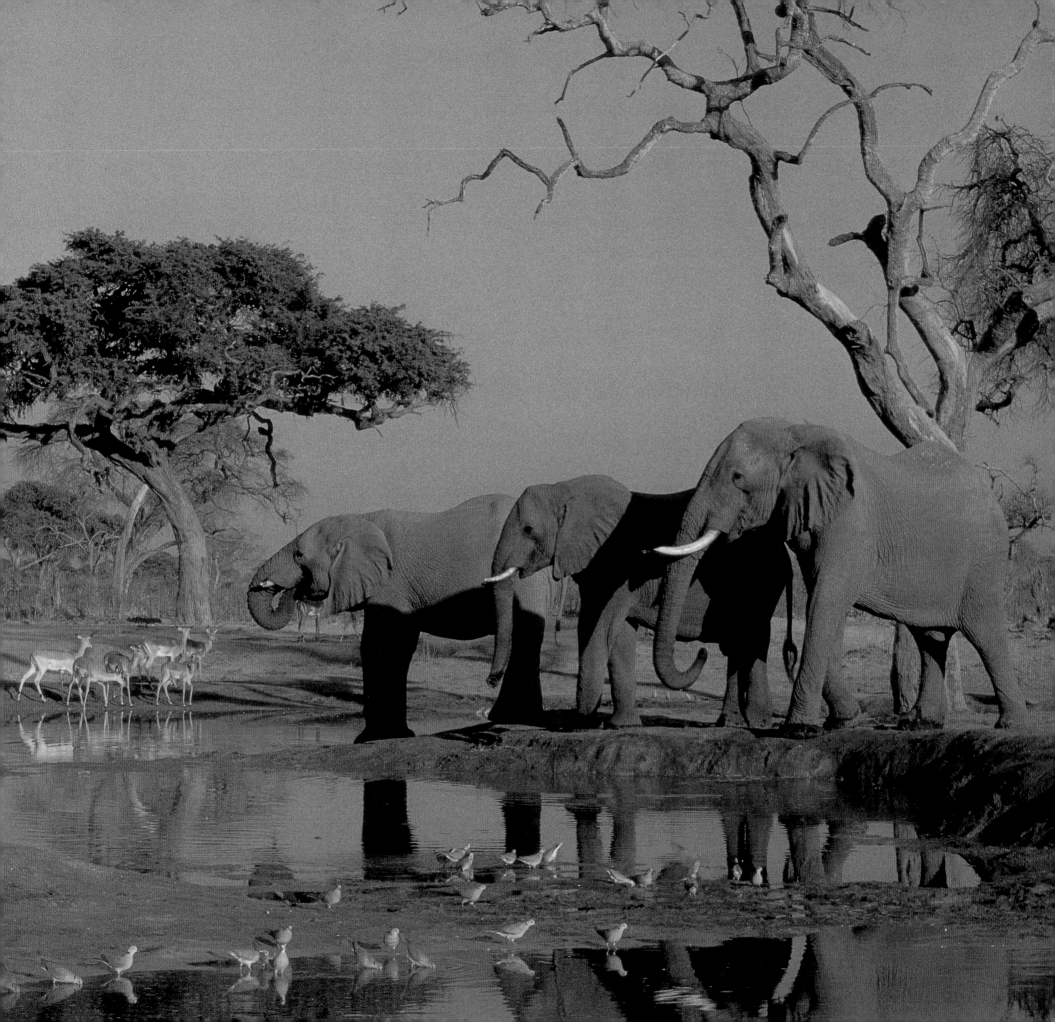

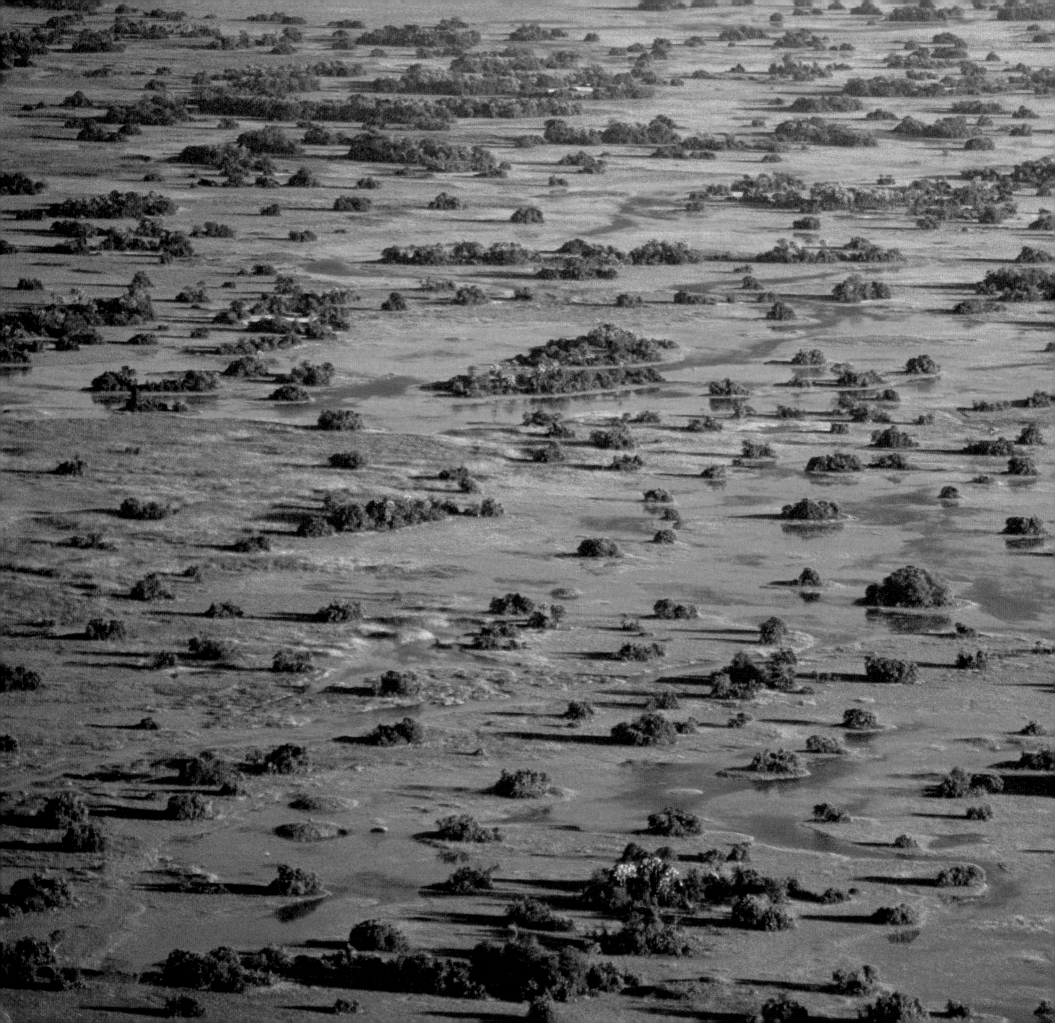

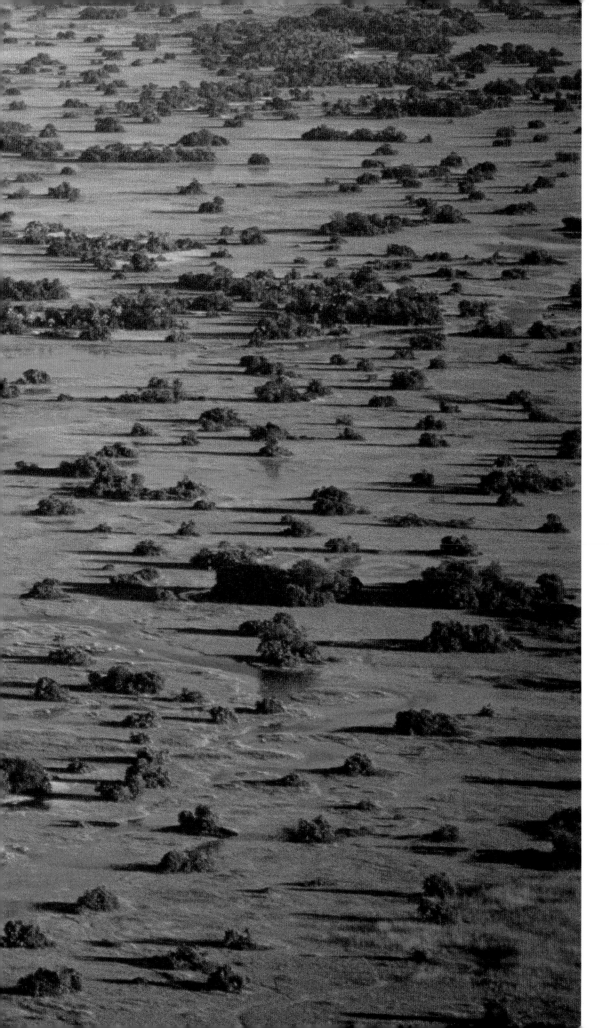

The word wonderful does not fit into science,
for from one point of view every natural occurrence
is as wonderful as another. But we are justified
in using the term when we meet a phenomenon which is
such an exception to the ordinary rules of nature
that it appears to be a miracle.

Eugène N. Marais, *The Soul of the White Ant*

For the animal shall not be measured by man. In a world older and more complete than ours they move finished and complete, gifted with extensions of the senses we have lost or never attained, living by voices we shall never hear. They are not brethren, they are not underlings; they are other nations, caught with ourselves in the net of life and time, fellow prisoners of the splendour and travail of the earth.

Henry Beston, *The Outermost House*, 1928

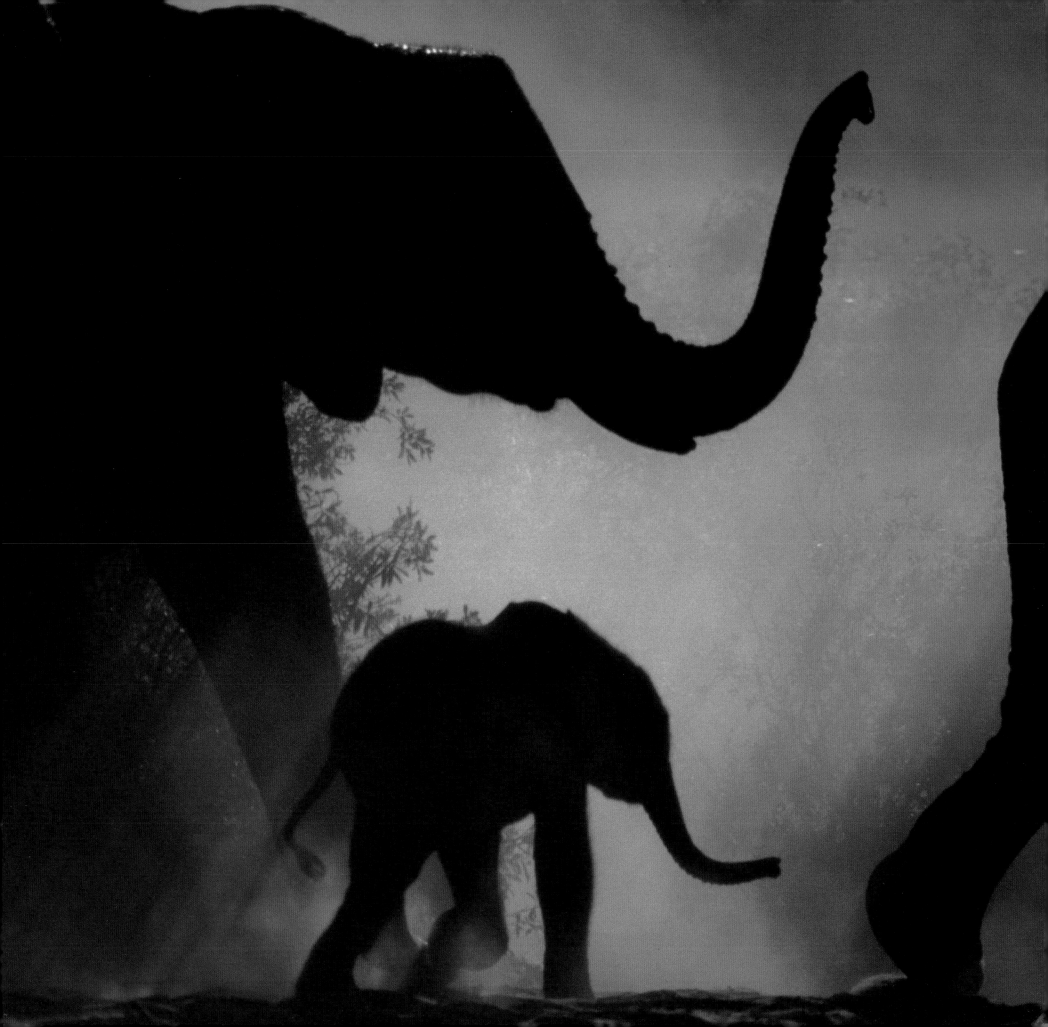

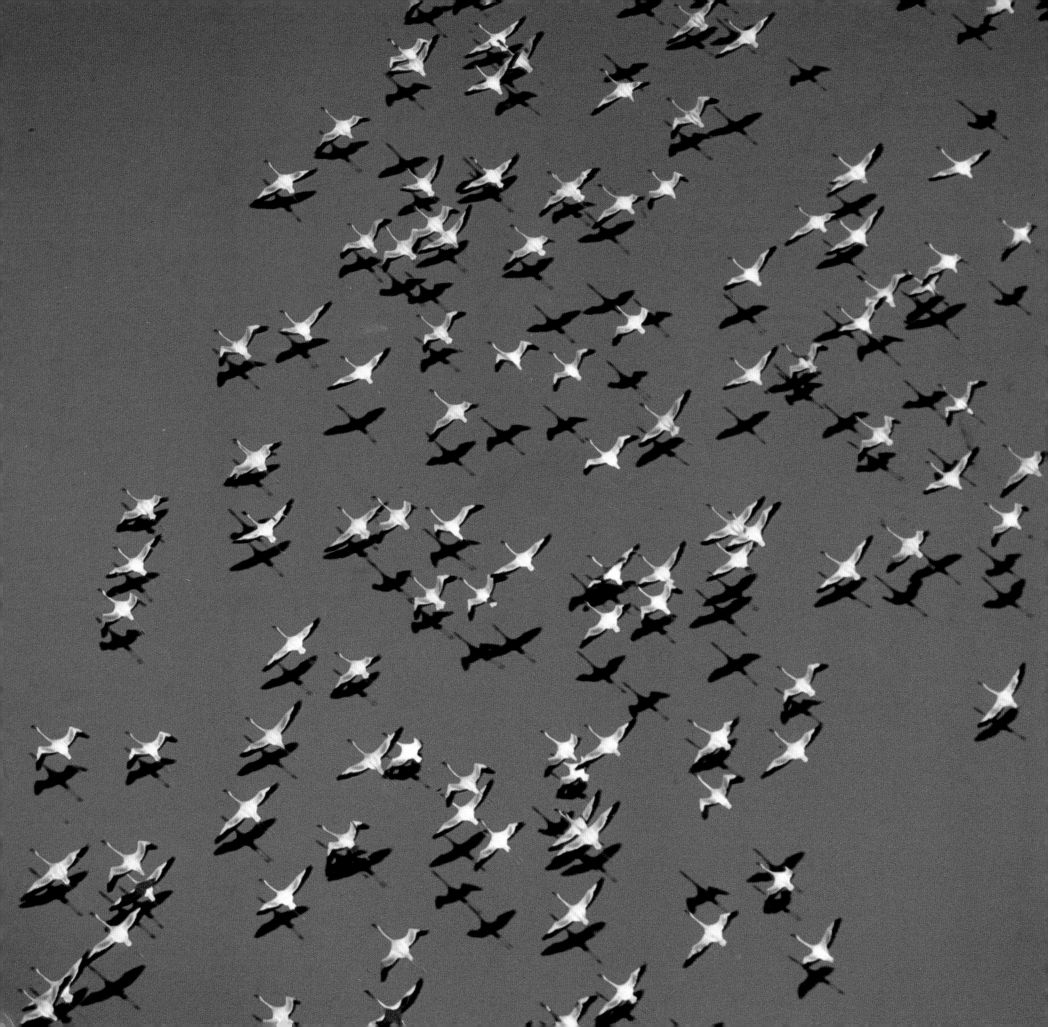

CONTENTS

Preface

The small town of Maun, a dusty settlement of some 20,000 people at the southern edge of the Okavango Delta, boasts one of the busiest airports in all of Africa. Most of the traffic, however, consists not of scheduled jet flights, but of bush planes, carrying people and supplies to remote camps and lodges sprinkled across many thousands of square miles of African wilderness. Maun is a gateway to the vast frontier of northern Botswana, and it

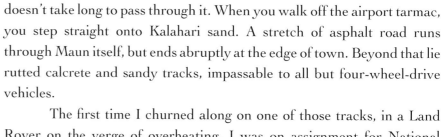

doesn't take long to pass through it. When you walk off the airport tarmac, you step straight onto Kalahari sand. A stretch of asphalt road runs through Maun itself, but ends abruptly at the edge of town. Beyond that lie rutted calcrete and sandy tracks, impassable to all but four-wheel-drive vehicles.

The first time I churned along on one of those tracks, in a Land Rover on the verge of overheating, I was on assignment for National Geographic. I had come to cover two protected areas, Chobe and Moremi, for a book about national parks of the world, but it wasn't long before I realized that in Botswana, wilderness doesn't end at the borders of a park. Beyond lies a huge expanse of bushland where great herds of animals roam a wilderness still governed by its own rules. I soon found myself in a bar by the airstrip in Maun, excitedly penning down a report back to editors in Washington, D.C.: In northern Botswana, I wrote, there is something larger to portray. Here is an Africa I thought no longer existed.

This was my first trip to southern Africa. Until then, as it has been for so many others, my knowledge of wildlife on this continent was based on working in East Africa. My own visits there had been enhanced by the interpretations of scores of scientists and artists who have documented that enchanted land. By contrast, southern Africa's natural heritage is less well known to people outside of Africa. After the grandeur of the savannas in Kenya and Tanzania, much of northern Botswana appears, to the uninitiated, like a featureless scrubland. There are no mountains like Kilimanjaro looming over the land or spectacles like the congregation of a million wildebeest on the open plains of Serengeti. But what Botswana has is wildness. It has often been compared, with some nostalgia, to the way East Africa was 30 years ago—before the tremendous pressure of population growth, before the commercialization of the safari industry, before hunting as a

way of life came to an end, before poaching became a major force. Botswana, many say, represents the last of Old Africa. And in the heart of this arid land lies a place as inspiring and as incongruous as the snow-capped summit of Kilimanjaro rising on the equator: the Okavango Delta, one of the greatest wetlands on earth, whose very existence in the middle of the Kalahari Desert is nothing short of miraculous.

The editors at National Geographic shared my excitement, and with their generous support, my mission expanded to covering the Okavango and northern Botswana in a way that was as comprehensive as the subject deserved. My efforts were aimed at chronicling not just the Pleistocene abundance of wildlife, but the epic quality of this world in which these animals are bound together—and the crucial importance of water, without which all life in this land would fade away. For a year, I roamed the wetlands and dry lands of northern Botswana. I lived by the rhythms of water and the movements of wildlife. I came to know landscapes intimately, and animals individually—and watched the dramas of their lives unfold. I lived out of Land Rovers and canvas tents and crouched at water holes for days on end. I slipped through the swamp in dugout canoes and followed lions through the night. I worked with scientists, hunters, and Bushmen; wildlife officials, safari guides, and people of many races and nationalities who were either born here or had come to know this hard-bitten country as home. By the end of the year, the dirt of the land was under my fingernails. It was hard to leave.

The experience was the realization of a personal dream. To others not yet familiar with this part of the world, the very notion that a place as wild and untouched as the Okavango even exists may seem like a dream. But the ultimate motivation behind this work is to connect the dream with a larger reality. That reality includes the human presence that will determine the Okavango's fate. In Botswana, the legitimate claims of local people and the economic aspirations of a developing country must be balanced with the growing concern over preserving the earth's last Edens. The Okavango represents the best of Old Africa on a grand scale, but it also affords perhaps the best opportunity on the continent to ensure that the glory of wildlife will be part of New Africa. And that is a dream I hope will be shared.

Frans Lanting
February 1993, Bonny Doon, California

At sunset, a male giraffe sniffs the air to check the scent of a female in Chobe.

1

KALAHARI

The Great Thirstland

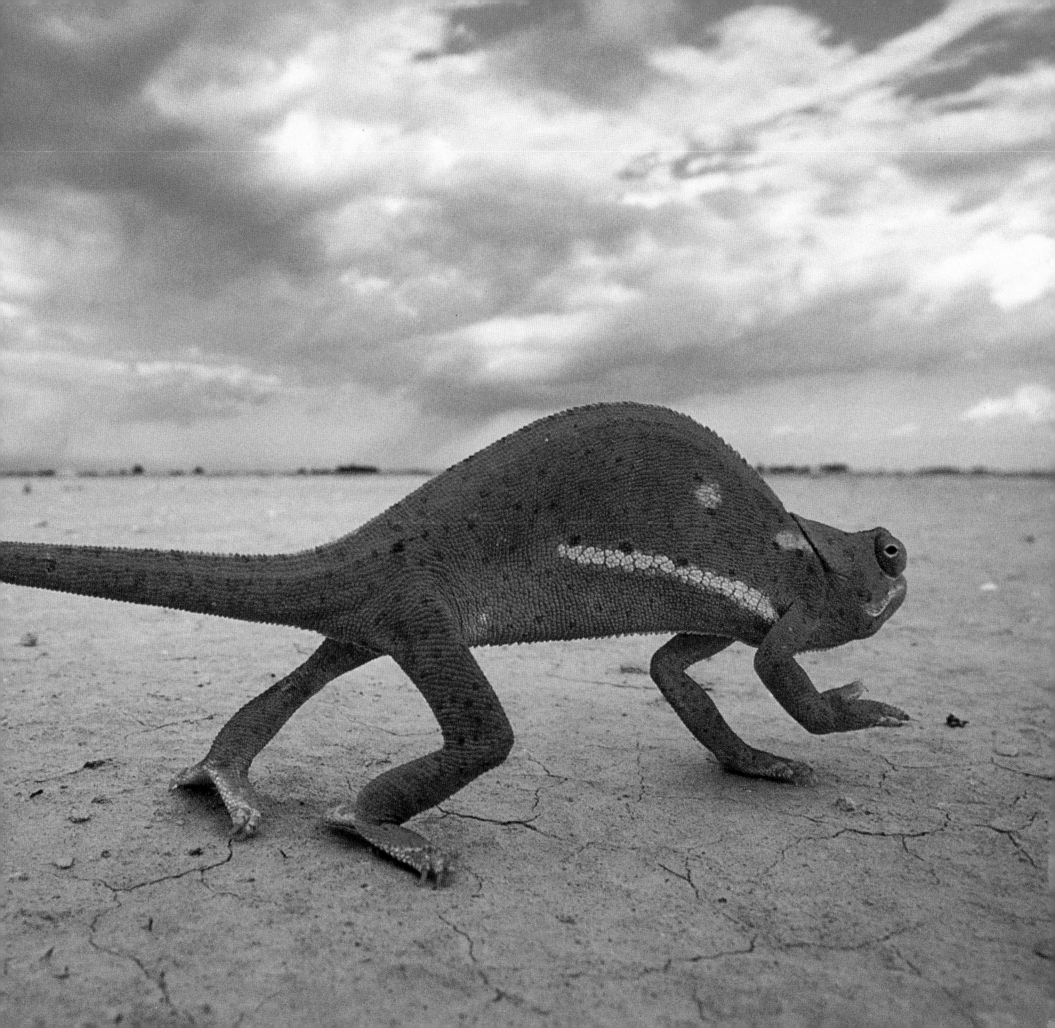

It was late afternoon when I took off from Maun

with pilot Lloyd Wilmot in his old stripped-down Cessna. Long shadows reached over the land, lending contour to a dust-colored world of *mopane* bush and dry savanna. With the wetlands of the Okavango Delta behind us, we flew southeast into a remote part of the great wilderness of northern Botswana.

As far as we could see, the land stretched flat toward horizons shimmering in heat. We were in the Kalahari, the vast basin of ancient sands that fills the southern interior of the African continent. It reaches from South Africa more than 1,500 miles north to Zaire and covers most of Botswana, forming the largest continuous stretch of sand in the world.

The Kalahari is called a thirstland, because for much of the year there is no standing water. Few rivers enter it; even fewer come out. Rain falls between December and March, bringing a short-lived green flush of fresh growth. Herds of zebra, wildebeest, and other animals come to take advantage of this bounty. But the land quickly withers. Most of the rain evaporates, and the rest sinks away in the sand. The herds move off, leaving behind as permanent inhabitants only those, like springbok, who can live on little or no water.

The landscape grew harsher as we flew farther south. Mopane woodlands alternated with swaths of brittle scrub, then yielded to plains of dry yellow grasses. Eventually, tree cover gave out altogether, and a white glare appeared on the horizon. Ahead lay an immensity of space so great it reached over the curve of the earth. We were flying into the Makgadikgadi, the largest salt pans in the world. They cover 15,000 square miles, an area the size of the Netherlands, without one settlement.

◄ *Overleaf*

A flap-necked chameleon inches along the edge of a dry clay pan.

16

Just before sunset we found our destination, Kubu Island, a low mound of granite far out in the alkaline flats. As we circled the island, I could see the stone walls and giant baobab trees that had drawn me here. The walls, made of rough piles of rocks, have baffled people for many years. There's no certainty about their purpose or their makers, and like the baobabs, they seem an incongruous sight on this forlorn island in the midst of a saline wilderness. But their stories do have a common thread: They suggest a change in the land—and the former presence of water.

We touched down and were engulfed by silence. Camp was pitched under a huge baobab, but that night, with a clear moon that lit the land silver, I didn't sleep. A wind sighed over the empty pans. In my imagination it became the sound of water. As recently as 20,000 years ago, these pans were covered by a giant lake, perhaps the largest ever in Africa's history. This inland sea was fed from the north by the Zambezi River until underground movements rippled the earth and the Zambezi changed course. Veering away from the heart of the Kalahari, the river turned east toward the Indian Ocean, into which it flows to this day. Cut off from its lifeline, Lake Makgadikgadi slowly dried up. Along its outer edges vegetation gained a foothold, but the interior was baked into salt pans utterly inhospitable to life.

But sometimes, like a dream come to life, a hint of Lake Makgadikgadi reappears. In rare years of abundant rains, water stays long enough on the pans to re-create the past. Then, on cues beyond our comprehension, great flocks of flamingos appear from more than a thousand miles away. They feast on the billions of brine shrimp freshly hatched from eggs that have lain dormant, perhaps for decades, in the pans, until they are reanimated by the rain. The flamingos stay as long as there is water: It could last a few weeks; it might linger for a year. They nest and raise chicks far out in the shallows, but as soon as the lake dries out, the birds vanish. A decade may pass before they return.

I turned my back on Kubu Island and walked onto the pans by the light of the moon. It had recently rained and imprinted in the pan's now soft surface were the tracks of animals roaming far in search of fresh growth—springbok, gemsbok, ostrich; and way beyond its range, the passage of a lone elephant marked by dry droppings. Life on these pans is evanescent. But if the earth shivered again and bent a river back toward Makgadikgadi, everything would change. Here in the Kalahari, all you need is water and life will find a way.

Endless vistas of flaxen grass impart a dizzying sense of space to that part of the northern Kalahari known as Makgadikgadi.

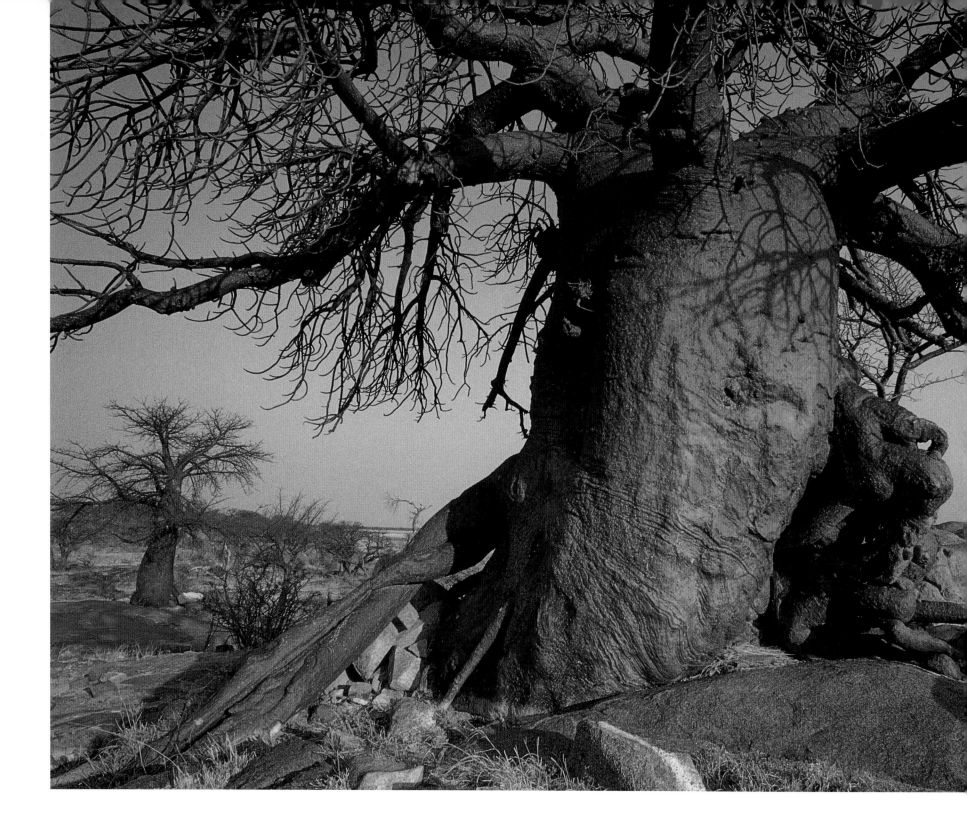

Rivers of white sand wind through the immense scrub savannas

of northern Botswana, marking the skeletal courses of
former waterways. Some stay dry for decades; others may
never run again. Rain is erratic in the Kalahari,
a name that has been interpreted as "mother of thirst."
Here, summer showers that began in December have
just brought forth a thin veneer of greenery.

Ancient baobabs
have the timeworn
appearance of ruins.
Some growing
on the edge of Kubu Island
are believed to be
more than 1,000 years old.
Their fibrous pulp stores
an enormous amount of water,
upon which the trees
rely during the episodic
droughts that affect
this part of the world.
Like sponges,
baobabs physically
expand and contract
in response to rain.
One tree measured in 1853
was found more than
a century later to
have shrunk—not grown
—in girth by 5 feet.

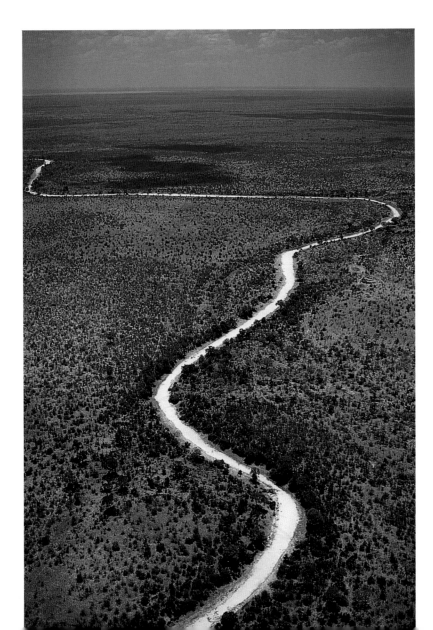

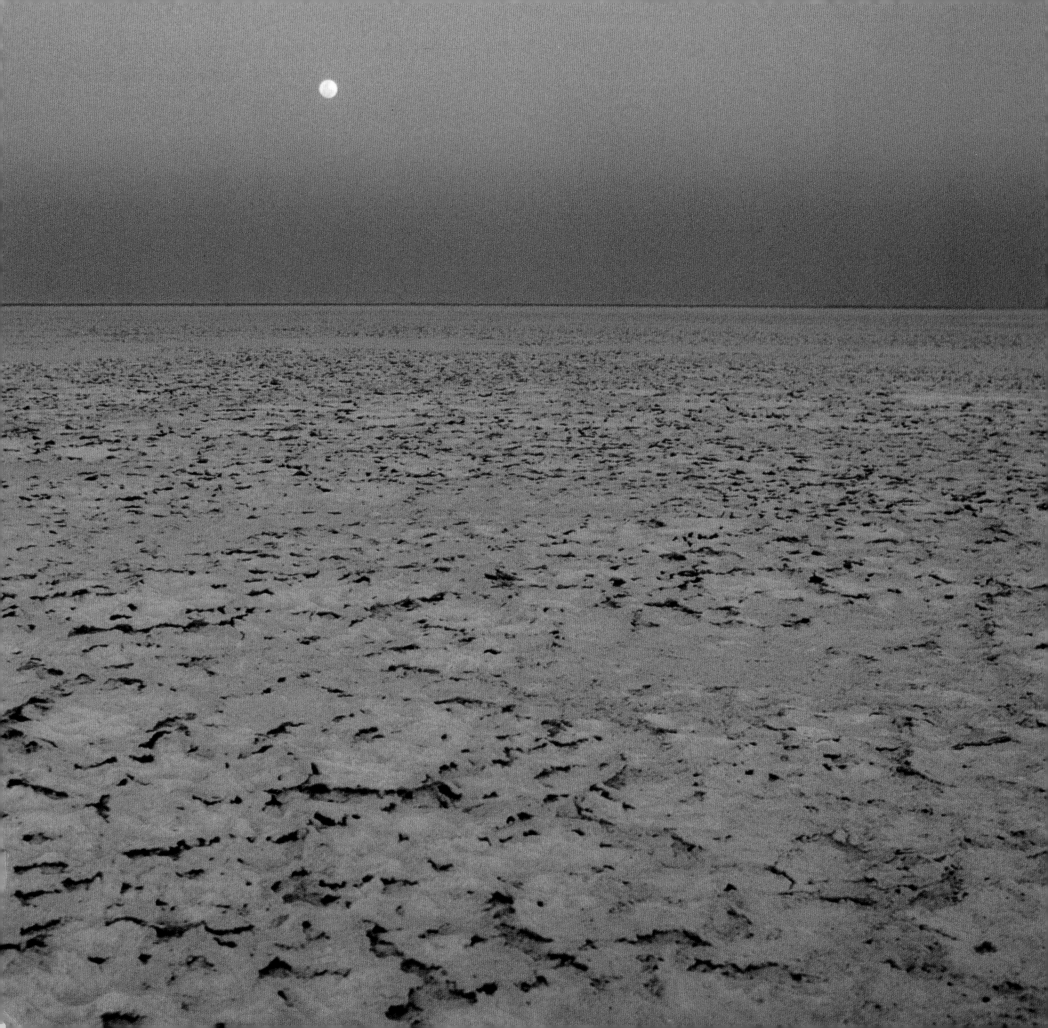

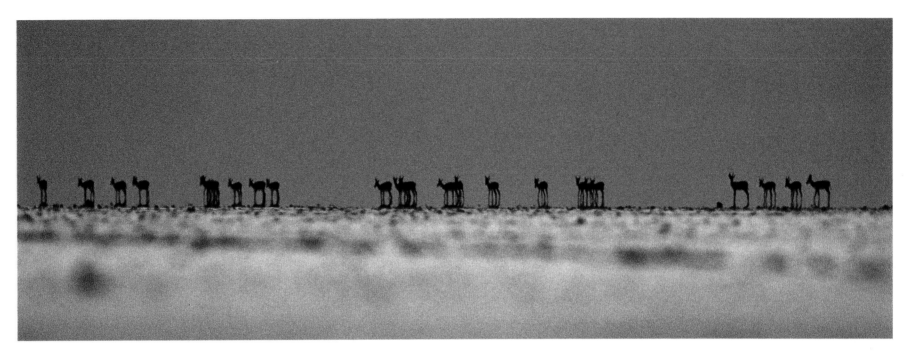

In the surreal
emptiness of Makgadikgadi,
springbok glide along the horizon,
elongated by mirage.
They thrive in the grasslands
surrounding the pans,
deriving enough moisture
from brittle browse
and dew to survive without
drinking water.

A rising moon glows
above the Makgadikgadi Pans,
the bed of an ancient lake
that dried up when the river
that fed it changed course.
The pans now lie baked
and barren, a place
where fossils of animals
and stone weapons
of ancient hunters are
reminders of earlier life.

Overleaf ➤
A formation of
flamingos struts across
Makgadikgadi's
Sua Pan.

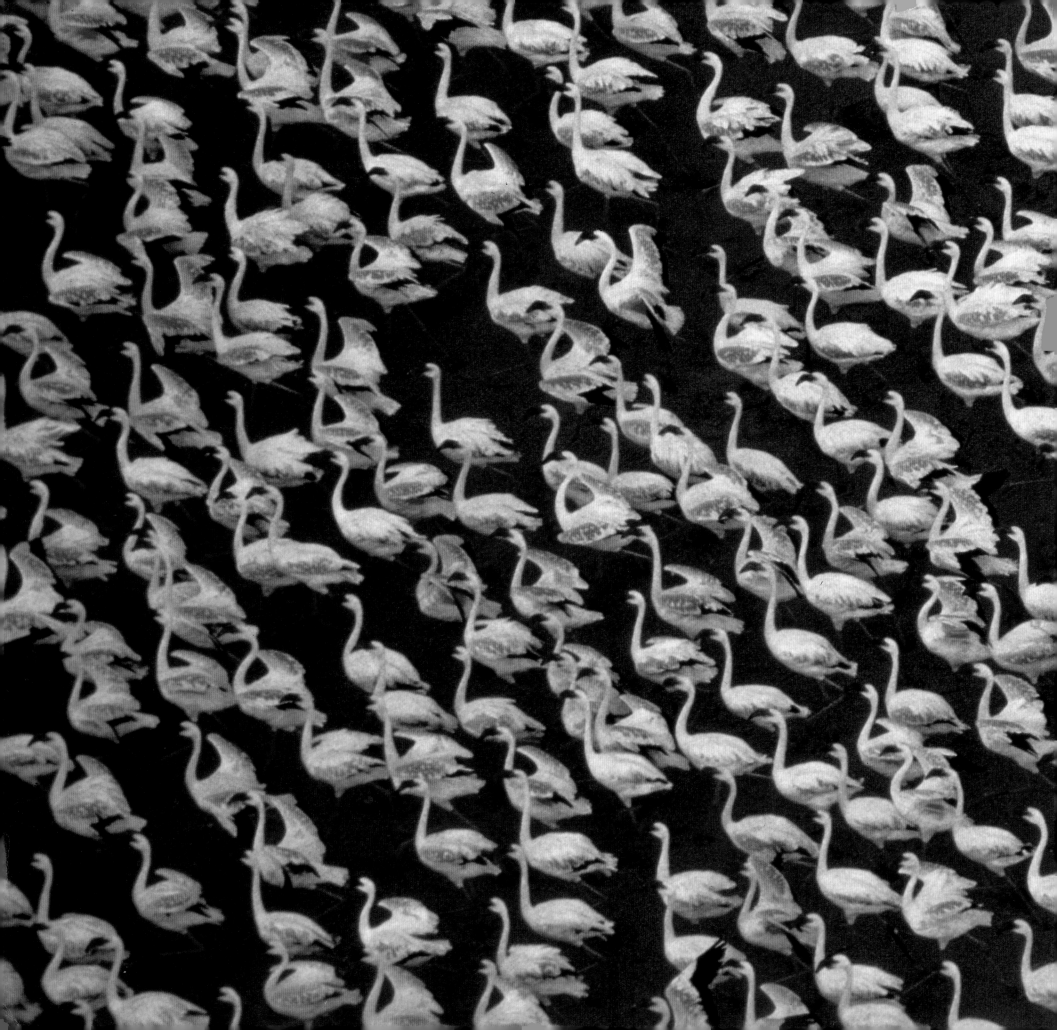

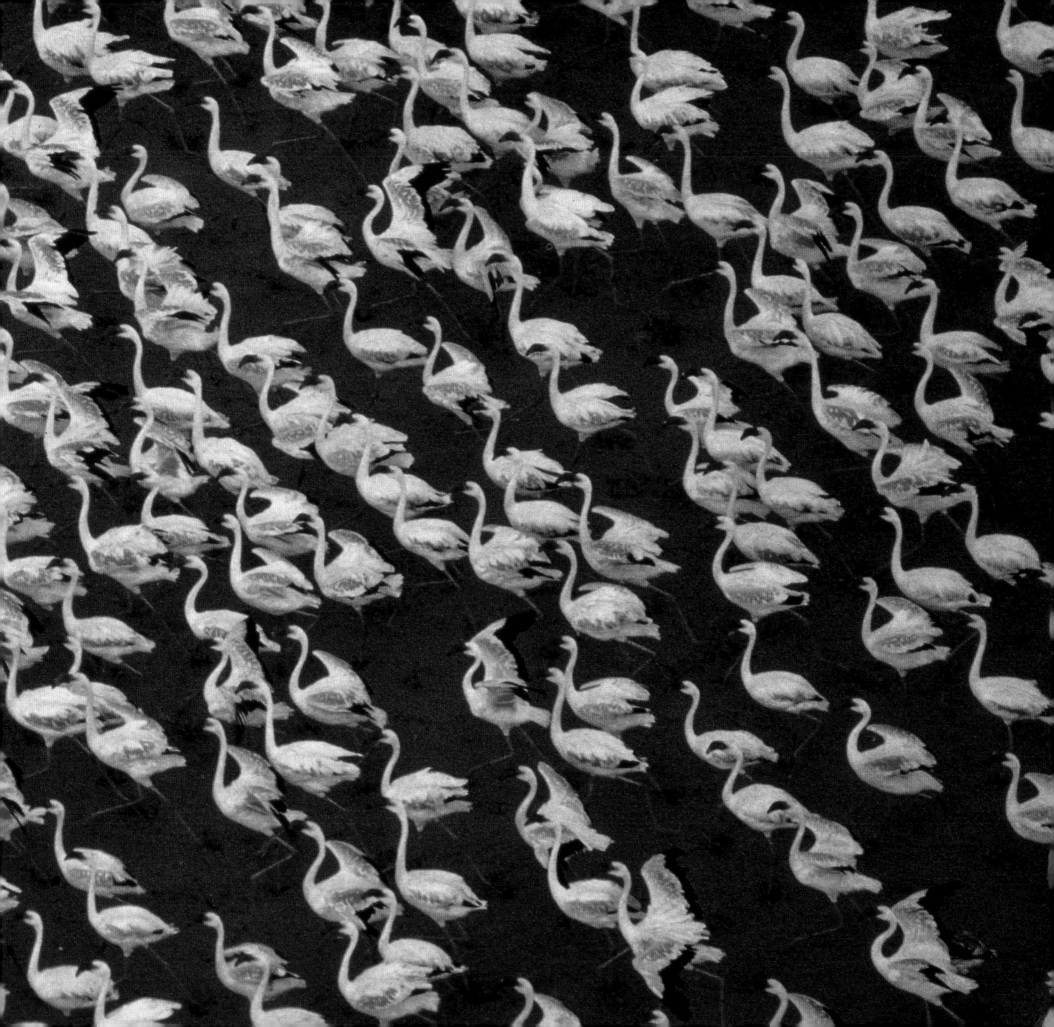

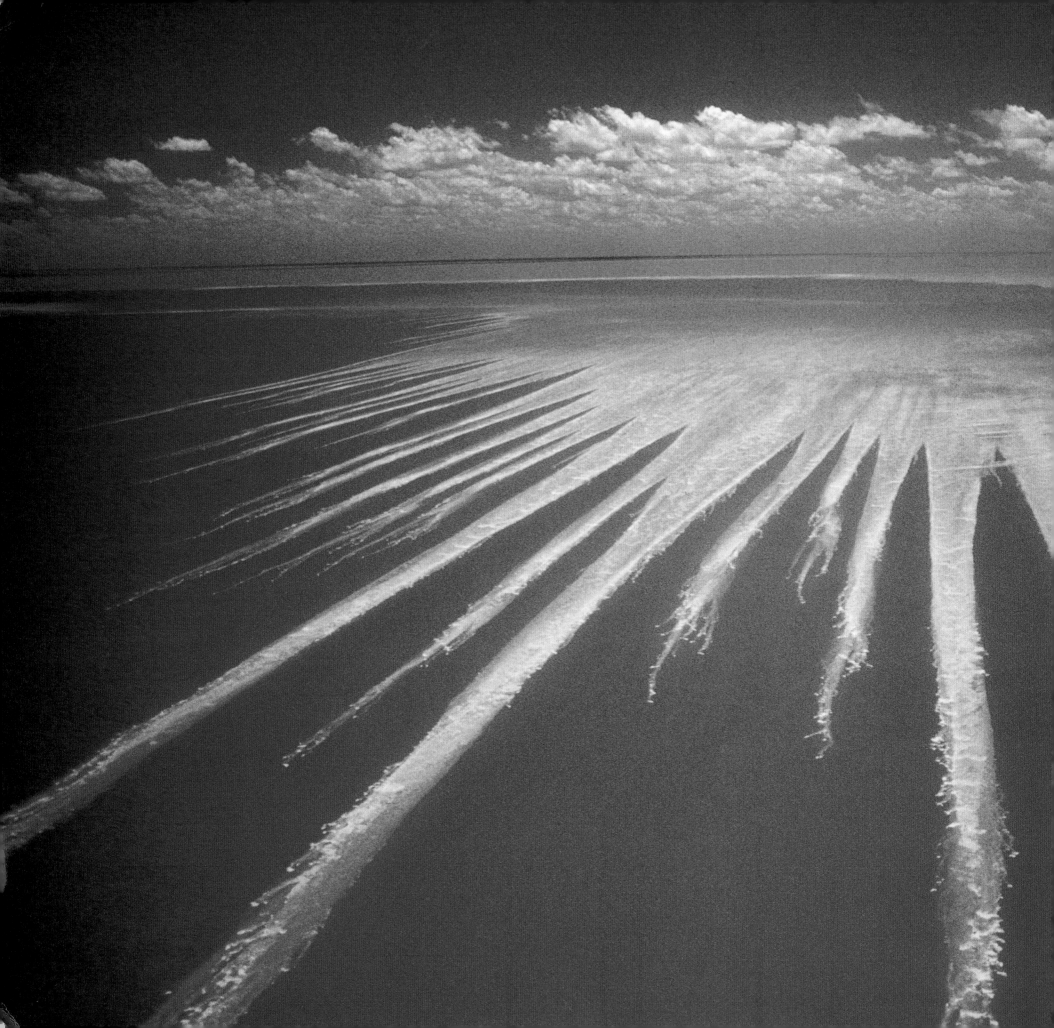

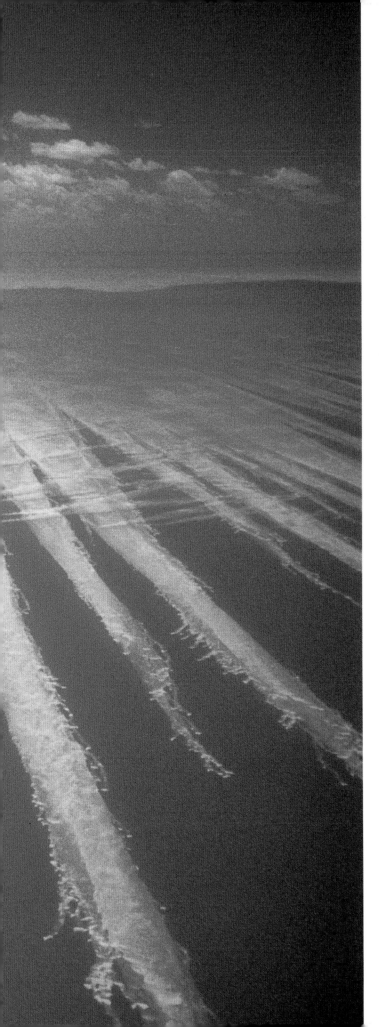

Wind sweeps
unchecked across
the flats of Makgadikgadi,
blowing long fingers of
briny foam across the pans.
A rare deluge has
created a shallow lake,
seen here as a ribbon
of blue beneath the sky,
its shore edged
with white froth.

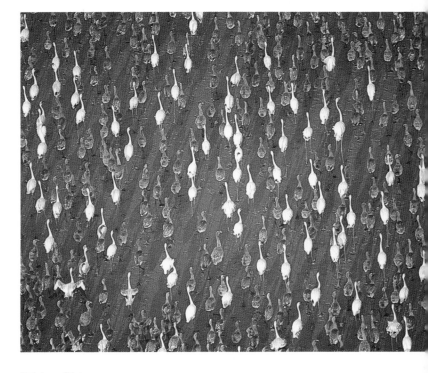

With sufficient water
on the pans, flamingos will
attempt to breed,
but their efforts
are a race against time.
A few years ago,
when the lake close to
their colony evaporated
before their water-dependent
young could fly,
white-plumaged parents
and their downy brown
offspring embarked
on a desperate trek of
dozens of miles
across scorched earth to
reach water again.

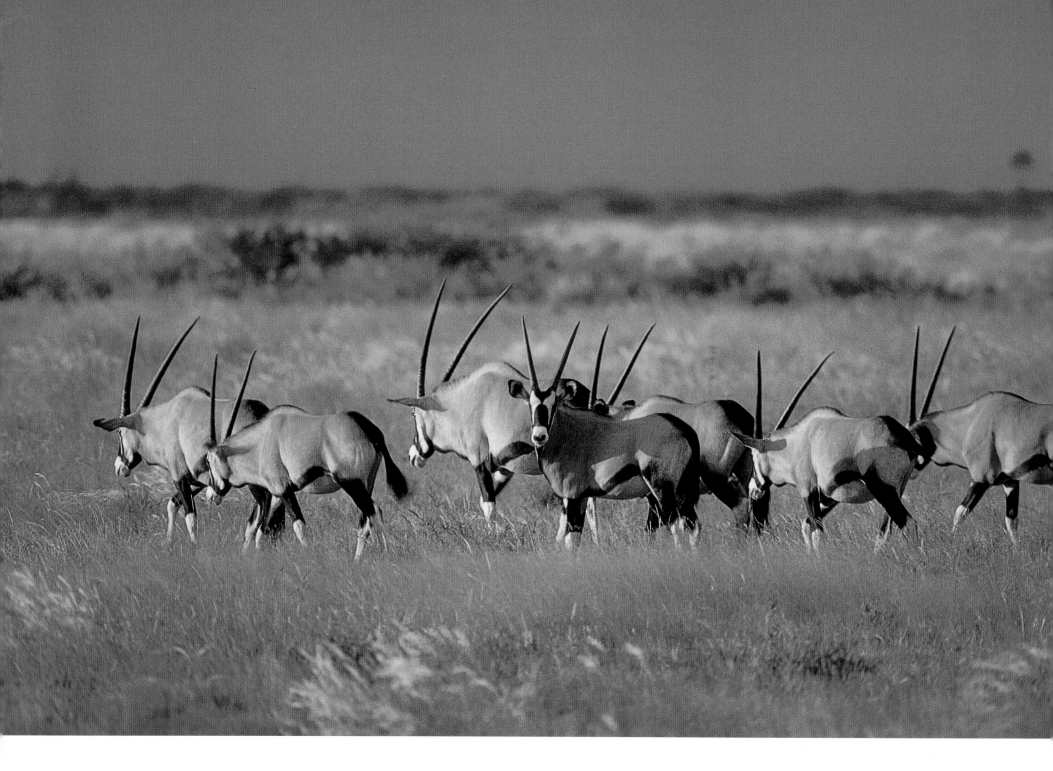

When rain comes to the Kalahari,

gemsbok, or oryx, gather up to graze on new grass. Unlike more
water-dependent animals, gemsbok can survive in the desert
even after all moisture has vanished, due to their extraordinary physical
adaptations: Under stress from heat they don't sweat; instead,
a unique network of vessels in the gemsbok's nose cools blood going
to the brain, while the rest of the body is allowed to soar to
temperatures that most other animals could not endure.

26

After good rains, grasses as lush as those on an American prairie
dominate a landscape too saline for tree growth.

In a landscape
without vantage points,
a yellow mongoose,
one of three kinds
of Kalahari meerkats, stands upright
for a better view.
Like other animals from
aardvarks to warthogs who live
here permanently,
this mongoose retreats
to an underground burrow to escape
the rigors of heat.

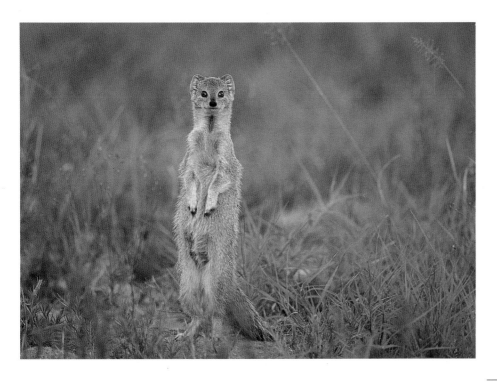

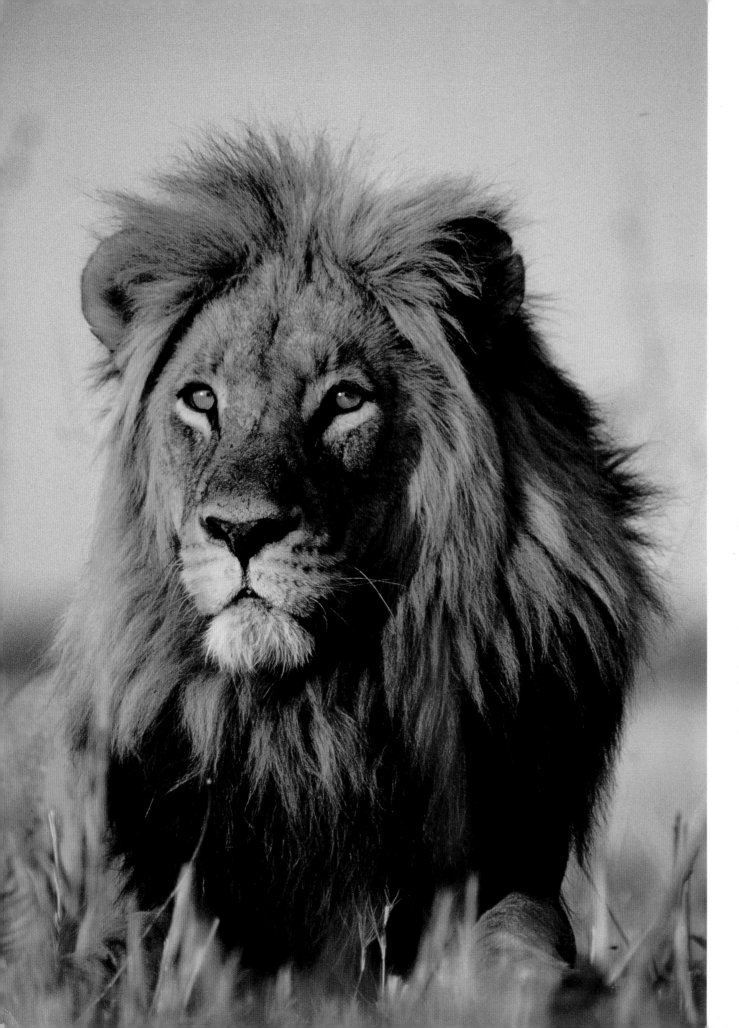

A splendid male approaching
his prime is showing the lush black
mane that distinguishes him
as a Kalahari lion. Some of Africa's
largest lions have been recorded
from this region, a finding
that has attracted trophy seekers
since the nineteenth century,
when famed hunters like
Frederick Courteney Selous
tracked lions here. Few animals have
inspired as much awe,
yet suffered such a decline
at the hand of man,
as have these big cats.
They once roamed over most
of Africa, across the Middle East
and deep into Eurasia.
Today, lions still range widely
through northern Botswana,
but outside parks, hunting for trophies
and livestock protection take
a constant toll.

Regal in repose, but an opportunist at heart, a lioness lounges
on a termite mound. Males and females associate only sporadically,
except for intense reunions during periods of estrus.
At other times, males often wander alone, while lionesses usually
live together in prides. In dry times, when big game becomes
so hard to find that social life cannot be supported, Kalahari prides
may break up, and in desperation Africa's largest carnivore will
stoop to sustenance as meager as mice and termites.

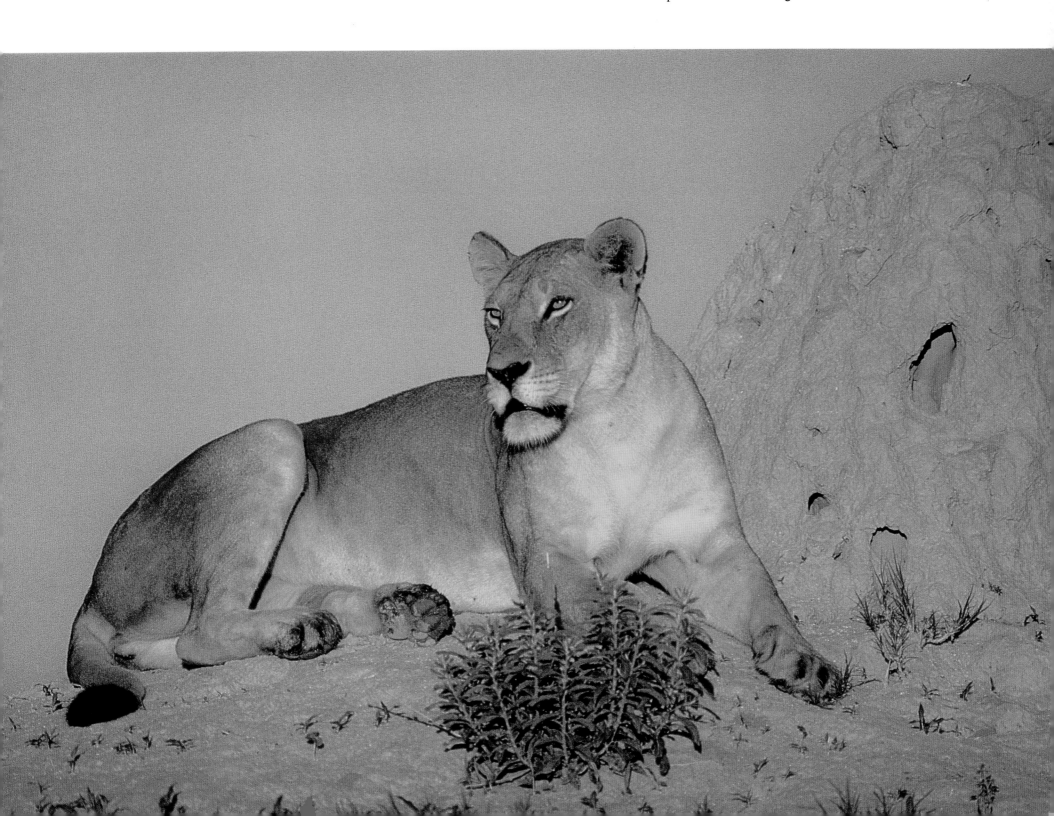

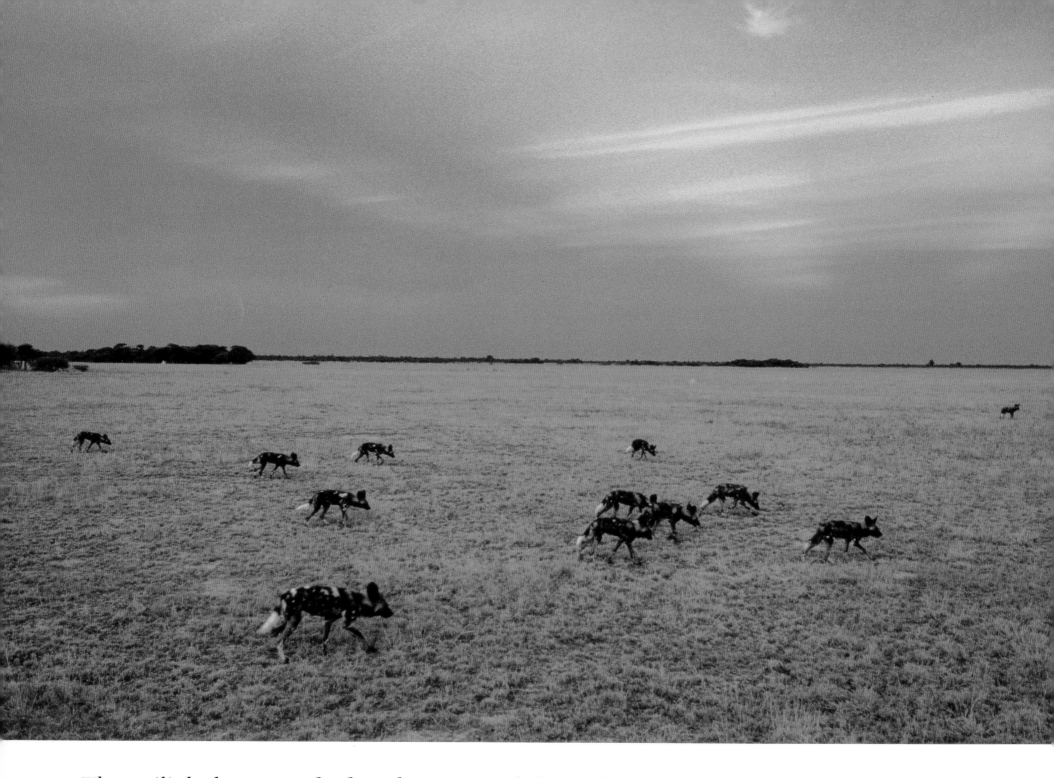

The twilight hunters of Africa have roused themselves for a hunt:

A pack of wild dogs fans out across Makgadikgadi's Nxai Pan. Restless and nomadic, they cover a great range, moving into an area one day, vanishing before sunrise the next. These wiry canids, once found all over the continent, are all but gone from much of Africa now, shot out as vermin, like the wolves of North America and Europe. For several days I followed this pack—one of around 30 in northern Botswana representing the largest population left on the continent—watching them hunt with the boundless energy that marks their kind.

A herd of springbok, sensing wild dogs approaching, flares white rump patches in a collective signal of alarm. They're still several hundred yards away, but the springbok know that a pack of wild dogs in a hunting mood is lethal at any distance. If lions were coming, the herd wouldn't react like this yet: Lions are dangerous only at close range.

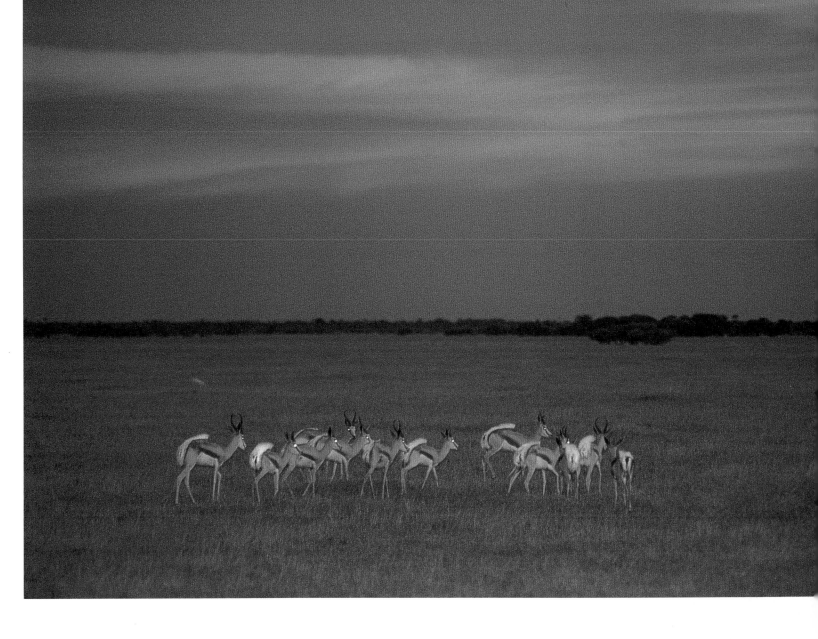

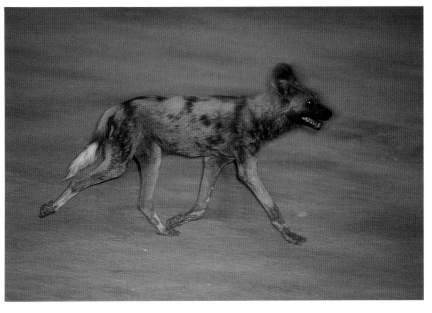

The "painted wolves of Africa" are known for their marathon endurance. I saw a chase that extended over 2 miles— far longer than other predators can sustain. The dogs finally overcame their quarry, exhausting it with an unflagging pace.

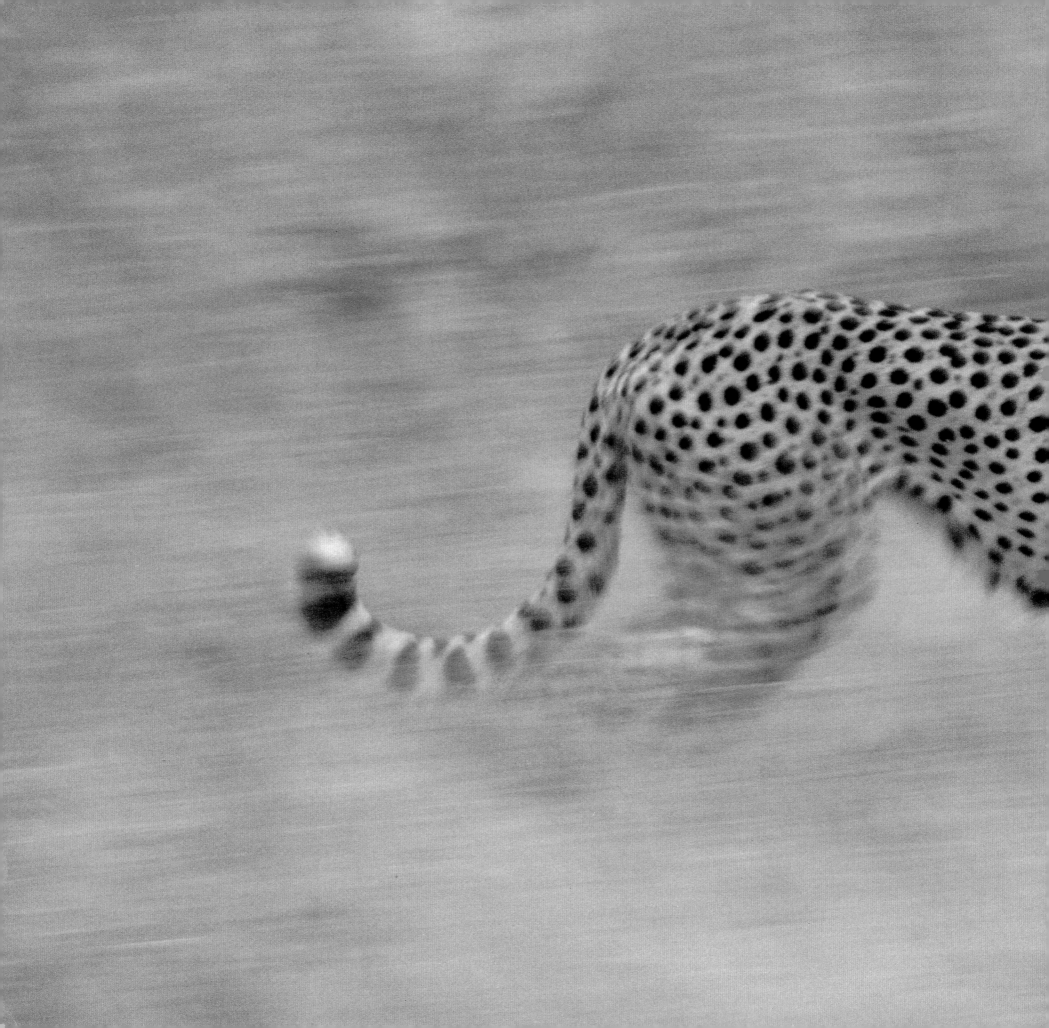

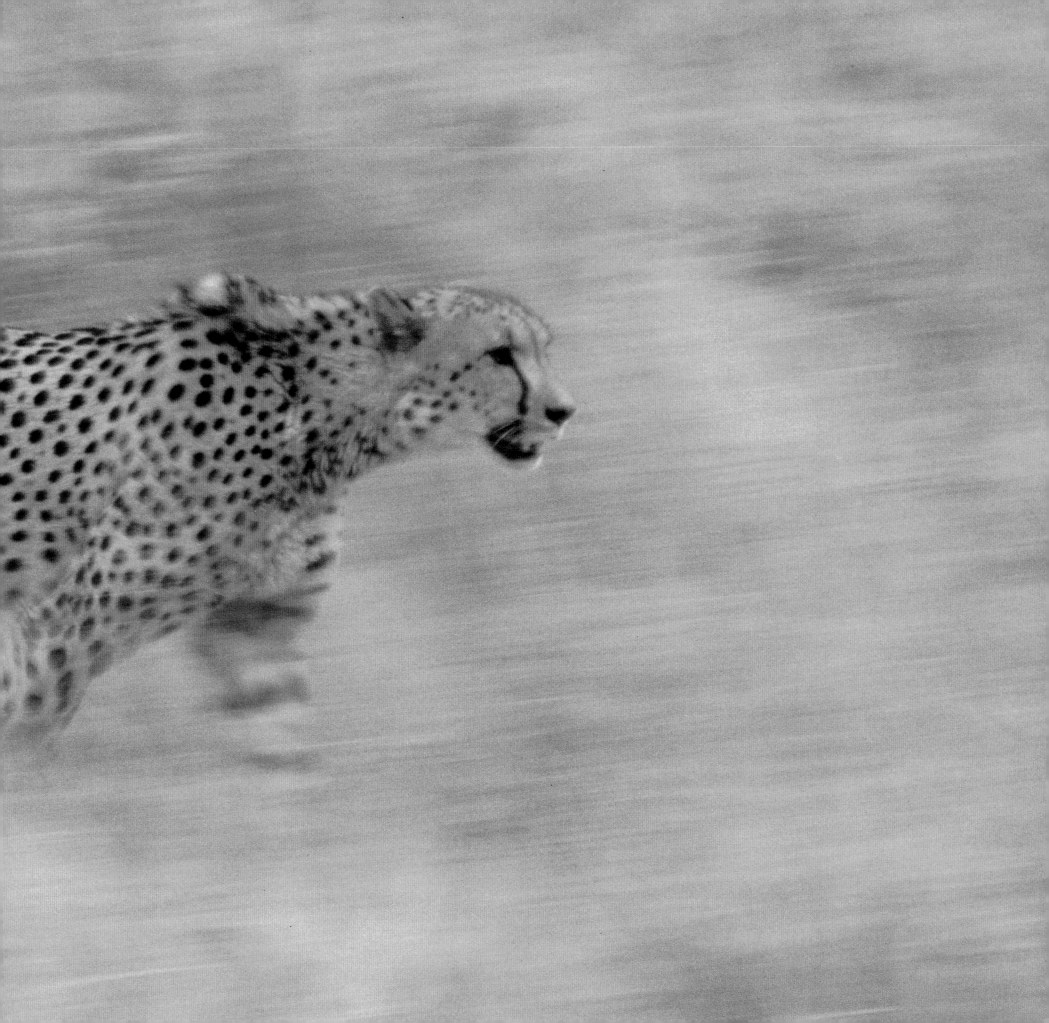

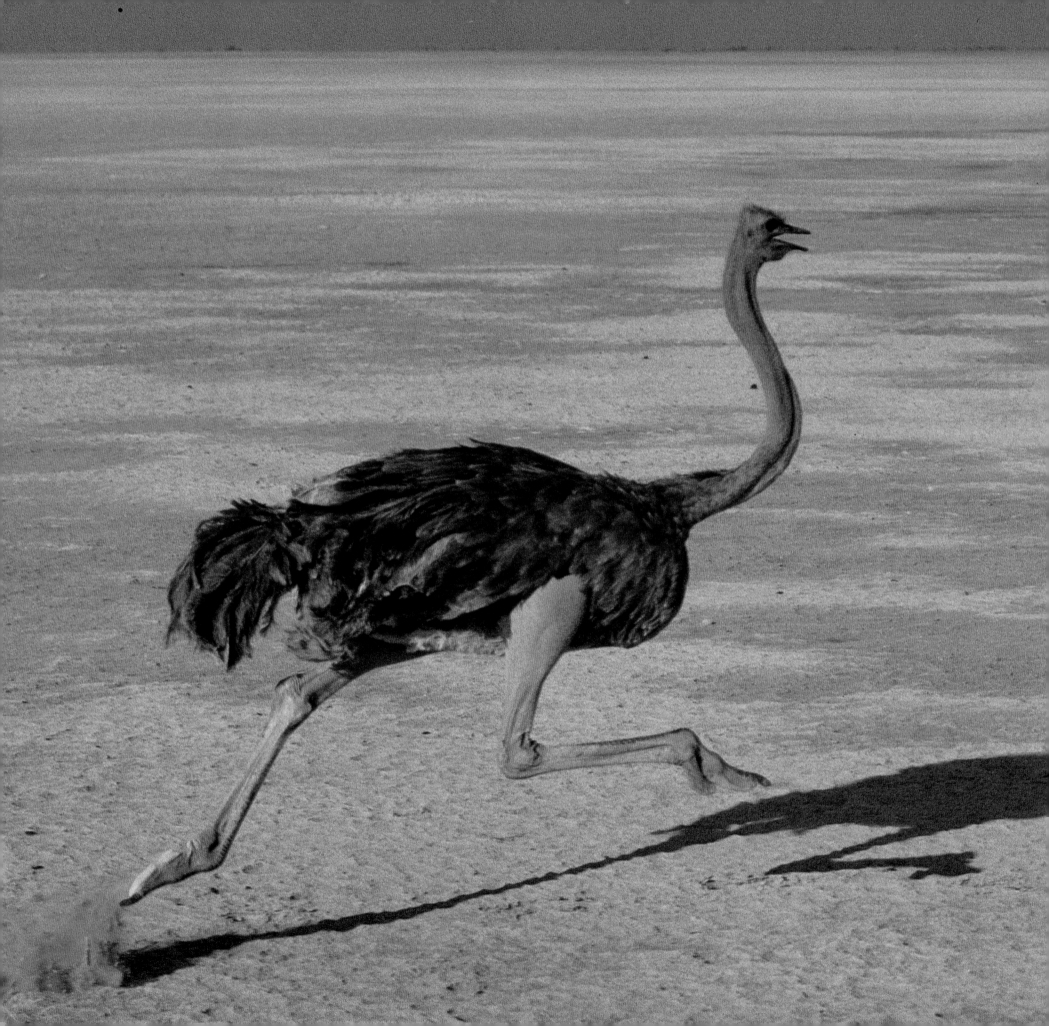

A female ostrich sprints
across a pan.
Some of the fastest creatures
on earth live in the wide open space of the Kalahari:
Ostrich chicks four weeks after birth
have been clocked at
35 miles per hour.

◄ *Overleaf*
A cheetah the color of Kalahari grass
slinks forward, eyes focused
on distant possibilities.

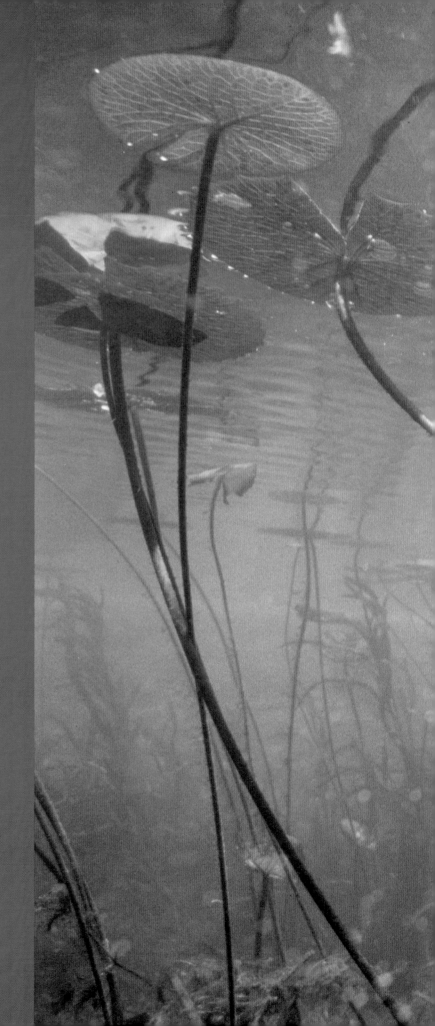

OKAVANGO

The Miracle of Water

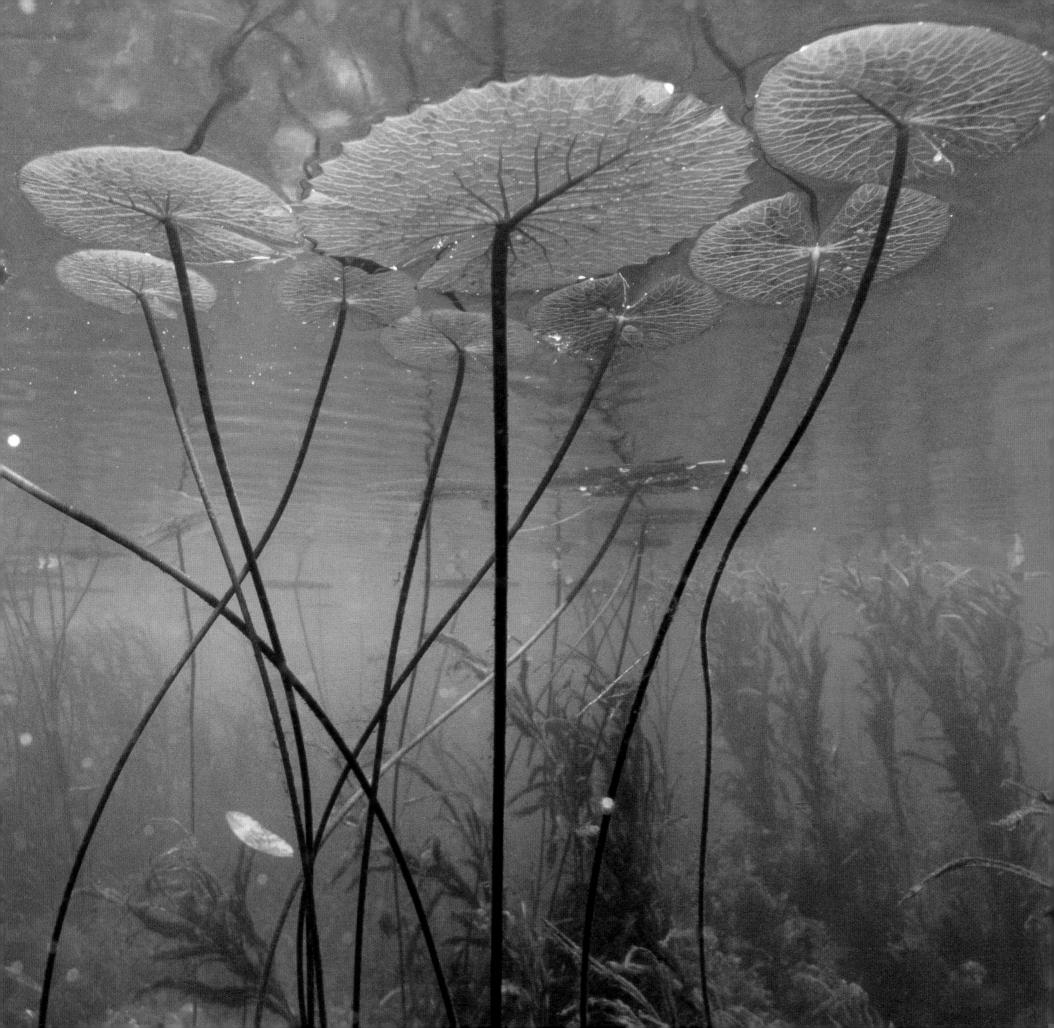

I took a deep breath and plunged into the swamp.

Just 10 feet down I hit bottom, where lily stems were anchored in white sand. The water was clear as glass. I floated back to the surface and turned in a slow circle. All around stretched a tranquil lagoon reflecting a blue sky full of high clouds. The water wound off in a maze of channels through beds of emerald papyrus. Beyond lay a scattering of round palm isles. It was a scene of soothing color and sensuous texture. I was in the heart of the Okavango Delta.

It was November, austral spring, a month when the water level is low. Even the biggest channels seemed barely deep enough to hide a hippo. At this time of year, however, the true nature of this swamp is best revealed: Essentially, the Okavango is just a thin sheet of water stretched over the Kalahari—but that layer of water covers 8,500 square miles. The Okavango is the largest inland delta in the world. It is such a distinctive feature on the African continent that astronauts looking down on the earth from outer space were captivated by its outline—an outstretched hand in the center of southern Africa, imprinted blue on the brown of the Kalahari.

The Okavango is that most unexpected of wonders: water in the desert. David Livingstone, the first white man to report its existence to the outside world, reached the delta in 1849 after a grueling journey by oxcart across the Kalahari. When he saw it, he marveled: "We found the water to be so clear, cold and soft the higher we ascended that the idea of melting snow was suggested to our minds." When he asked local people where the water came from, he was told: "Oh, from a country full of rivers, so many that no one can tell their number."

Africa's great oasis originates from a spring-fed stream in the highlands of Angola. Joined by other streams, it forms a river, the Cubango, that flows southeast for some 1,000 miles before it enters northern Botswana as the Okavango. There the river's fate is determined by a series of geologic faults, the southernmost extension of the Great Rift Valley system that cleaves down through eastern Africa. After the river crosses a first fault, it splits into several main channels and spreads out in a huge fan of smaller waterways. Water flows through a labyrinth of passages to the southeast, until it reaches another

◄ *Overleaf*
Suspended below the surface of the Okavango Delta, water lilies sway in the current.

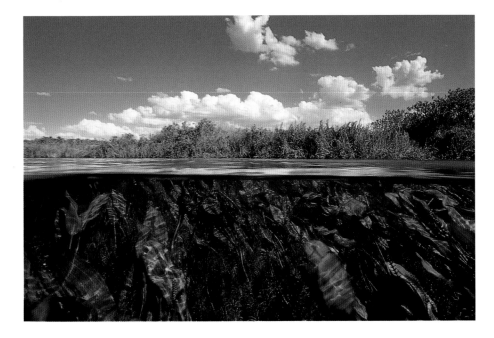

A split-level view of the Okavango shows a crocodile's perspective on the swamp.

fault which blocks the water like a dam, condemning the river to a splendid death in the middle of the Kalahari as one of the greatest wetlands on earth.

Two annual endowments of water replenish the delta. The first comes as a quiet flood. December rains in the Angola highlands swell the Cubango, but a few months pass before that rush of new water reaches the northern part of the delta. Around March, the Okavango begins to expand, but it takes several more months for the flood to spread to the farthest edges of the system. It can be July before it reaches the base of the delta near the town of Maun. It's austral winter then, a cold and dry time of year, but in the midst of this harsh season, the rising water seeps into the surrounding land and greens the earth.

Herds of big mammals that roam the arid bush of northern Botswana now turn toward the Okavango. The land surrounding the delta is dry, water holes are disappearing, and nutritious grasses and browse are becoming scarce. At that time the Okavango provides reprieve. The annual flood crests, then ebbs like a sea tide; in its wake, fresh grasses sprout on the delta's *molapos*, or floodplains, and animals gather there in great numbers to feed and drink. Elephants, buffalo, zebra, wildebeest all move in, some by the hundreds, others by the thousands. It might seem that these multitudes of animals would overgraze and trample the molapos to a muddy waste, but the very character of the flood ensures a constant renewal: As the water recedes, it exposes new areas of fresh pasture, and animals follow the shifting edge.

The second flush of water comes as the flood recedes. Local rains fall in the austral summer, supplying the delta with one-third of its annual influx of water. That is when herds scatter away from the Okavango again to greening lands and fresh water pools beyond. Over the course of a year, the Okavango expands and contracts to the syncopated rhythms of water. This wild, pulsing heart of the Kalahari is a constant that's constantly changing.

The innermost part of the Okavango is a perennial swamp. There are no tracks for vehicles here, or any that even come near. For parts of the year, the water is so low that the only way to get around is by dugout canoe. The Okavango is a watery wilderness of looping channels lined with walls of papyrus that can reach heights of 25 feet—a tangled domain, half-liquid, half-grass, where only one channel leads anywhere, the rest to reedjams, or nowhere—or to a broad blue lagoon you never guessed was there. Flocks of water birds flap overhead, hippos slosh and grunt in pools, crocs drift through backwaters; and in silk-smooth lagoons, jacanas with spidery feet tiptoe across lily pads.

The inner swamp is a world apart. But it is at the outer edges, where delta touches desert, that the wonder of the Okavango is most apparent. Here, vast areas of reed beds and flooded savanna covered by only a few inches of water are peppered with herds of red lechwes, flocks of storks and waders, and other creatures who like to keep their feet wet. They live within the perimeters of the delta, bound by the moving edge of the wetlands. Besides attracting the seasonal arrival of herds from the surrounding dry lands, another annual spectacle has its source here. When water fills the floodplains, schools of catfish move out to spawn in the molapos. As the delta contracts again, they retreat to the deeper channels of the swamp, where they gather in ever-growing numbers until they become squirming, gurgling masses of fish, migrating upstream to meet head-on the next flood coming down from Angola.

There is a finality at the outer edge of the Okavango. Turn your back, and you face thorns and sand, a land without water. One bone-dry day in August, as I searched for animals in the bush near the southern edge of the delta, I bogged my truck down in deep sand. I walked out to survey the scene. A weak winter sun shone overhead as I worked my way through a brittle thicket—and came upon an unexpected sight. Just ahead, a tongue of water oozed toward me. It was an inconspicuous muddy trickle, a feeble finger of the annual flood from the Okavango stretching across the sand. I watched it advance inch by inch into the desert, slow but unstoppable, the simple miracle of water.

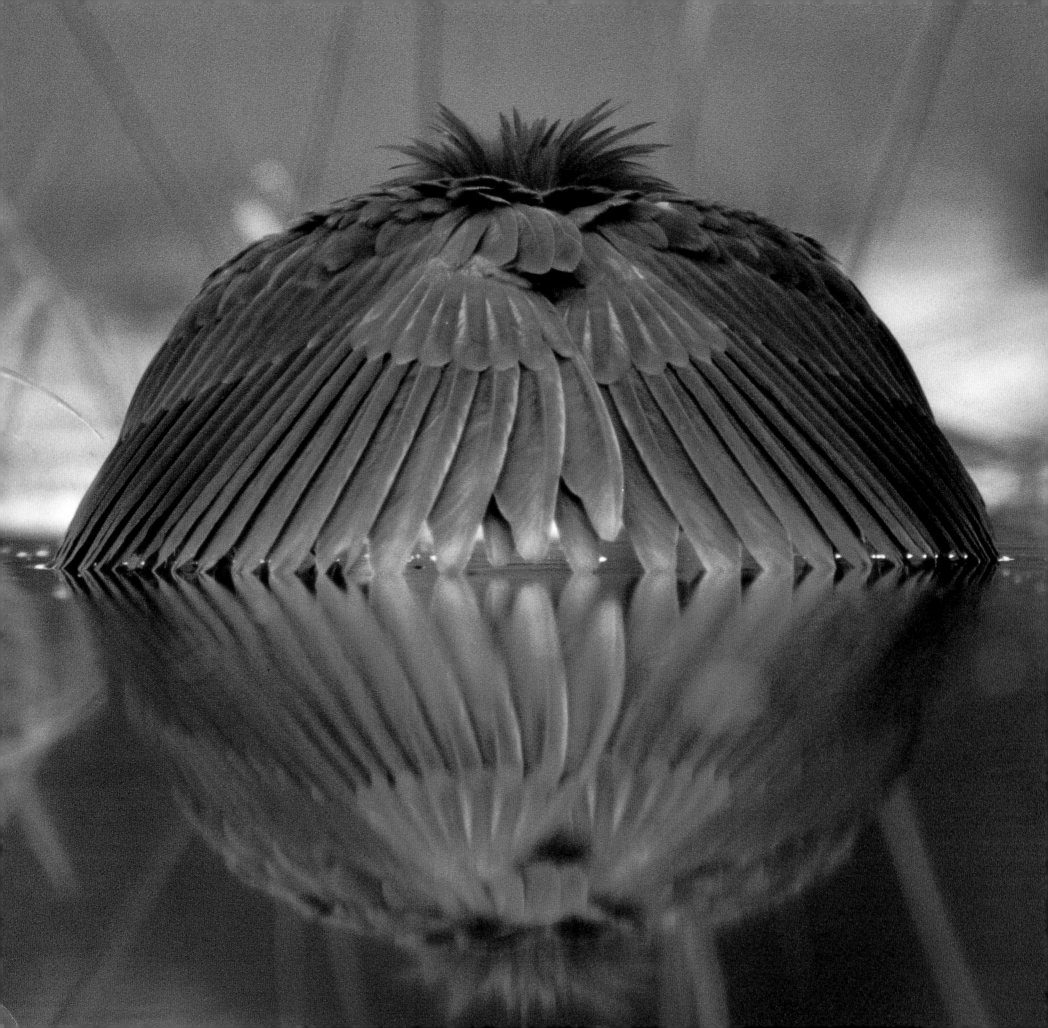

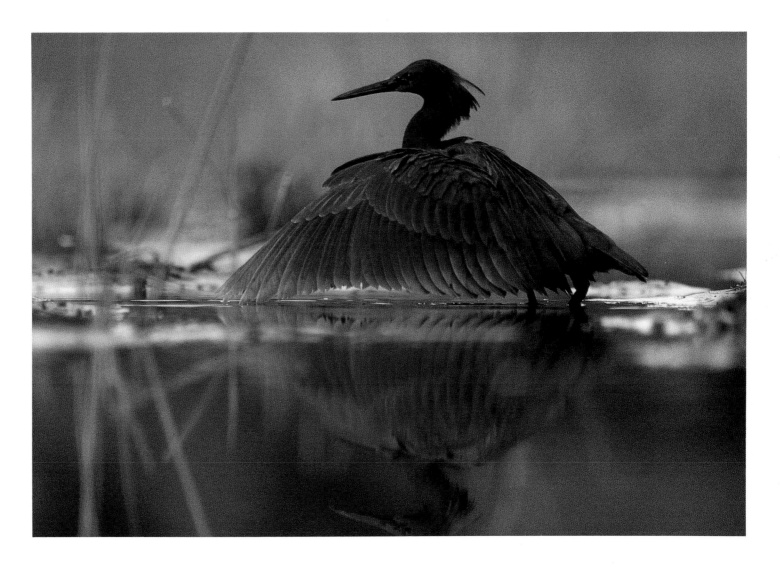

In a backwater of the delta, a black egret fishes

within the dark compound of its own spread wings.

It is unclear whether, as some suggest, this method reduces glare

so that prey is seen more easily, or, as others say,

the darkness makes small fish rise to the surface.

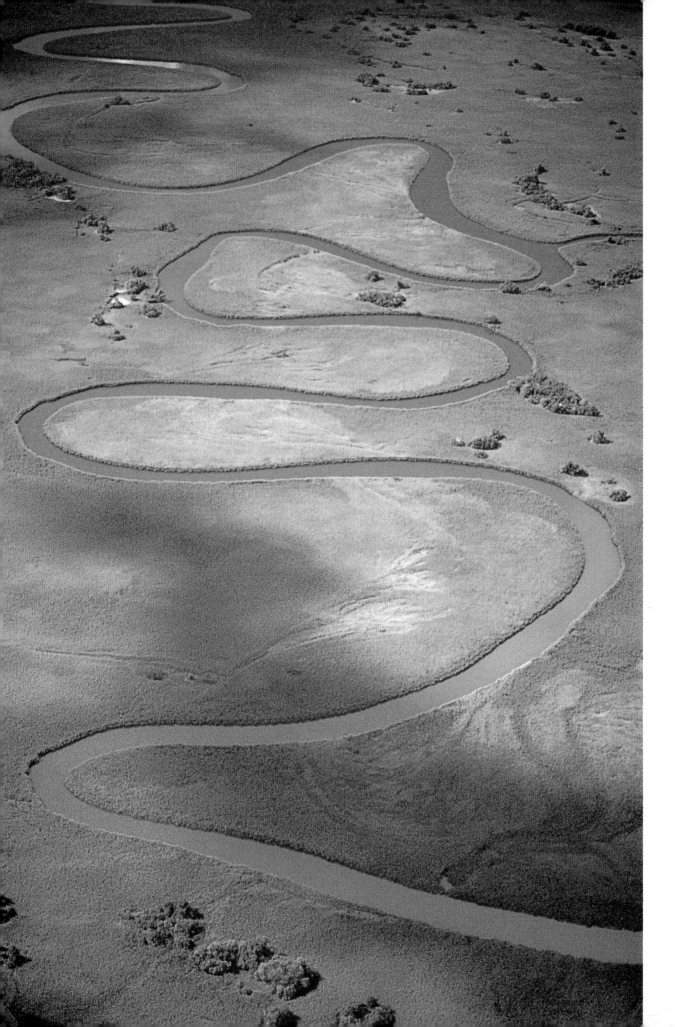

Lifeline for the delta,
the Okavango River meanders
through northern Botswana,
its floodplains covered
with dense stands of papyrus.
Giant oxbows loop
between two parallel faults
that funnel the river southeast.
Narrow enough
to throw a stone across
in dry times,
the river is nonetheless
the umbilical cord
through which water from
the highlands
of Angola flows down into
the dry Kalahari—
a distance of more than
1,000 miles.

Here, in the middle of a desert in southern Africa, the river ends,

creating one of the earth's great wetlands. At its outer edges, the Okavango
pulses with the ebb and flow of seasonal rains, but at its center lies
a perennial swamp that never disappears—a water wilderness of papyrus and
scattered palm isles, many of which have formed around
old termite mounds.

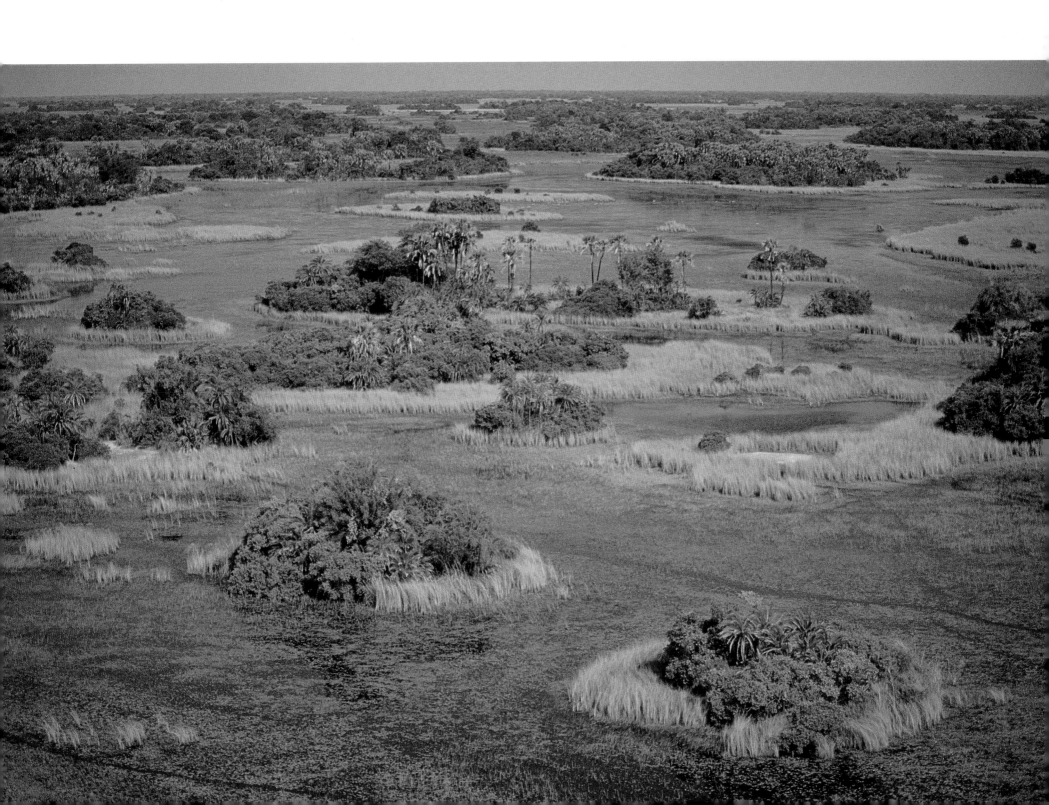

An anhinga pops up
with a bill full of bream,
swallowing it whole
moments later.
Some call the anhinga
a darter, but I like the name
"snake bird" best.
Underwater it's sleek
and fast, a sinuous
form with reptilian agility,
propelled by
huge webbed feet.

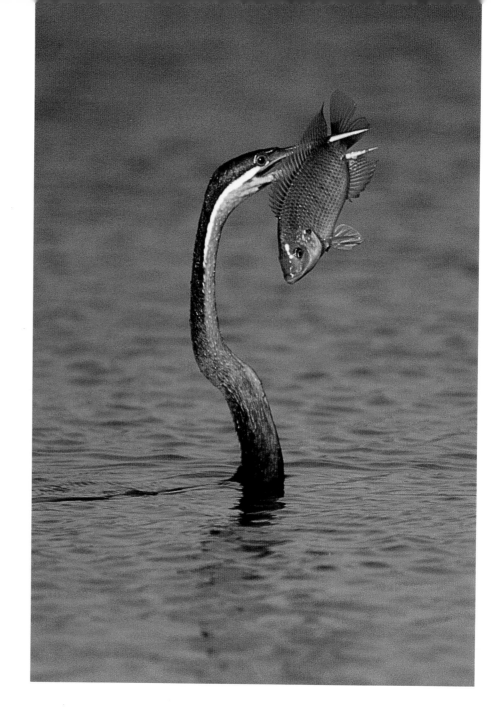

The bold face of a curious young hippo

displays little of the belligerence for which adults are feared.
The swamp's biggest permanent residents, hippos play an important ecological role
as fertilizers and dredgers. A single hippopotamus may consume as much as
400 pounds of fodder per night on land, and much of that is released into the water
as nutrient-rich dung, while paths used habitually by hippos open new channels
through the delta. But that abstract understanding gives way to an adrenaline rush
during a face-to-face encounter with a hippo in a narrow waterway.
More than once I saw one submerge ahead of my small boat, then watched
a bubble trail approach like a torpedo—and pass.

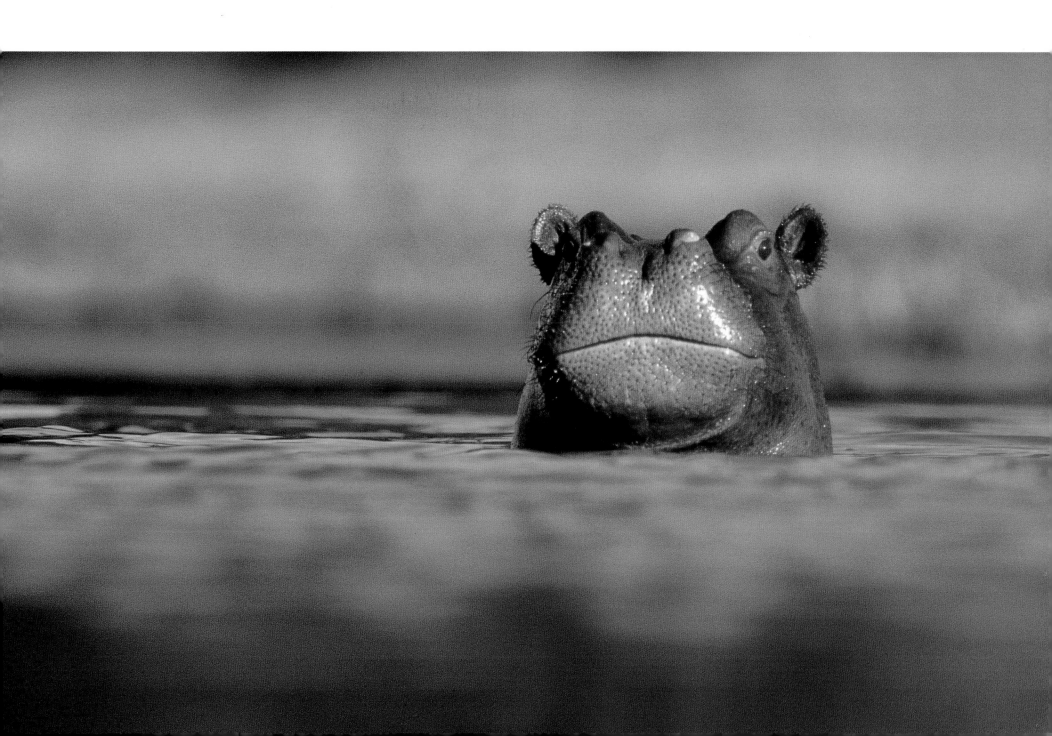

The sheer surprise
of seeing an elephant emerge
from underwater
is one of the Okavango's
wondrous sights.
It is easier to understand
after you spend time
with these giants and realize
that they not only need
water but seem simply to enjoy it.
I've seen them wade
through channels to feed
on swamp grass,
and I've watched them
linger in pools
for needless hours,
all for the love of a swim.

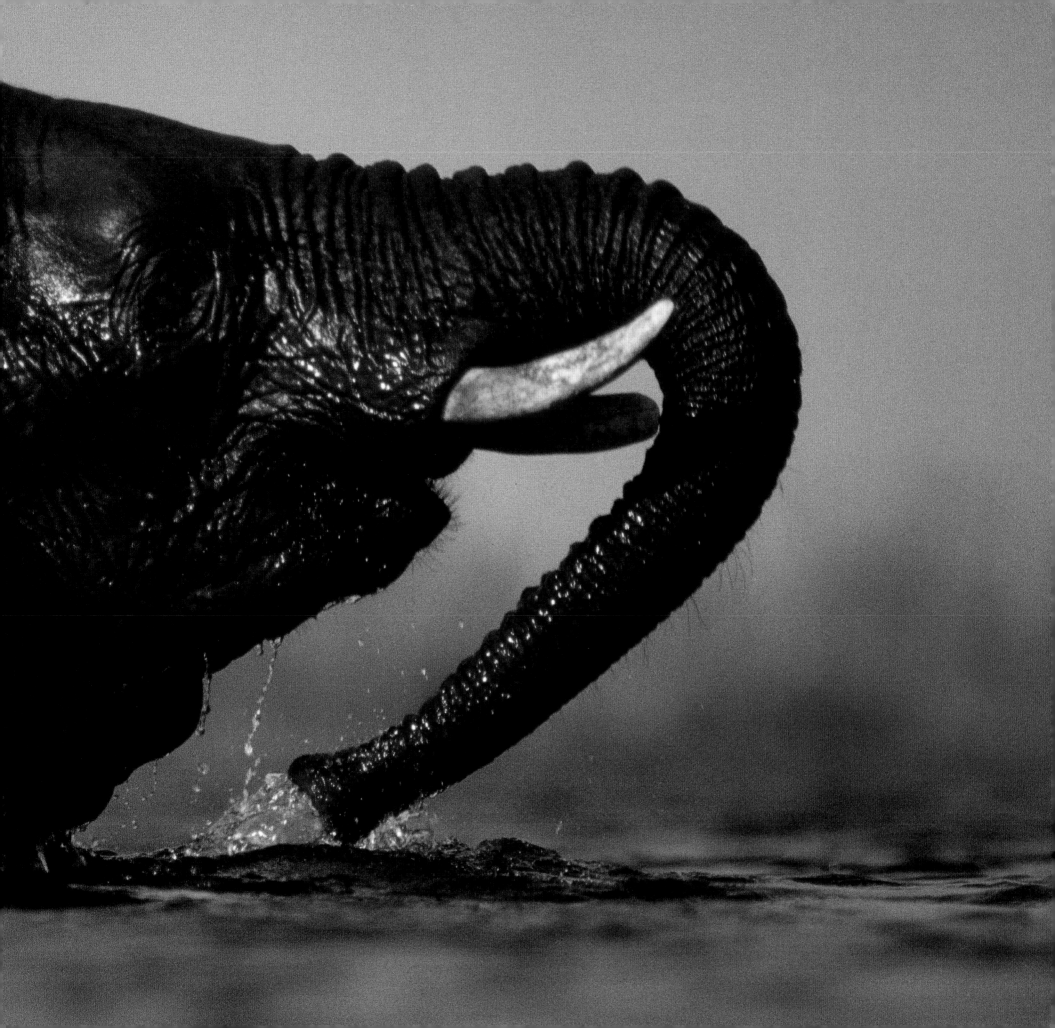

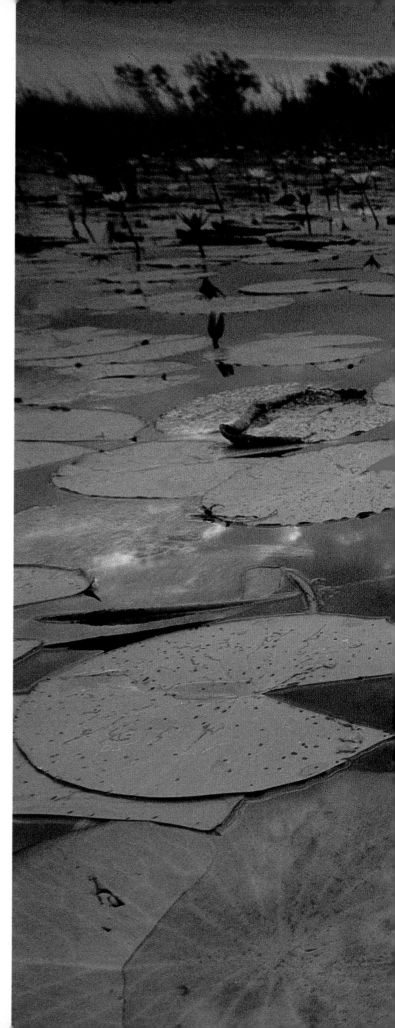

On summer nights
the icy tinkling of reed frogs
calling for mates
drifts across delta lagoons.

The delta's backwater lagoons are oases of calm;
removed from the flow of main channels, some are so mantled
with lilies that in a dugout canoe, you literally pole through blossoms.
Each water lily opens for a few days during the flood;
then its stalk recoils and pulls the bloom underwater,
where fruits ripen and seeds drift away.

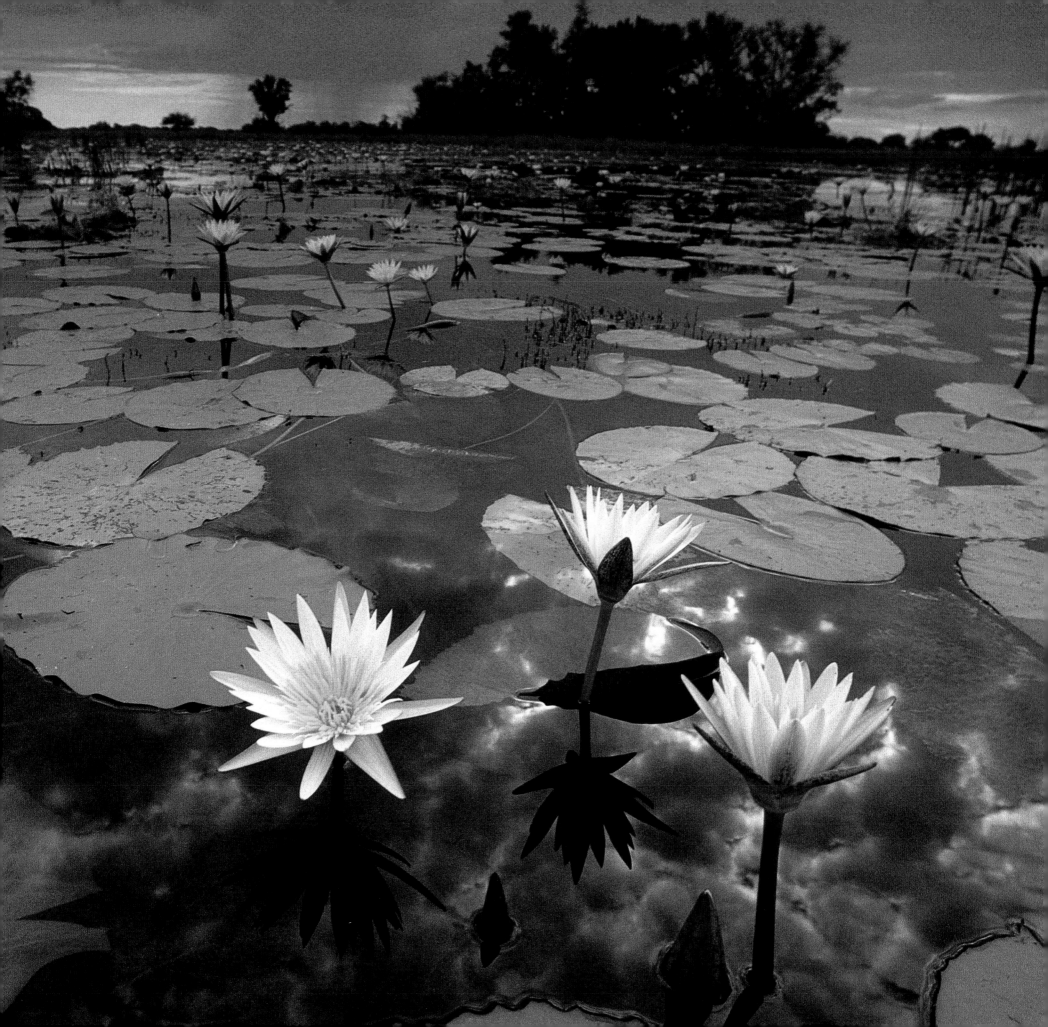

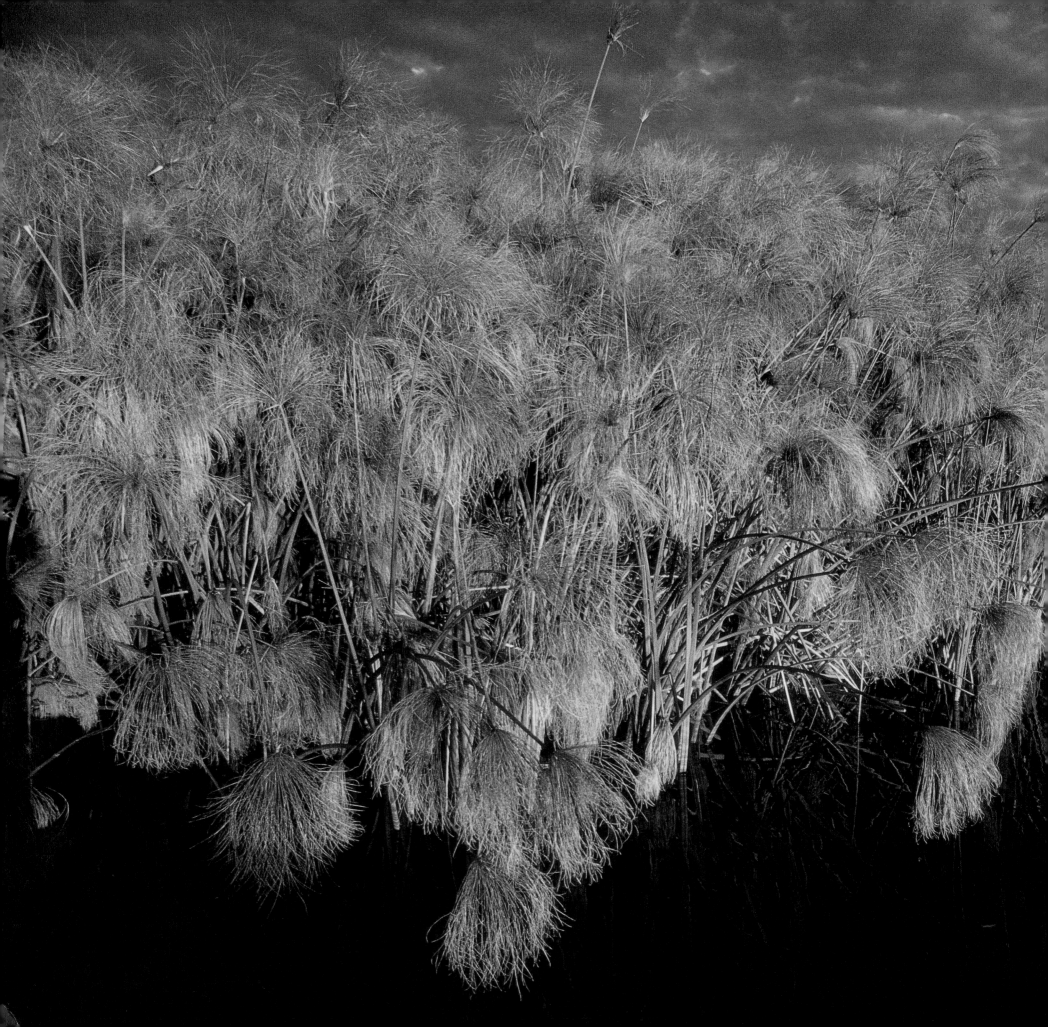

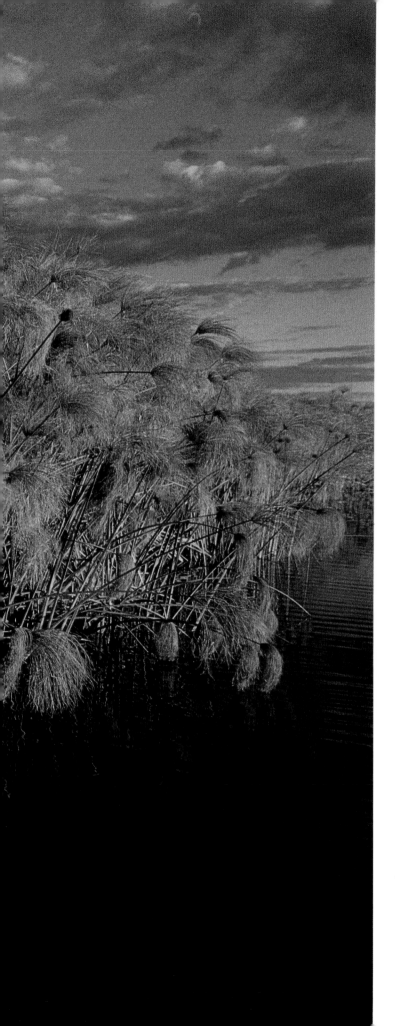

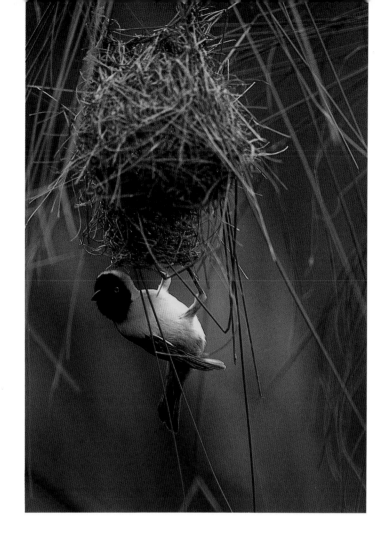

Papyrus has little to offer
to most wildlife in the way of food
or shelter, but this masked weaver
has succeeded in connecting
two stalks for a nest.

Despite its lush appearance,
the Okavango is actually a low-nutrient
environment, and yet the speed
with which papyrus grows in the swamp
rivals that of the best-tended
agricultural crops. Papyrus recycles
its own nutrients to an unusual degree,
and a rare but very effective form
of photosynthesis helps boost its
growth rate. So successful is the plant
in this particular niche that its
unbroken stands go on for many miles
as a virtual monoculture.

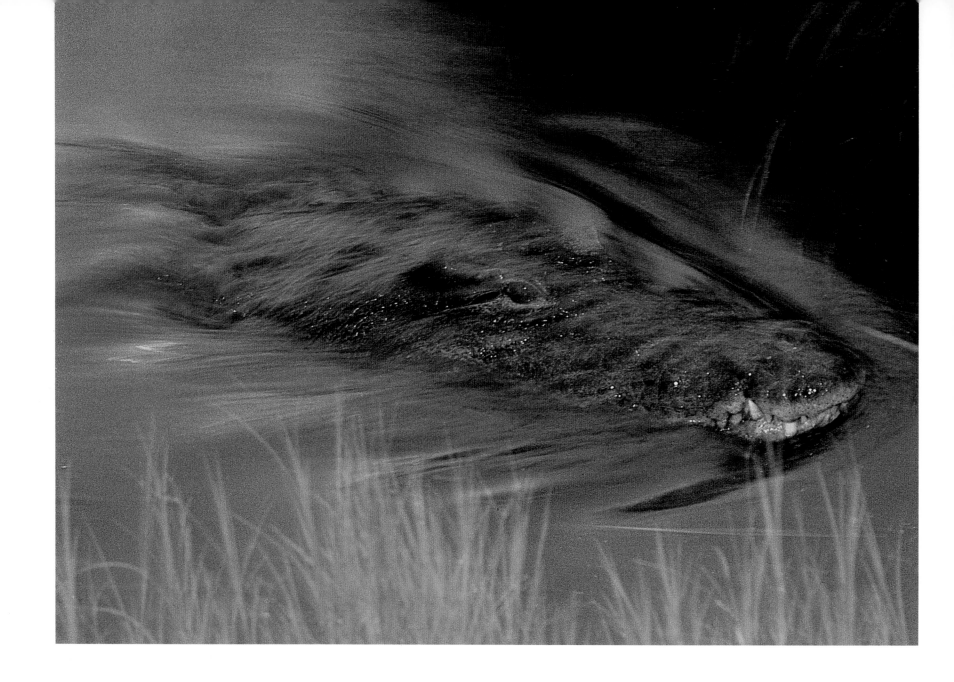

Stealth is a silent craft that has been mastered by crocodiles
over the ages. A 16-footer that weighs 1,000 pounds
can slide through the water with barely a ripple. When they drift along slowly
or lie motionless in the sun, their passivity is deceiving.

When crocs strike,

they do so
with astonishing speed
and strength.
Big ones are not
often spotted
in the delta these days;
decades of
commercial hunting
have decimated
their population.
Although crocs are
protected now, older ones
have learned to stay
in backwaters,
away from people.

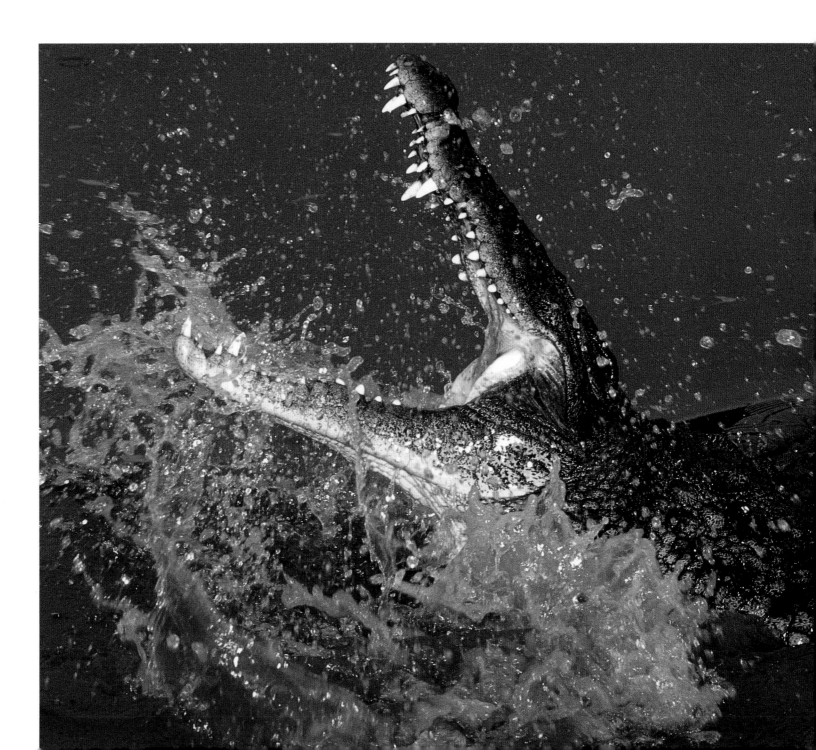

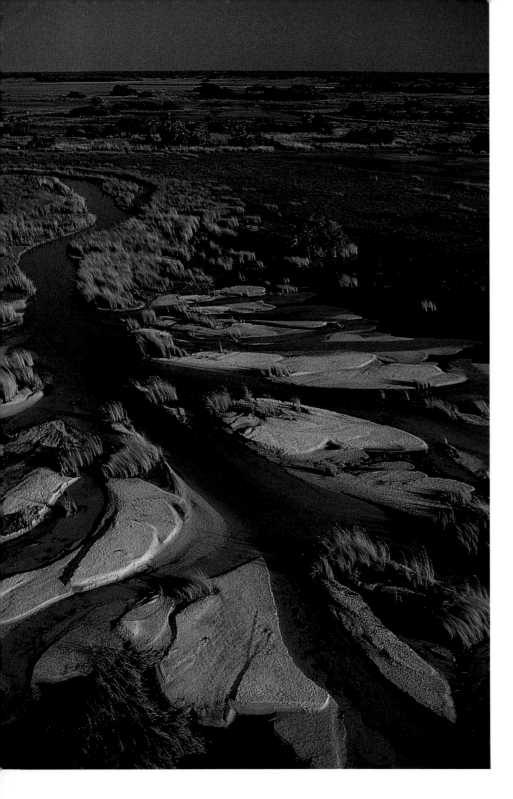

Under the Kalahari sun,
a staggering 95 percent
of the delta's water
evaporates each year.
When the water level begins
to drop in August,
floodplains are drained
and sand banks
are exposed along the channels
that vein the swamp.
The banks become nurseries
for the eggs of shorebirds
and crocodiles,
whose young need to hatch
before the water
rises again.

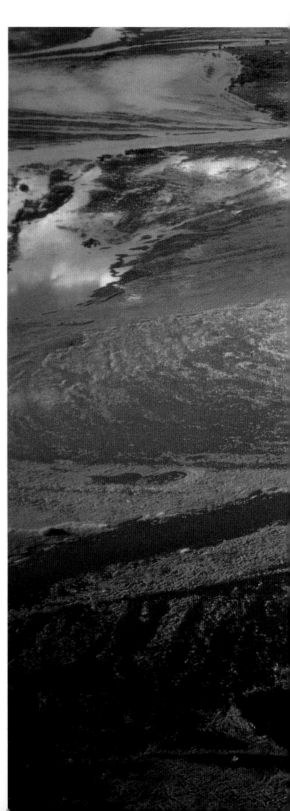

When the Okavango swells
with a new flood,
water rushes through every
sinuous passage.
Rivers overflow their channels
and spill onto floodplains;
in a matter of months, the delta
can literally double in size.

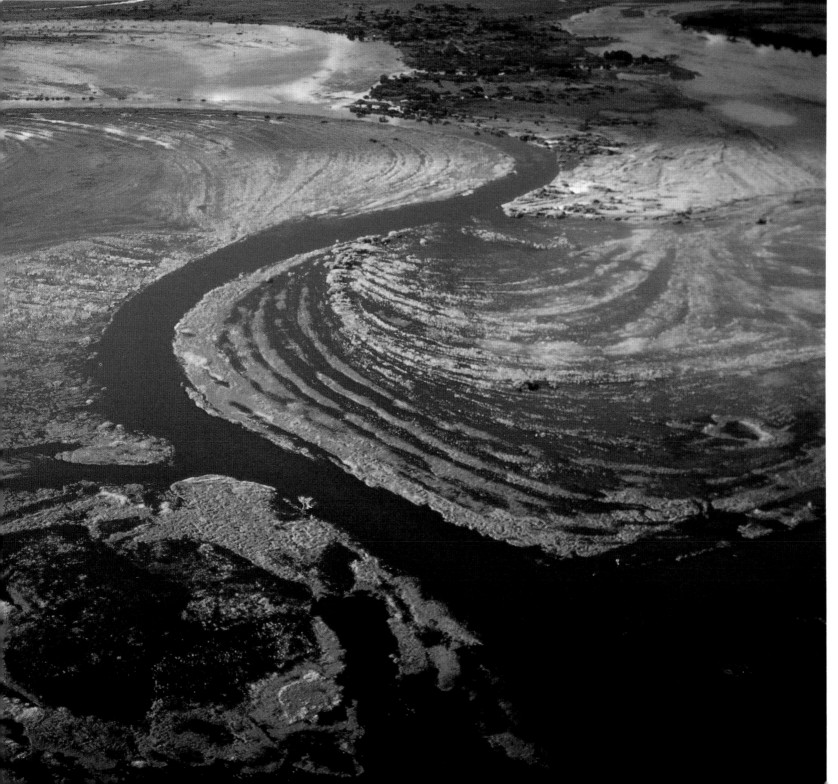

Like Noah's dove bearing an olive branch, this yellow-billed stork carrying nesting material to a breeding colony in the middle of the delta signifies the flood's subsiding. As do many birds, these storks time their nesting to coincide with the lowering water table that makes prey more available.

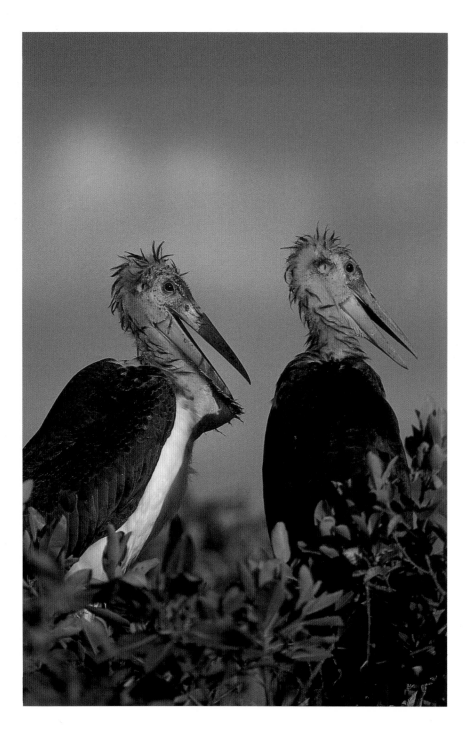

Panting in the sun, two young marabou storks on a nest await the return of their parents.

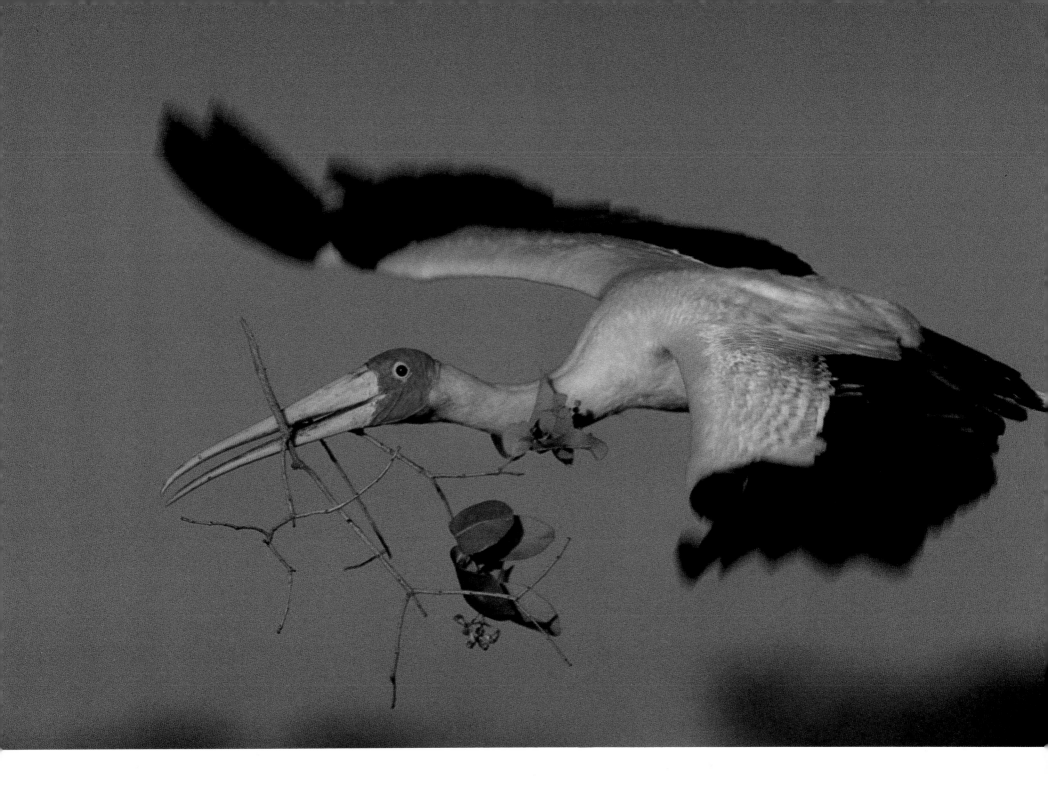

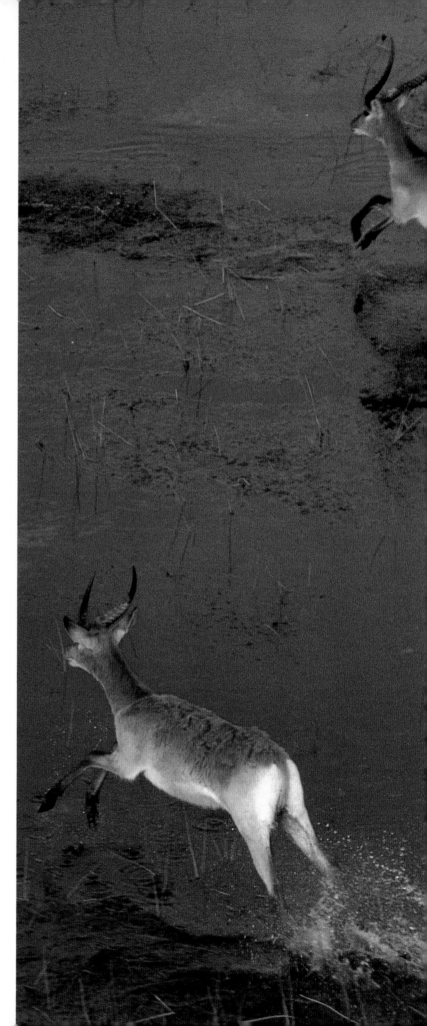

Herds of red lechwes abound

on the flooded grasslands or molapos. They will run
into deeper water when pursued, and often lay their heads far back
on their shoulders when fleeing, an instinctive behavior
believed to prevent their horns from becoming entangled in reeds or papyrus.
Another antelope, the elusive sitatunga, is even better adapted to living
in the deeper recesses of the swamp. Its deeply splayed hooves
allow this aquatic antelope to move with ease through the boggy terrain,
where it feeds on tender papyrus crowns.

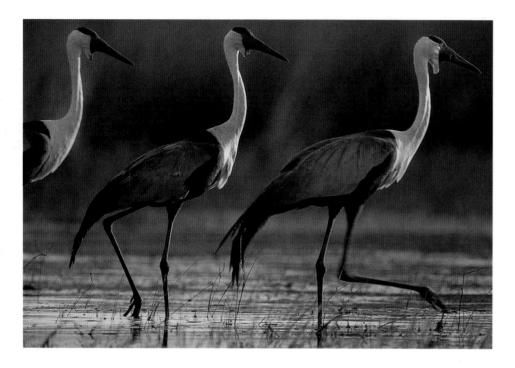

Found side by side
with lechwes in
the swamp shallows,
wattled cranes
are among the largest
and rarest of cranes.
The Okavango
is a crucial habitat
for this species.

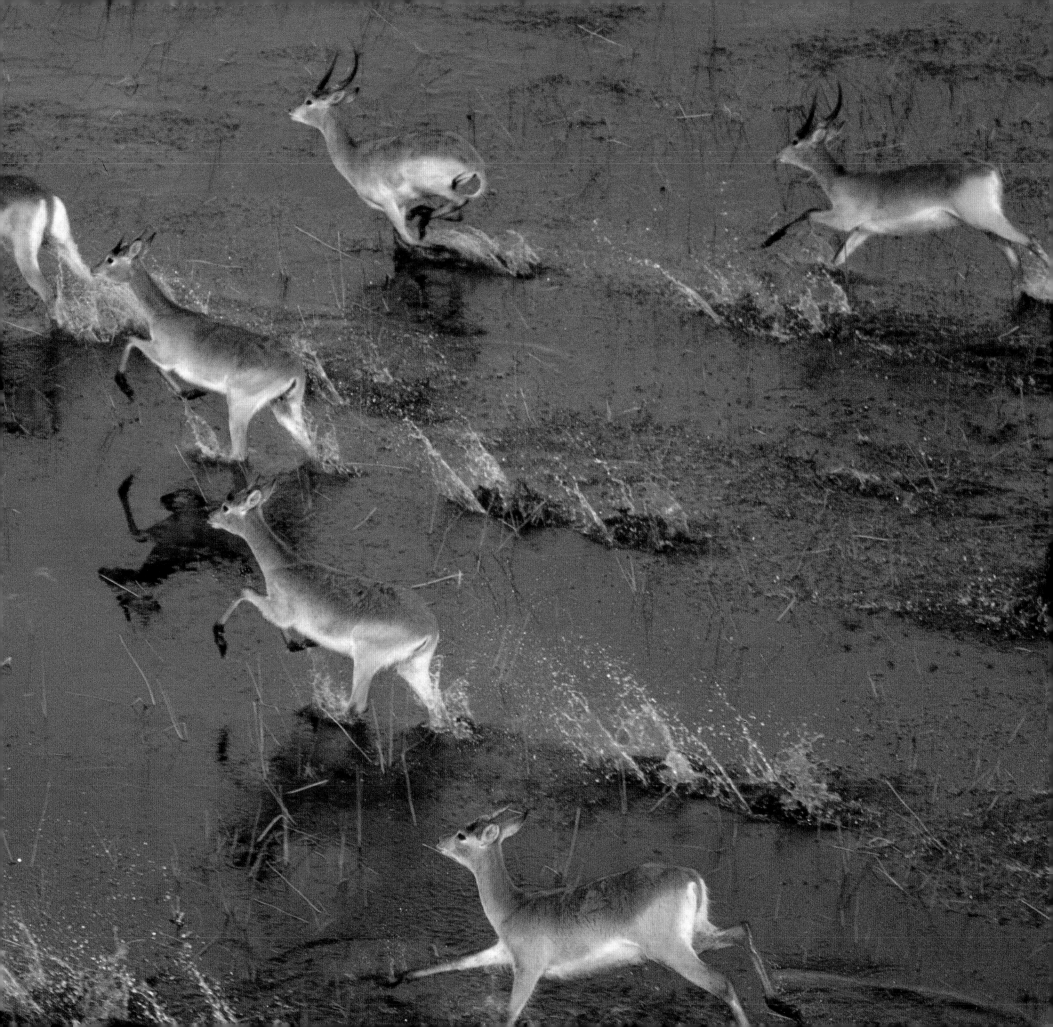

Herds of buffalo lead the great movement back to the delta's edges in the dry season. Northern Botswana's wetlands may well support the largest population of buffalo on the African continent. Herds numbering in the thousands are not exceptional.

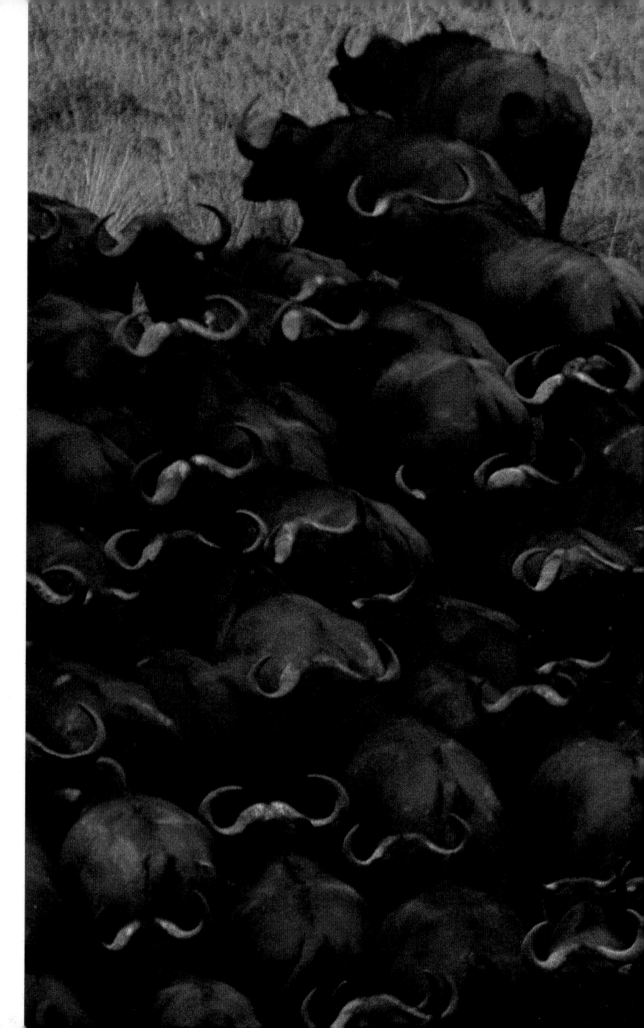

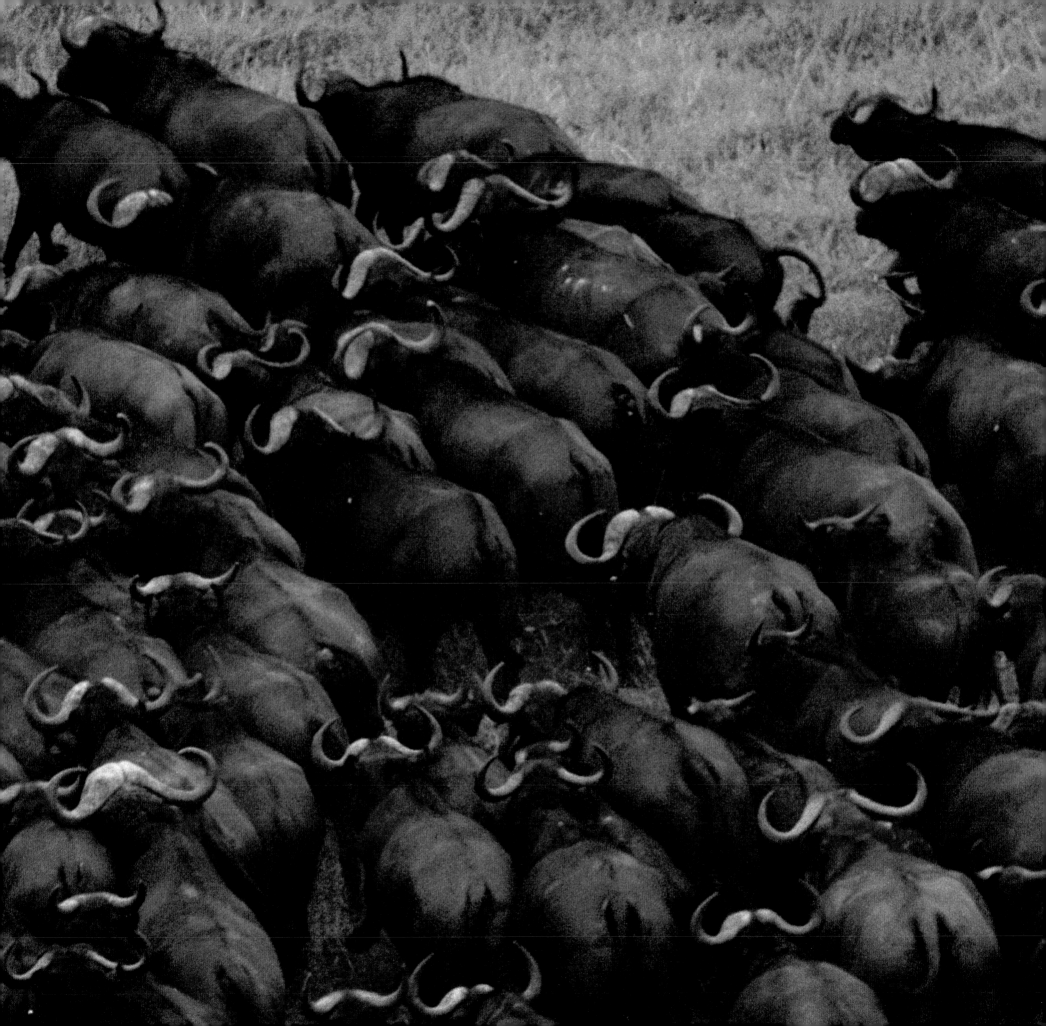

Dry Times

Life on the Edge

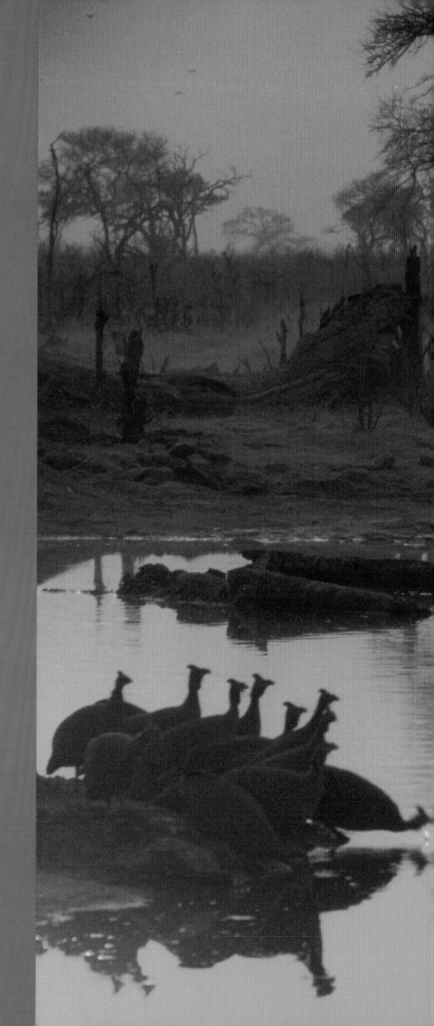

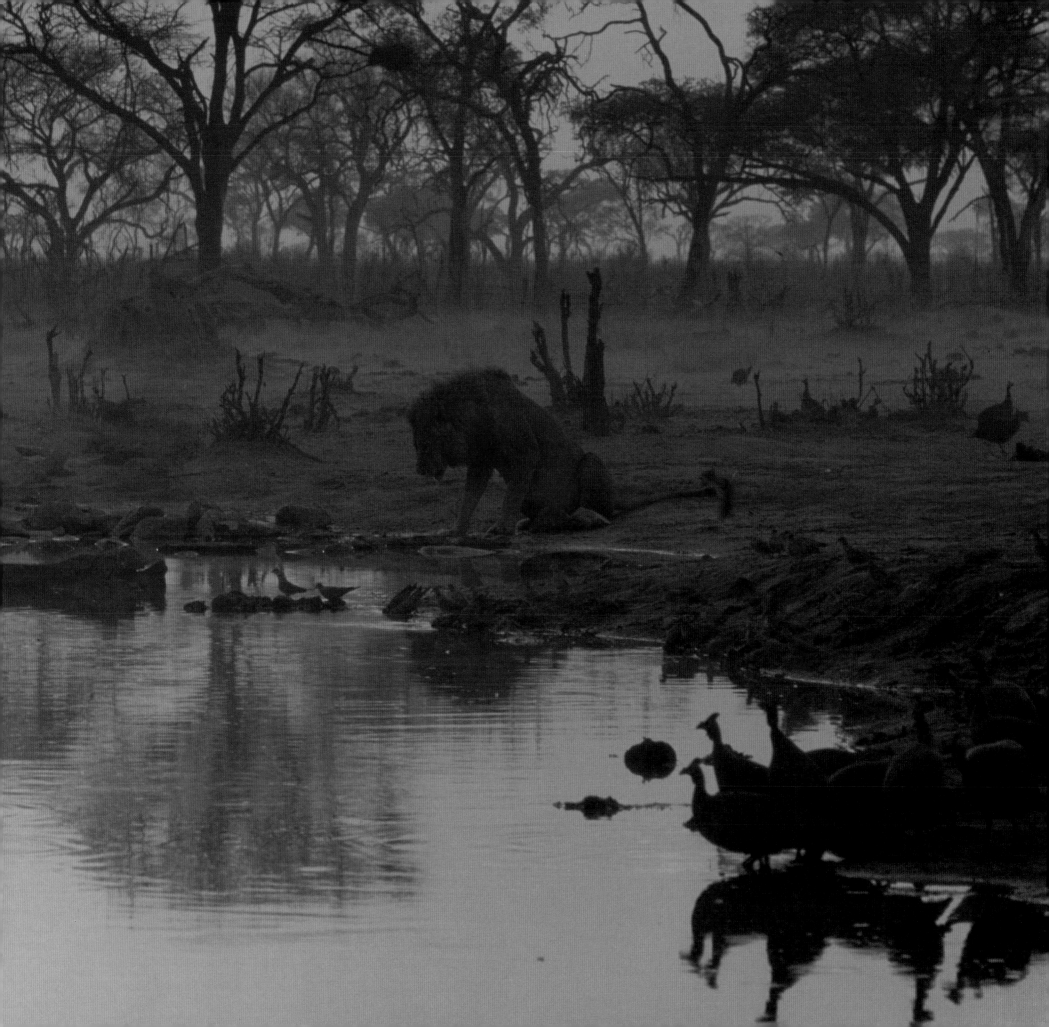

The first thing I heard was a chuckling sound,

a staccato cackle that filled the still air of a cloudless morning. Then a flock of heavy-bodied birds appeared with fast-beating wings. They circled around the water hole and settled in a flurry at the edge. Looking around nervously, they dipped their bills in to drink, straight across the water from where I lay motionless on the ground, watching. They are spotted sandgrouse, and during the dry season they come each day to this water hole in Savute, an area just east of the Okavango, arriving in great waves and with clockwork regularity.

Like the pigeons they resemble, sandgrouse are seed-eaters who derive little moisture from their diet. Through the rainless months of April to December, they must travel to water to drink. These birds with plumage the color of Kalahari sand nest during the hottest time of year, and raise their young on barren open ground where temperatures soar to a height that could drive a man insane. Their chicks can survive the heat, provided they get water. To meet this need, sandgrouse have evolved an extraordinary capability. Some of the birds in each flock wade deep into the water and hunker down to soak their bellies, which are covered with an intricate meshwork of feathers uniquely adapted to hold moisture. They then fly off, carrying a precious cargo of water drops to their chicks, waiting at nests as far as dozens of miles away.

The sandgrouse's daily journey is but one illustration of the razor's edge on which life balances during the dry season in this part of the world. In normal years, the rains end in March, after which the land steadily dries out. Grass becomes hay that is soon trampled to straw. By July the soil is brown powder. Bare earth lies exposed between stubble. This is the time when animals that need water move to the last places where it is sure to be found—to the great delta of the Okavango, to the perennial swamps of Linyanti to the north, and to the scattering of small clay pans sprinkled across northern Botswana that still hold water into the dry season. Their trails are traces of thirst.

◄ *Overleaf*
At dawn, guineafowl keep their distance
from a lion at a water hole.

Instead of following the herds, I went where I knew they would come—to a water hole in a well-beaten plain, where I lay by the edge day after day, soaking up heat and breathing dust. By flattening out on the ground and staying still for long periods, I became part of the landscape, and animals took little notice of me as I faced them eye to eye. For weeks I watched the never-ending parade to water. Kudu came with spiraling horns, then stiff-legged impalas, herds of skittish zebra and, at times, wary families of warthogs. Chains of mooing gnus rumbled in, then massive buffalo veiled in great clouds of dust. A spirit of truce hung around the water. Foes kept a respectful distance. But the scene also attracted opportunists, who hid in the scant shade of leafless scrub: lions, barely perceptible against the tawny land. Their presence was sensed—or suspected. Antelope approached with great caution, muscles tensed, ready to flee. When they committed themselves to water, they drank hard and fast, their relief mixed with fear.

Not all creatures I knew from the bush came here to drink. There are other ways to survive in this thirstland. Antelope like springbok and gemsbok will drink water if it's around, but if they must, they can obtain the moisture they need from the food they eat. Gemsbok include in their diet desert fruits like the tsama melon, pale yellow-green balls, fist-size or bigger, that are found throughout the Kalahari. Their watery pulp has helped sustain many a desert dweller, including the few last free-living bands of Bushmen who still roam the Kalahari. Thirsty elephants will often attack baobabs to get at the trees' spongy pulp.

Antelope can do without water if their food has a high enough moisture content. But during the dry months, as a strategy for minimizing dehydration, most plants withdraw their fluids and nutrients into deeper, less exposed parts. As the dry season progresses, animals face not only the heat but the dual stress of this decline in food value and the lack of water. Many adjust their routines, lying in shade by day, moving and feeding at dusk and early morning when it's cooler and there may be some dew.

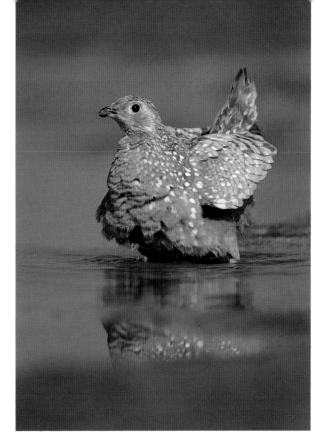

A sandgrouse with soaked belly feathers is poised for a journey back into the desert, carrying water to its chicks.

By September, the land looks desolate. Day after day a blazing sun arcs through the sky without meeting a cloud. Desiccating winds rob plants of any liquid still within. Dust devils whirl up from the earth. Animals become listless now. Their battles are few, and even territorial claims may be put on hold. More dry weeks pass. In Botswana, some call October suicide month. All too often in this part of the world, dry seasons are followed not by rain but by drought. Those are times of terrible dying. But in the Kalahari, larger rhythms are also at work. The heavy losses that occur in droughts are matched by quick recoveries in the better times that eventually come.

One image endures—of an October day when a few clouds had formed. They soon burned off, leaving another day without shade. Yet there was a change. In the midst of this thirstland, one acacia—all thorns and little else—had put forth masses of delicate yellow blossoms, flowering now so that seeds will set with the moisture to come; flowering in anticipation of clouds that will soon bloom in the sky and seed the earth.

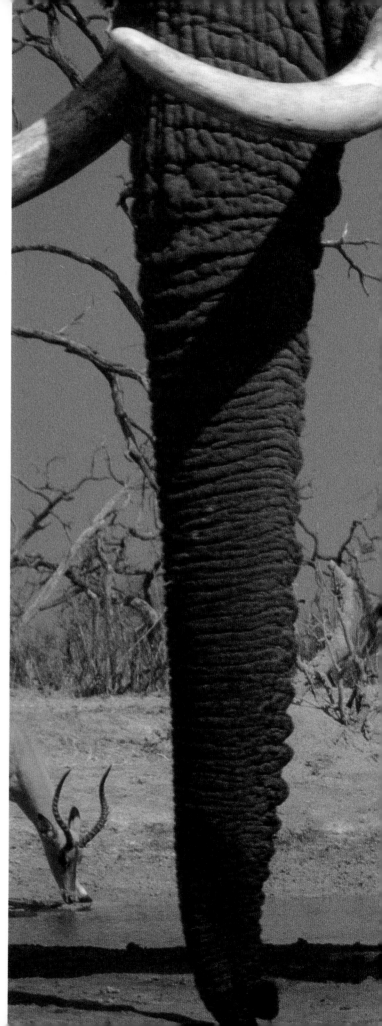

Thirst unites all who need water

at the few pools scattered across

the arid wilderness of northern Botswana.

Impalas bow to drink

near an old bull elephant in Savute,

east of the Okavango Delta.

While impalas can forego drinking water

if they must—surviving on moisture in their browse—

elephants' needs are less forgiving:

Like humans, they must drink free water

about every four days.

Overleaf ➤

A herd of impala does
lines up to drink.

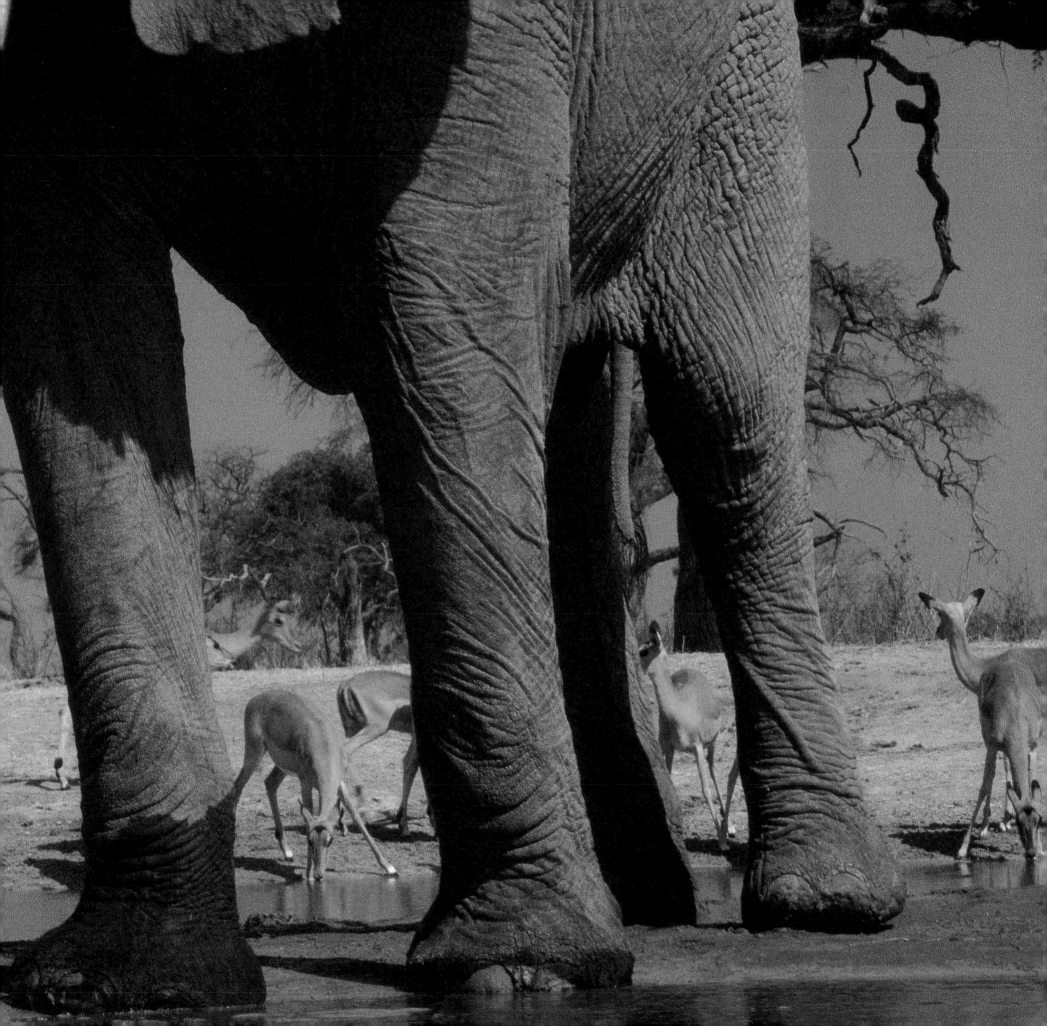

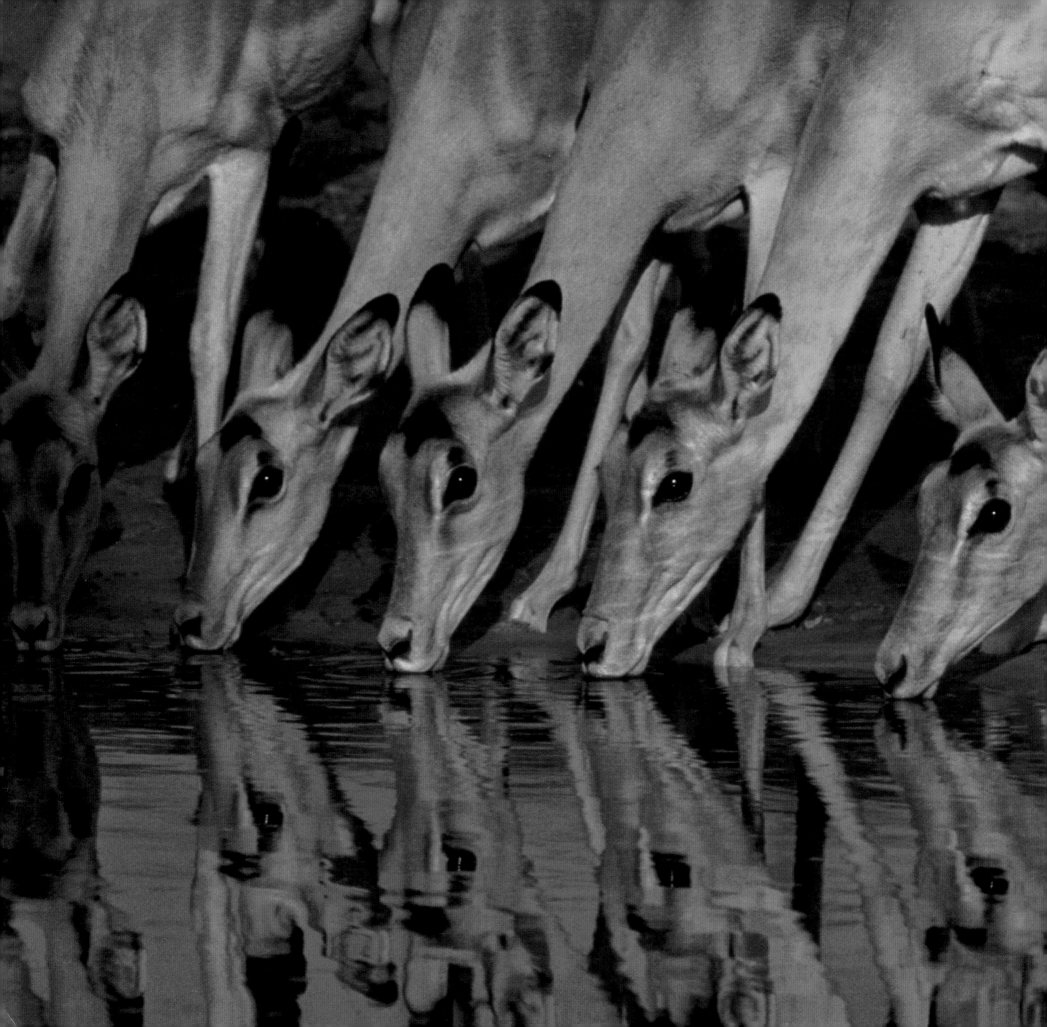

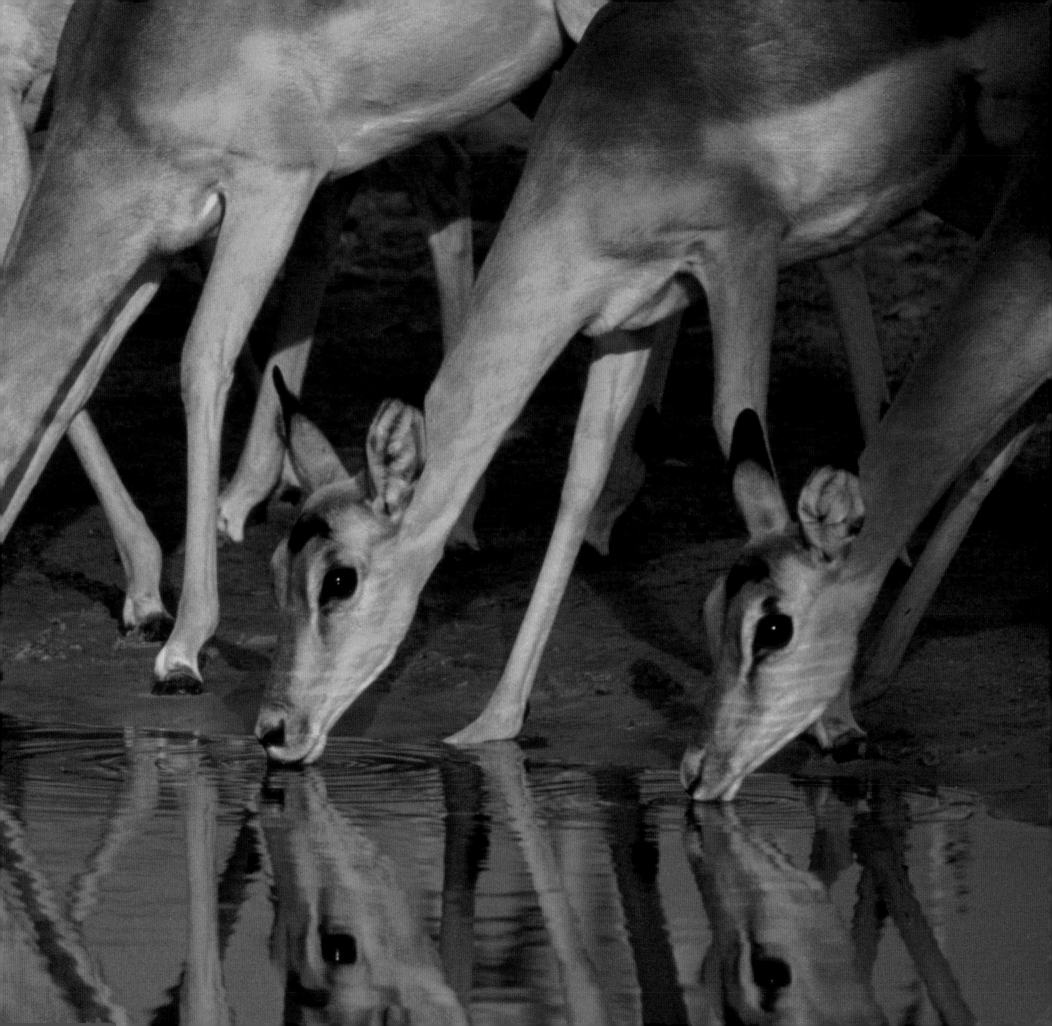

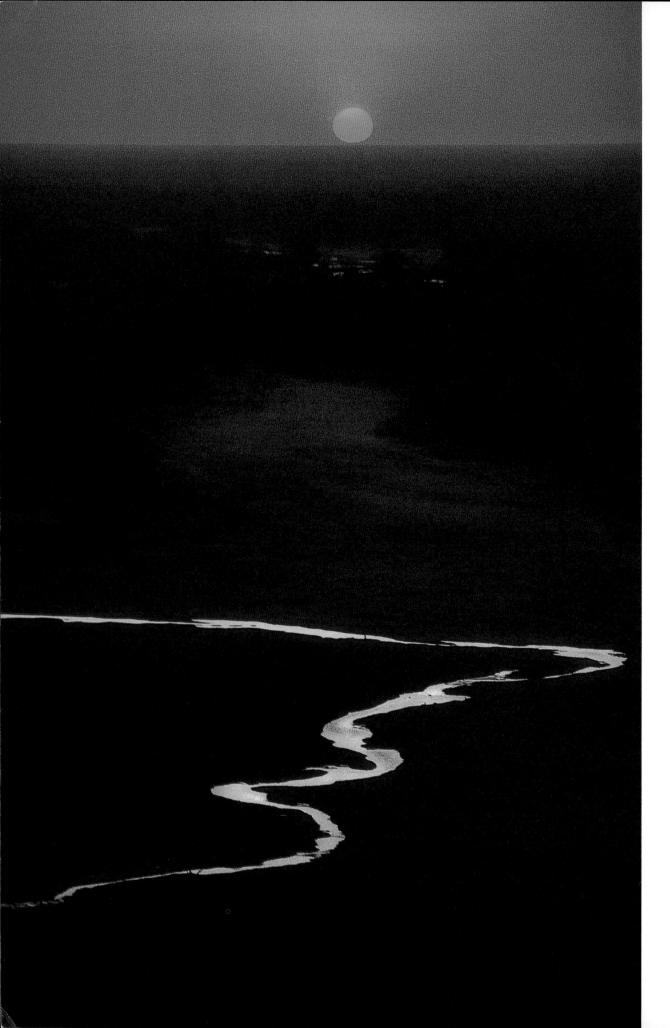

Ribbon of relief,
the water of the Savute channel
is a dry season lifeline
for a great variety of animals.
Fed by water from the Linyanti swamp
north of the Okavango,
the Savute once flowed far
into sandy savanna,
allowing large populations
of wildlife to thrive.
Now it has shriveled,
possibly due to tectonic tremors
that altered the flow
of water from Linyanti,
leaving much of the channel
an empty vein.

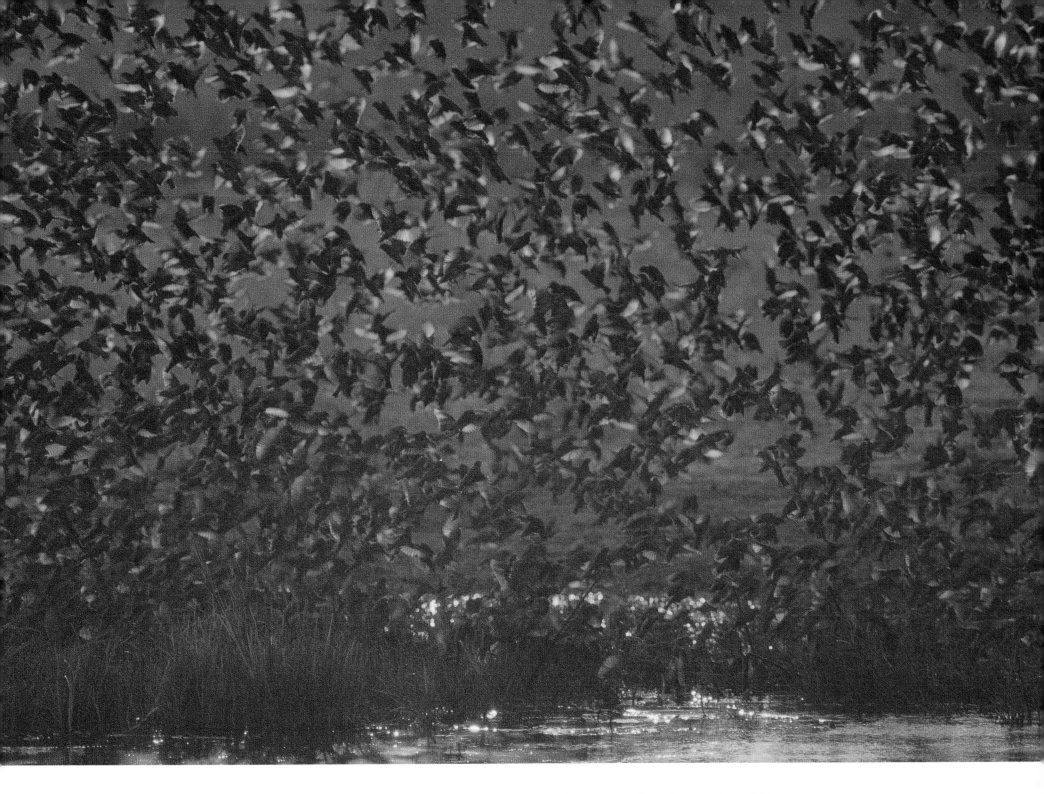

Swirling in flocks of millions,

red-billed queleas mass in the dry season
and descend on water to drink. With prey in such abundance,
crocodiles have a chance to zero in: They explode from
the water and scoop up mouthfuls
of birds at a time.

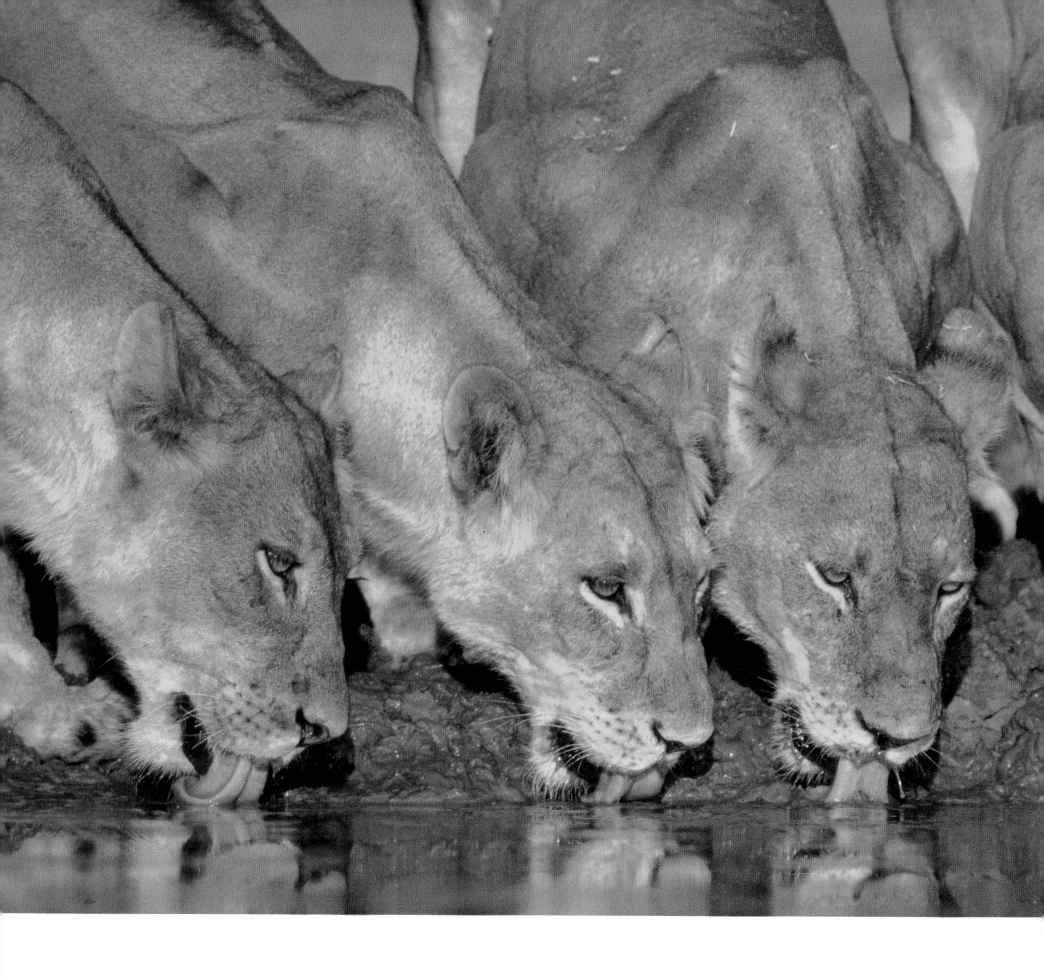

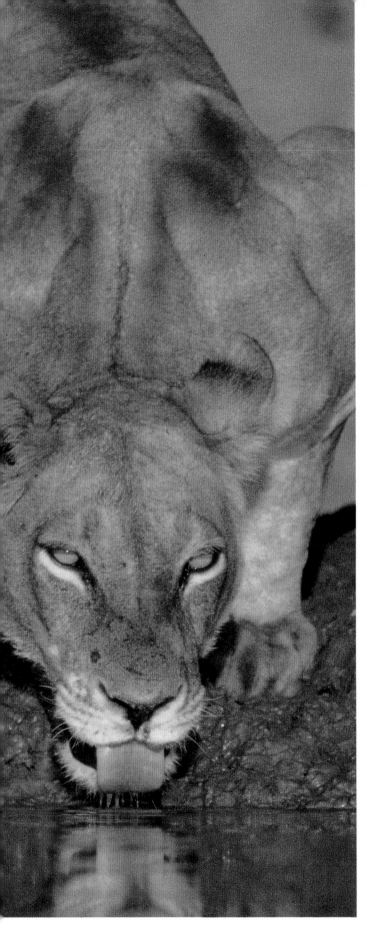

They were so near
that I could hear
their quick breaths as they lapped.
These lionesses
ranged a territory that
included a water hole in Savute.
In other parts
of the Kalahari that lack
permanent water,
some lions are known
to survive for long periods
without drinking,
getting by on the blood
of their kills.

Two sisters in a pride
nuzzle nonchalantly
in late afternoon,
just awakened
and working up to a hunt.

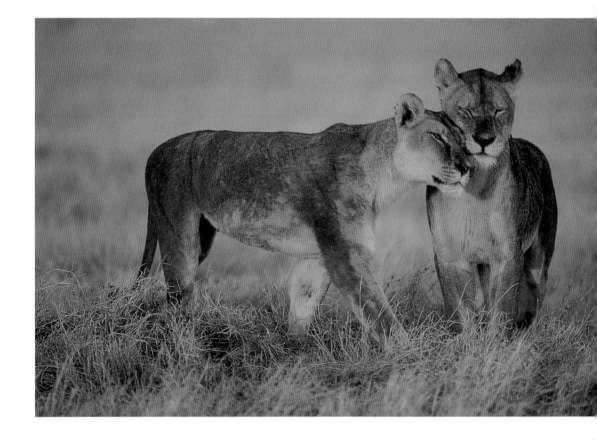

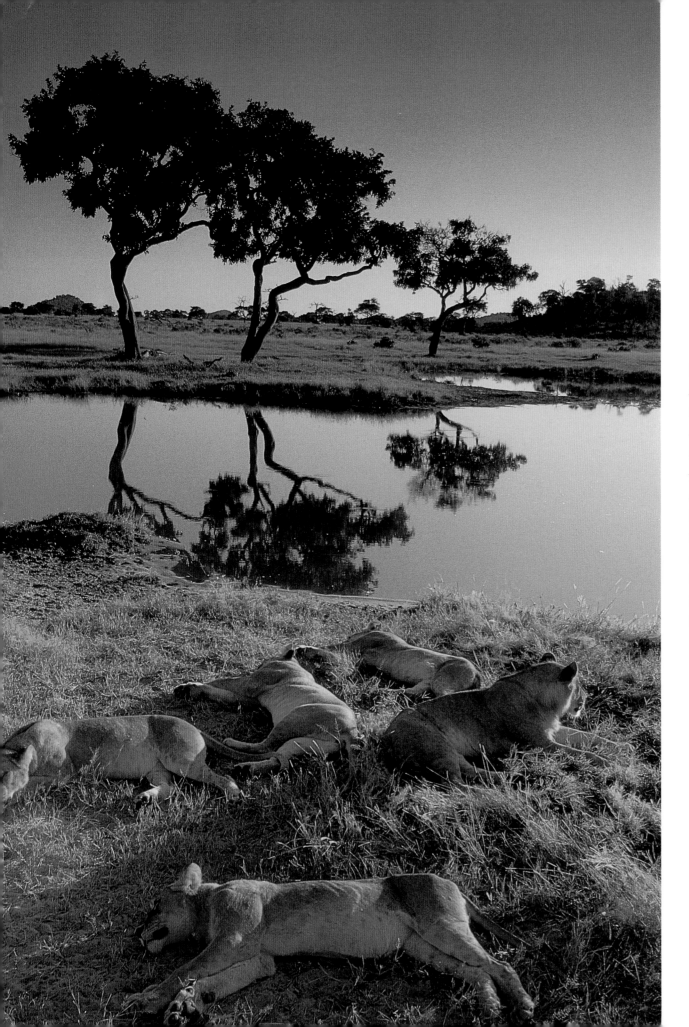

Full bellies betray
a successful night's hunting
for a pride of lions
drowsing in the sharp light
of dawn. Soon heat
will drive them to shade—
and free the water-filled pan
for others to use.
Lush foliage and a tinge
of green in the grass
hint that the dry season
has only just begun.
Harder times are ahead.

Caught between thirst and fright,

two young kudu ease
toward a pan. One sniffs for
danger; both stand poised
to flee, ears scanning
for a sound that betrays a threat.
Creatures of woodlands
and thickets, kudu prefer to remain
in thick cover, but they'll step
out in the open to drink
when they need to,
their unease visible.

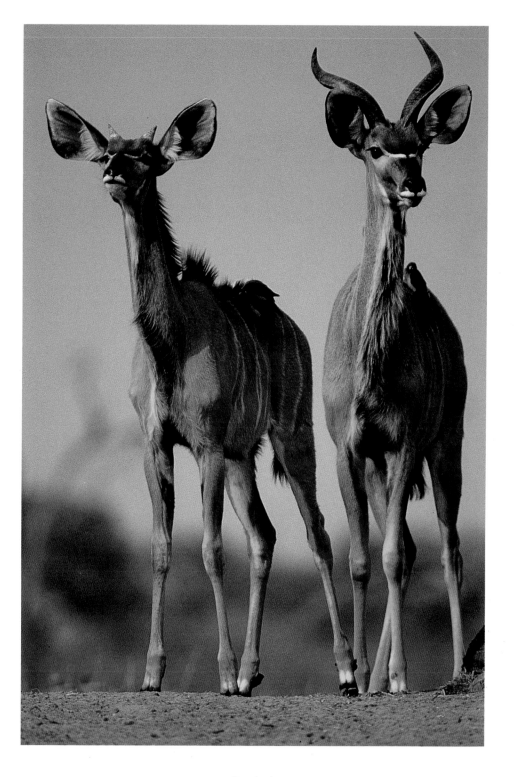

Overleaf ➤
Totally dependent on drinking water,
zebra seldom venture more than 10 miles from it.

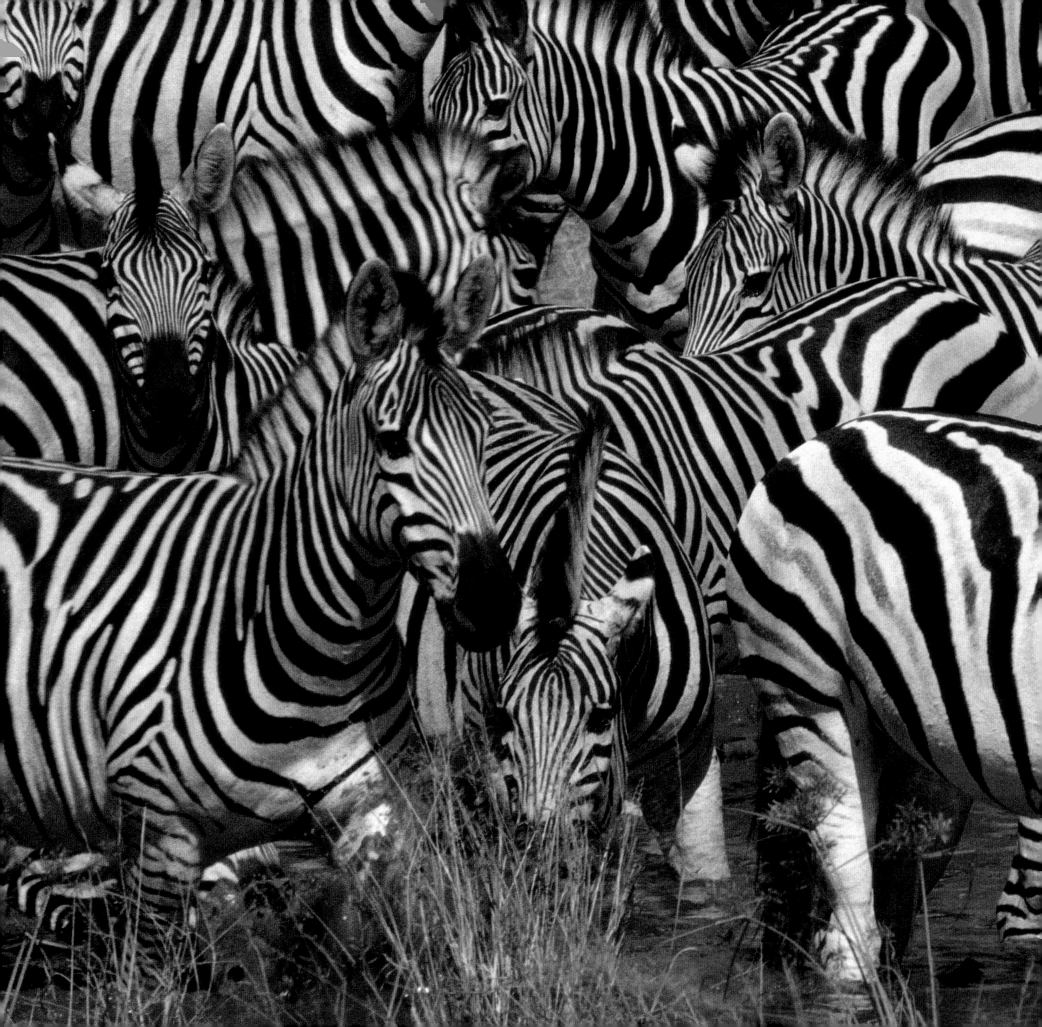

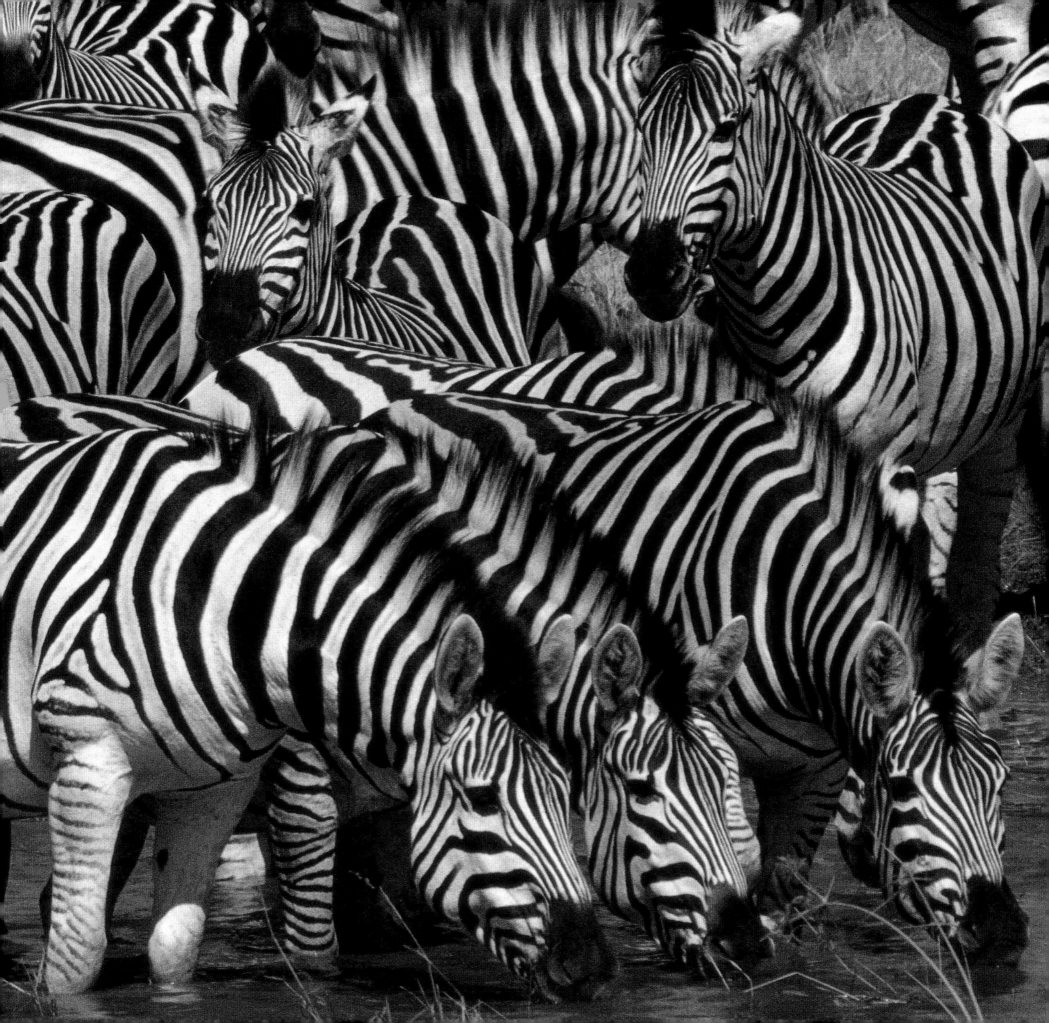

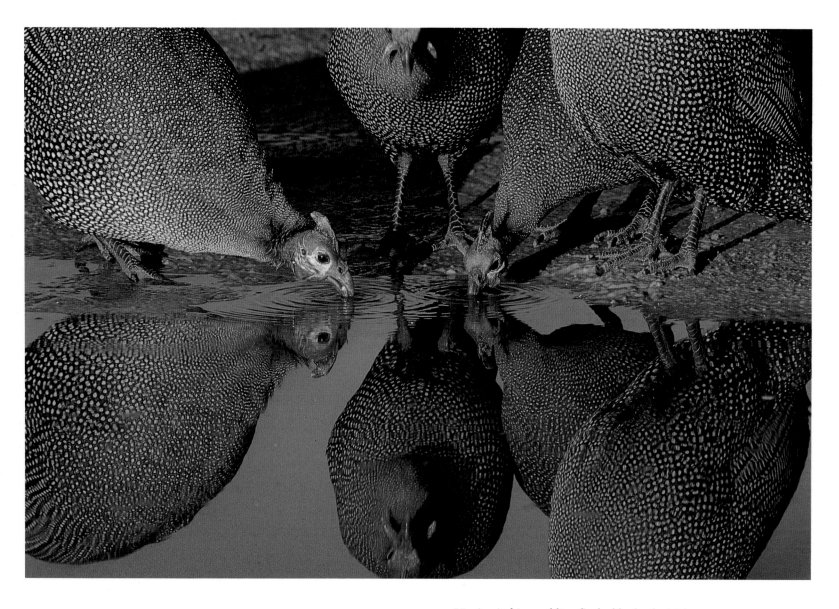

Moving in big, cackling flocks like bush chickens,
guineafowl race up to water in long,
winding files. Nervous creatures that they are,
the slightest twitch sends them
off in a wild whir.

For a giraffe, getting down
to drink is a precarious but necessary task.
To lower their enormous frames,
giraffe must splay their legs ever wider—
first one front leg, then another—
rocking from side to side, until they can
reach down. Once they're crouched,
knock-kneed, they are utterly vulnerable.
Unable to spring up quickly,
they are trapped by their own bulk.

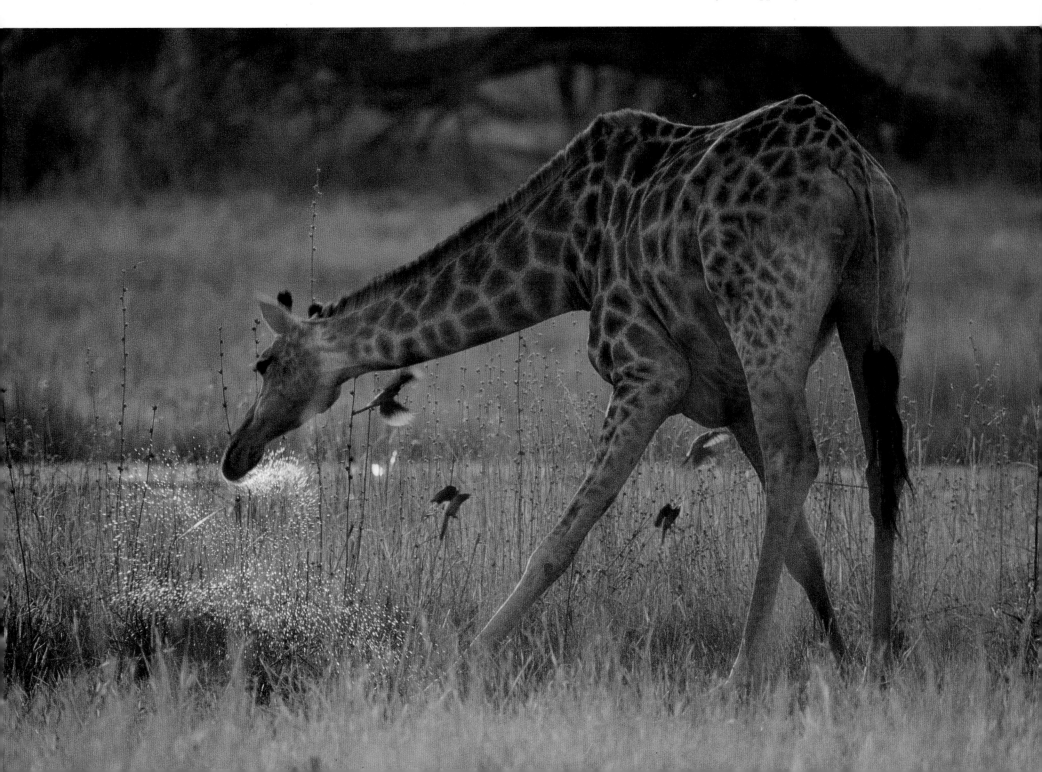

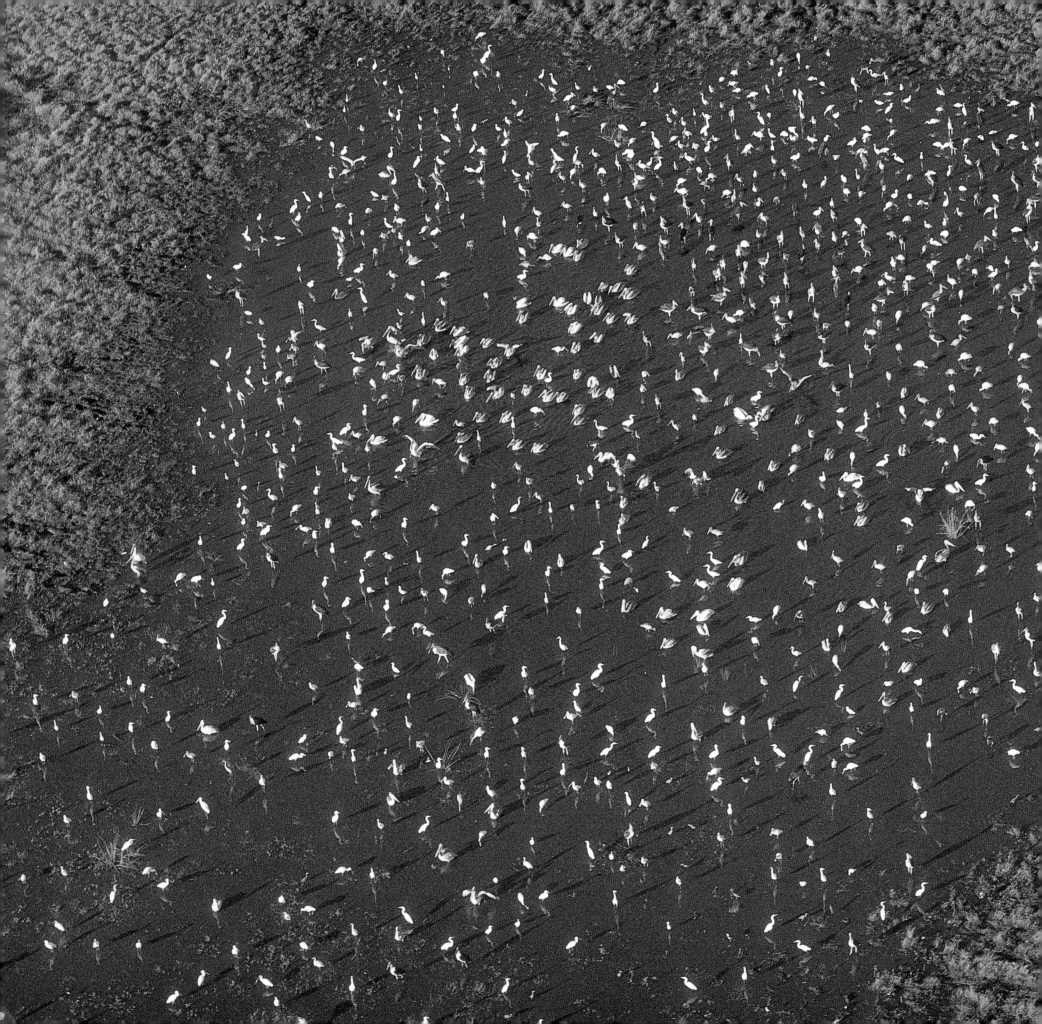

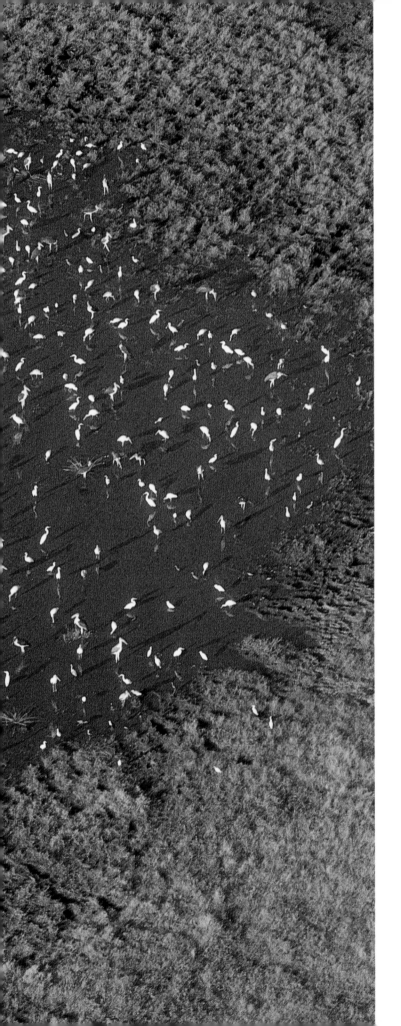

A tongue of water on the fringe of the Okavango Delta evaporates,
and swirls of birds move in. As water retreats from floodplains, masses of fish
get trapped in shrinking pools, and when birds discover them,
a feeding frenzy follows. In one such place, I counted almost 30 different kinds—
including exotic storks like open-bills, stately purple herons,
and even small shorebirds like sandpipers and fragile stilts. It is rare to find
so many species together this way, but the phenomenon is brief
and such a bonanza that there is plenty for all—
and traditional rivalries are suspended.

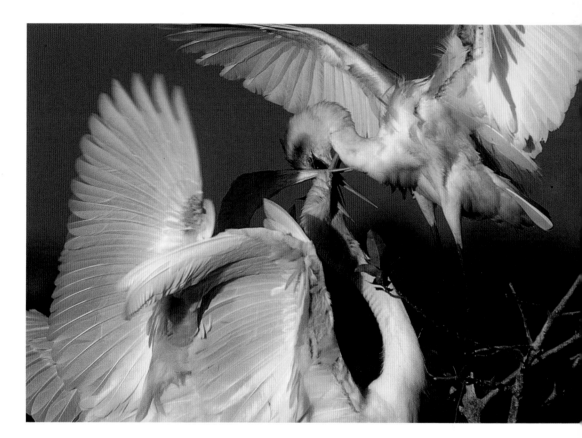

The long austral spring days
of October trigger the nesting season
for water birds in the delta.
The lowering water level exposes island thickets
where they nest, and concentrates the fish
on which chicks can grow fat.
Late in the season, two nearly full-grown
great white egrets accost a parent
for yet another meal.

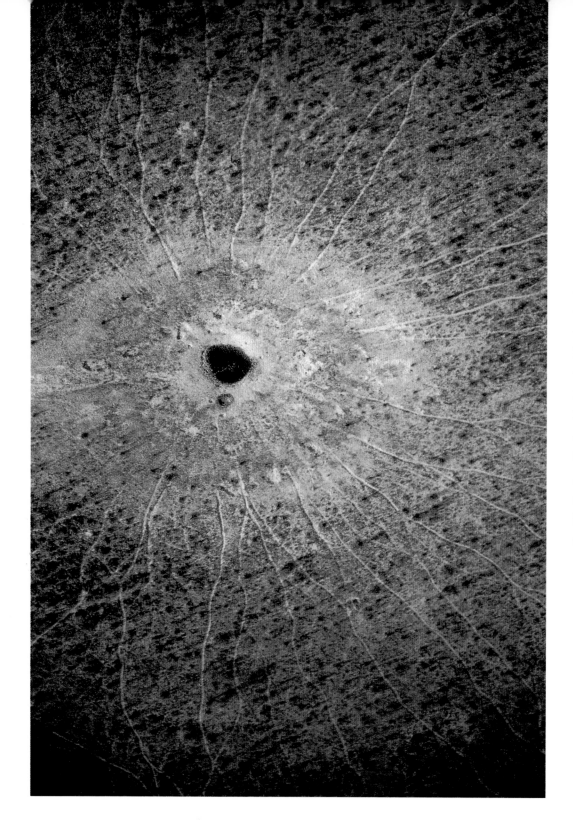

By the end
of the dry season,
the land is etched
with animal trails
leading to
the last sources of water.
In a northern
Botswana woodland,
a water hole
has been lapped down to mud.
All that remains
are deep hoof prints
in soft clay
and tracks leading out.

The November sun desiccates the land.

It hasn't rained in half a year;
good grazing is gone. Buffalo in continuous search
of pasture and water now rumble together
in great herds. Here on a floodplain of
the Chobe River, they shroud themselves
and the land with dust.

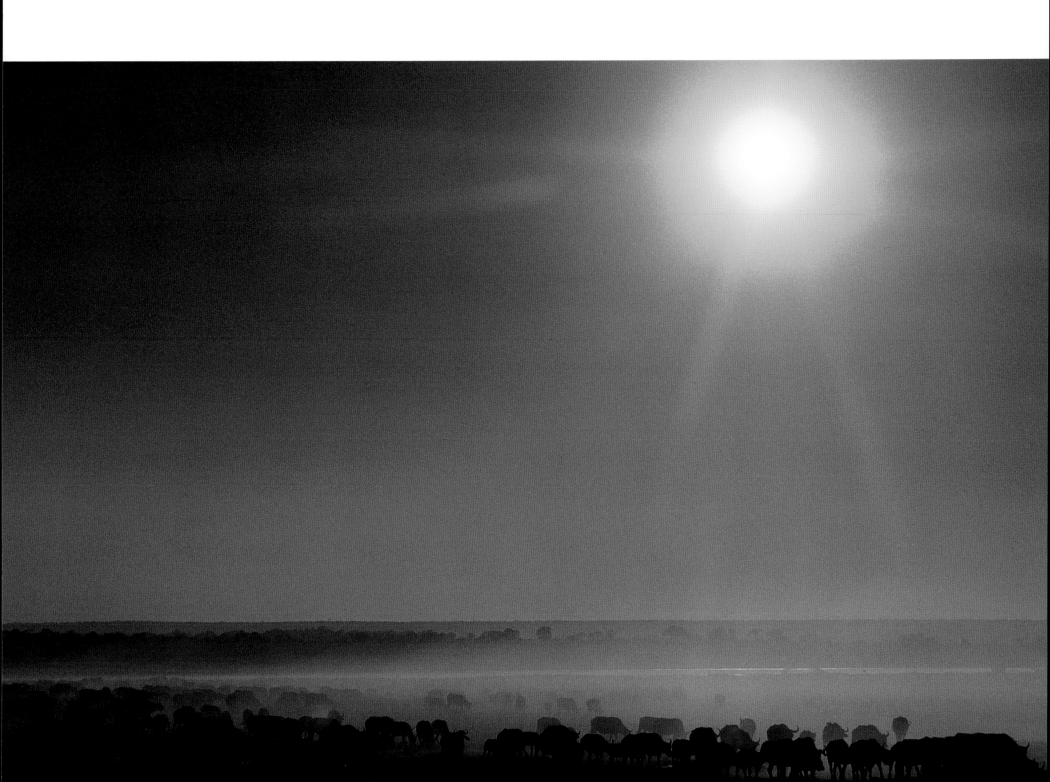

PULA
A Season of Plenty

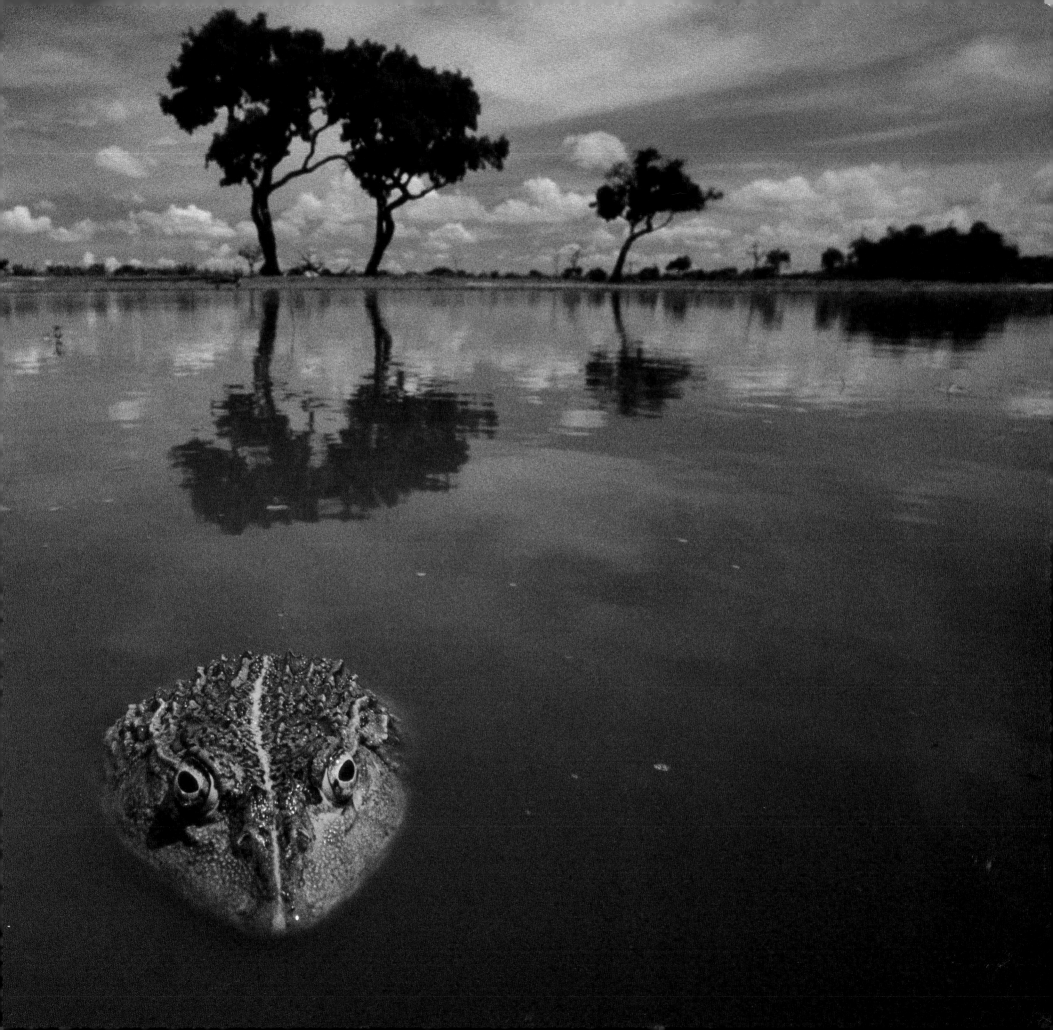

It happens once a year. From a small crack in their castle,

they fly out by the millions. It is a nuptial flight that becomes an orgy ending in death for most. They are termites, and their mounds poke up like crooked fingers all across the Kalahari—hard as brick and impervious to water. Deep inside live the termites, shielded from the vagaries of weather. But they monitor the outside world for at least one crucial event: the coming of rain. On a balmy evening just after the season's first downpour, young winged termites emerge. Streaming out from the mounds, they rise like smoke in the evening sky and waft out over the land. Everything moves in to gorge on them—snakes, birds, even jackals. Toads eat themselves silly. Only a few termites survive this onslaught. They land, shed their wings and mate in a hurry, then burrow into the just-moistened earth to start a new colony.

Everything and everyone responds to rain in this land. In Setswana, the national language of Botswana, rain is called *pula*. So crucial, so valued is rain that pula has become the name of Botswana's currency. Water, symbolized as two blue bands, figures prominently on the national flag. For most of the year, however, blue is the color of the sky from which the sun blazes down on a Kalahari bushland scorched to dust.

By the end of the dry season, the land craves water. Then, far-off clouds begin to build into awesome thunderheads—huge billowing cumuli with flat black bottoms. At night, lightning flickers within. Distant thunder rumbles; the smell of rain fills the air. Animals sense it before it falls. Zebra and wildebeest, unwilling to wait any longer, have been known to take off for storm clouds on the horizon. Sometimes showers fall, then evaporate in the intense heat, stillborn, before any moisture reaches the ground. But the momentum builds, and one day, the sky turns a menacing steely blue. The wind picks up. The horizon disappears. Darkness presses down, and finally, it is there. Rain. It comes like a blessing. Fat drops pock the sand. Then it drums down in a torrent. Animals turn their backs to the wind, heads bowed in the downpour.

The first heavy rain is a hinge around which the year turns. Instantly the land is transformed. A musky scent rises up from the earth, and creatures that have been hiding for months—sometimes years—come out: tortoises

◄ Overleaf

Rain was the wake-up call for a bullfrog newly emerged from the earth
after nearly a year spent in estivation underneath a hard clay pan.
When the season's first downpour transformed the pan to a pool, the bullfrog
shed the membrane that kept him moist underground
and crawled up to the surface to resume his territorial claim.

Dead termites float
on a rain puddle after
a nuptial flight.

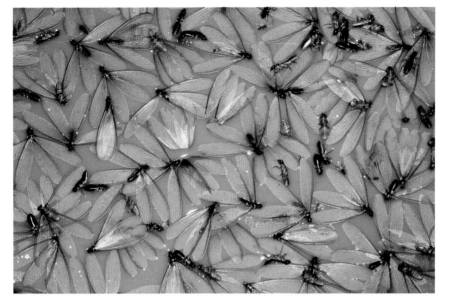

lumber around, frogs emerge, gargoyle-headed chameleons rock along in their inimitable gait—and everywhere, dung beetles are rolling elephant droppings into balls to bury as food for their larvae. Rain ponds form, clay pans fill up, and in a frenzy all of nature perpetuates itself.

When rain falls on the short grass plains of the Savute marsh, zebra show up practically overnight. Within days their numbers swell to hundreds, then thousands, their arrival prompted by the appearance of sweet new grass. In wild, whinnying waves, Africa's second-largest zebra migration—surpassed only by the herds of Serengeti—passes through Savute, the animals mowing the plains as they move through. It is a seasonal trek, and once the first flush of growth is exhausted, the striped horses head on, disappearing as suddenly as they arrived. Many melt into the untracked sandveldt of Mababe, southeast of Savute, and won't be seen again for many months. It is a testament to the vastness of this wilderness that thousands of animals can move into an area one day, then vanish the next without a trace.

Water birds flock to the marsh and court—storks, cranes, and the heaviest of all flying birds, kori bustards, whose males strut around with throats puffed out, calling in deep, booming voices to females. Black khoraans cocks perform kamikaze displays in the air—rising up high then plummeting straight down, spreading their wings just short of a crash—all for want of a mate. From the woodlands a panoply of animals steps out—wildebeest, buffalo, tsessebe, giraffe, and others, from warthogs to elephants. In the rainy season, they spread across the short grass plains, evoking the classic image of primordial Africa—open vistas of green savanna sprinkled with an array of big mammals without equal anywhere on earth.

The basis of this extravagance is grass, plain grass. It supports dozens of species of herbivores, from the 10-pound dik-dik to the one-ton eland. More energy flows through this savanna ecosystem than through any other terrestrial food web, including tropical rain forests. But, although the resource of grass is totally exploited, there is less competition than one might think. Many communities of savanna mammals feed in a loosely sequential fashion that amounts to a grazing symbiosis. Zebra take the coarse top parts of herbs and grasses; others, like wildebeest and smaller gazelle, feed on tender shoots exposed by the zebra. It has been suggested that the passing of the first wave of grazers facilitates the feeding for those that follow. They trample the ground, open up the savanna, and stimulate a flush of new growth.

Just as an interdependence has developed between animals that eat grass, the evolution of grasses and grazers is linked. What we see today on the plains of Savute is an outflow of the extraordinary changes that occurred in the Pleistocene era—when the African continent dried out and forests gave way to grasslands. New species of herbivores arose in response to this expanded niche, and an ecosystem grew that revolved around the give and take between grasses and grazers: As plants developed chemicals that made them unpalatable, or assumed growth forms that made them difficult to get to, animals responded by evolving ways to ingest and detoxify plants.

The most important factor that governs the balance in this dynamic system, however, is rain. It draws the line between forest and grassland, savanna and desert. In northern Botswana, pula turns a brown land emerald. It replenishes rivers and swamps, slakes the thirst of every living thing, heals the wounds of dry times. It sets the seeds for the year to come and nourishes the new life born in this season of plenty. On the day of the first heavy rain, I ran out and let myself be drenched, arms outstretched, face to the sky. That night I drove through a squall of swirling termites so thick I had to use my windshield wipers to see. The next morning, I watched gazelle on the dawn horizon, jumping high against a rising sun, and though many might say it can't be so, I couldn't help but imagine this was joy.

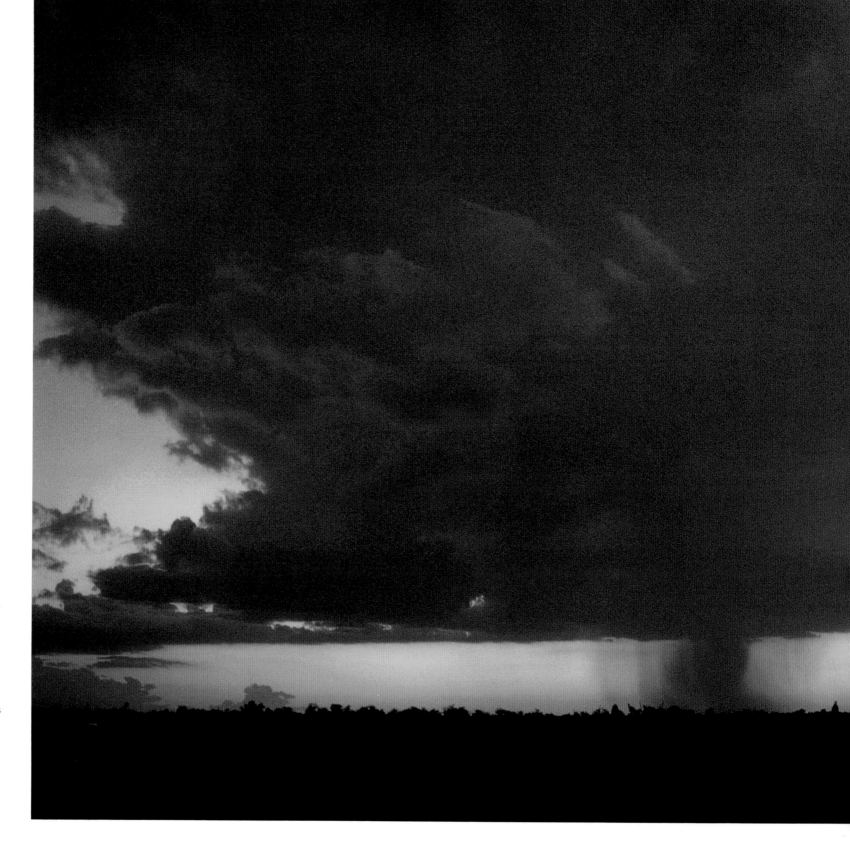

A cloudburst
drops long-awaited moisture
on dry savanna
east of the delta.
But rain
is a fickle benefactor:
The enormous thunderheads
that build
over the land
often release their load
over only a small area,
bringing luxuriant growth
to one place
while leaving another
nearby bone-dry.

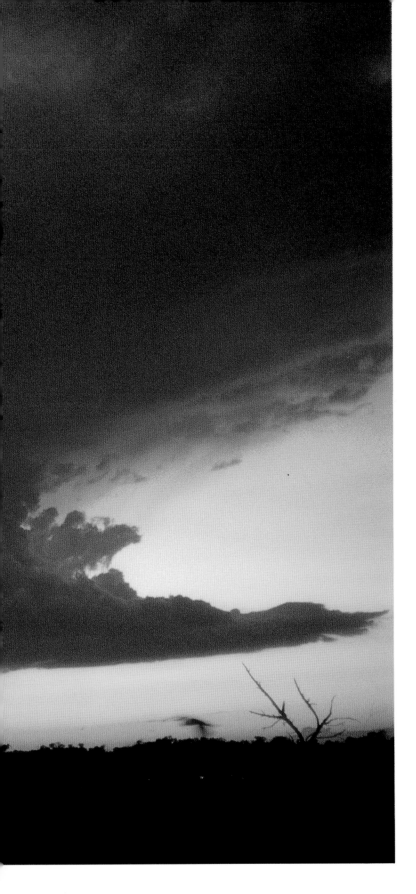

A storm is fast approaching.

It will become a deluge minutes later, turning the sun-baked ground
of Savute into soggy grassland. In recent centuries,
this area has repeatedly alternated between marsh and savanna
as a result of the on-again, off-again flow of water
from the Linyanti swamps to the north.

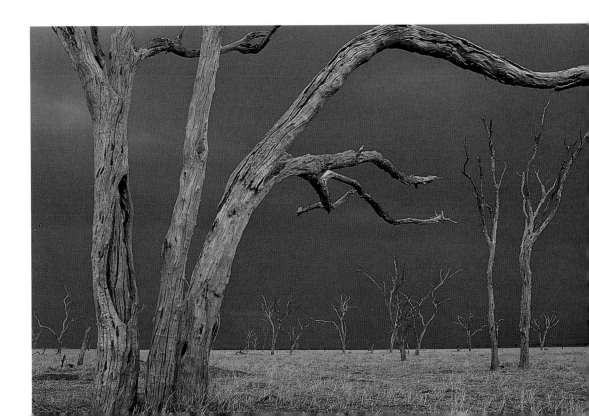

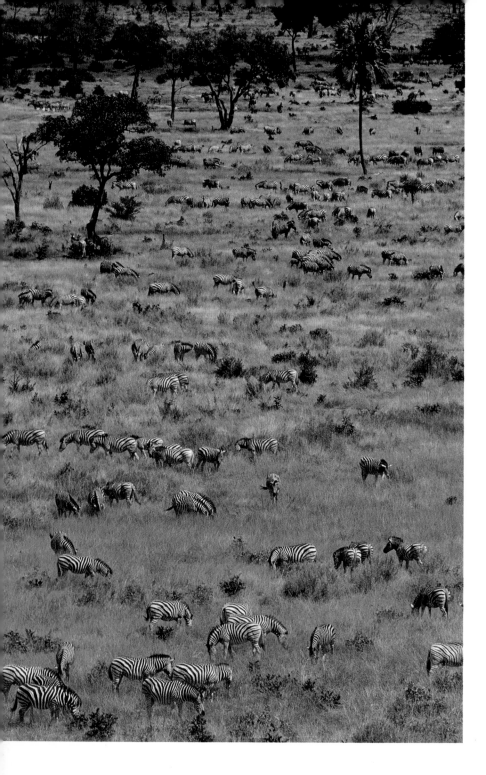

The movements
of zebra
are as ephemeral
as the comings
and goings of storms.
Thousands migrate
through Savute
twice each year,
heading north
to the swamps of Linyanti,
then passing through again
on their way back south
to the bushland
of Mababe.
Thirst is the force
that drives them:
Zebra will give up
even prime pastures
if no water
exists nearby.

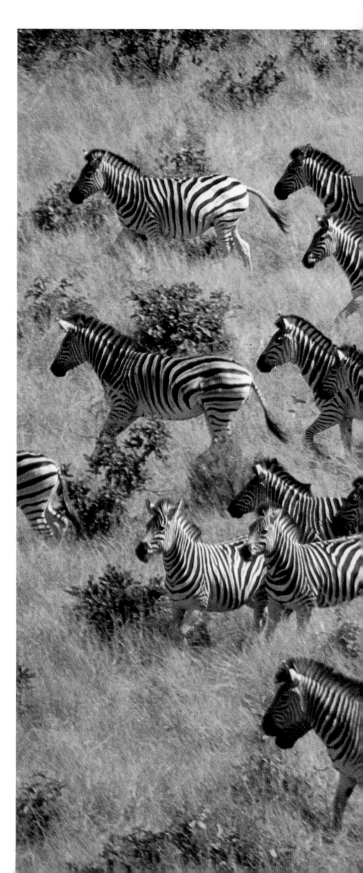

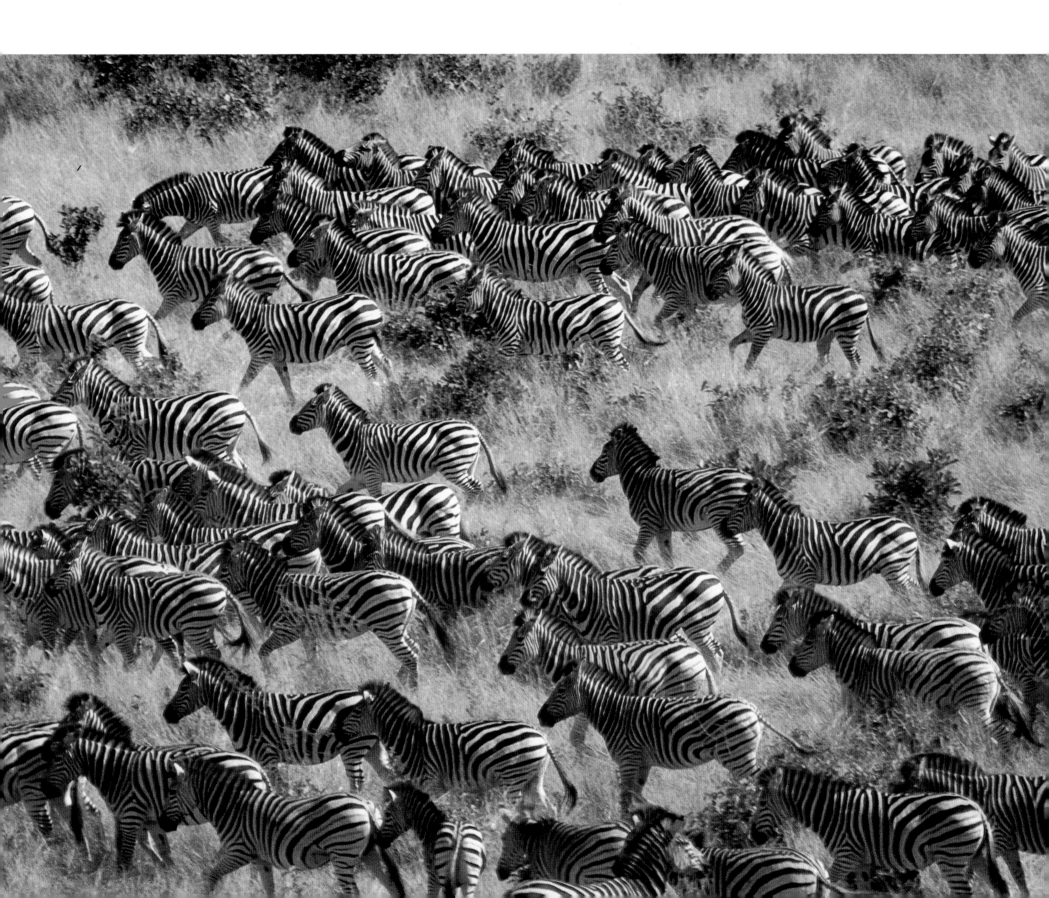

In the season of pula,

the savanna becomes a parkland.
Temperatures are now more forgiving,
and animals like hyenas,
which overheat easily, are seen even in daylight.
Not far from a hyena, a pack of wild dogs
rests under a bush. Though no herbivores are visible,
their presence is apparent:
Every tree and bush has been pruned by browsers,
from impalas to giraffe. When the land is lush,
there is time enough for even a wild dog
to indulge in a bath, and it is easy to forget
how harsh an environment
the Kalahari becomes when the time
of pula has passed.

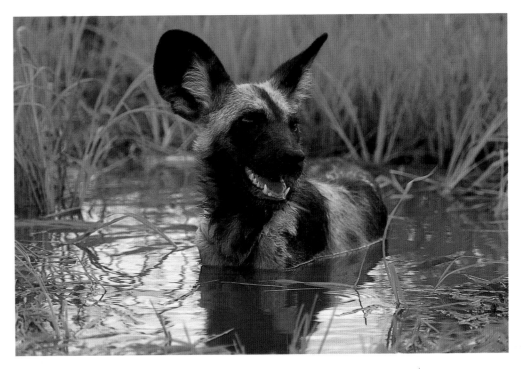

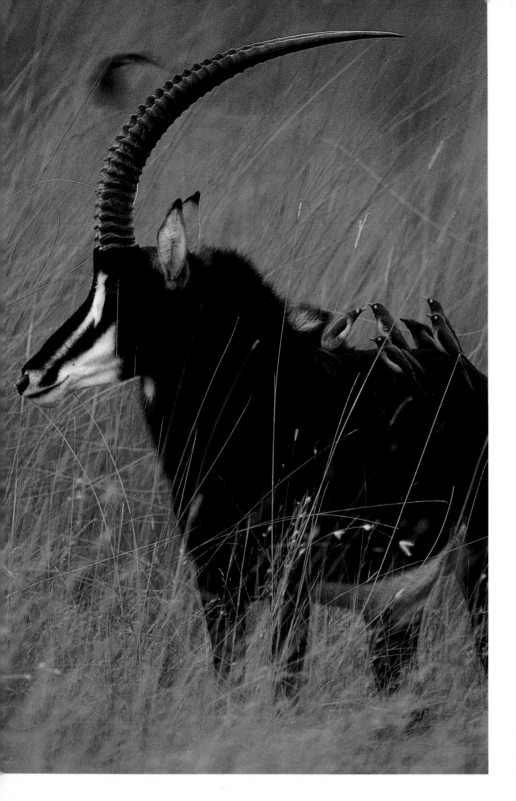

The tallest
animal on earth
normally feeds
in the crowns of acacias,
but new grass
on the savanna presents
such a succulent temptation
that giraffe will
temporarily abandon
the woodlands to
bend down and graze.

Magnificent
scimitar horns distinguish
the uncommon sable antelope.
This young male the
size of a horse
grazes while oxpeckers
glean ticks from his back,
a symbiotic relationship
characteristic of a
savanna ecosystem
where resources are distinctly
partitioned, and everyone
has a niche.

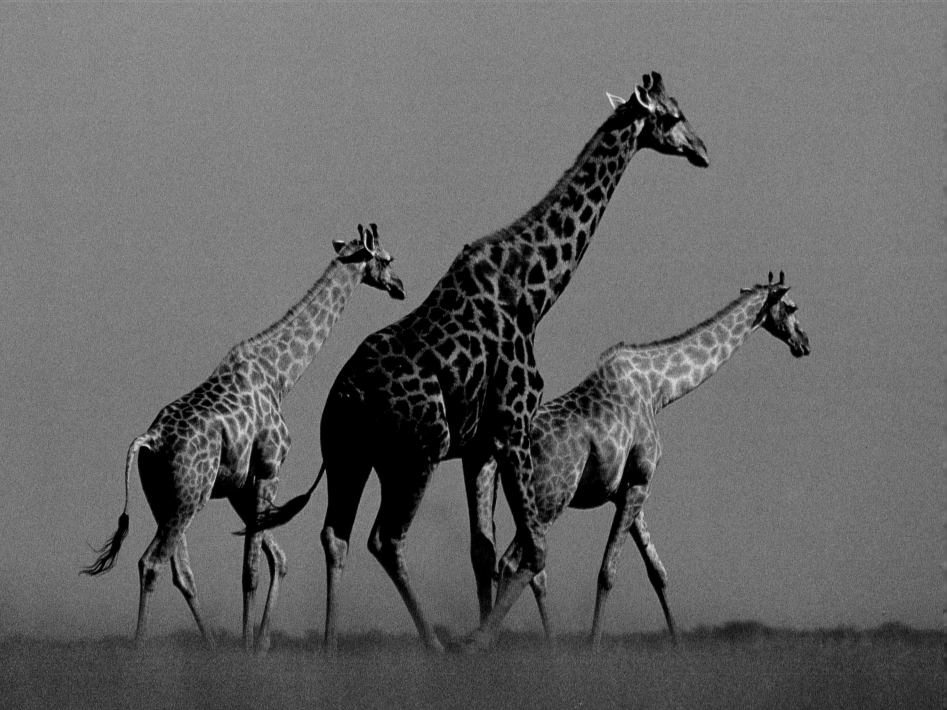

New life appears with the arrival of rain.

Most antelope give birth now so that their young can take advantage
of the season's reprieve. Grass contains more protein
at this time of the year, a critical factor for lactating females.
During drought, impalas may abort spontaneously, saving their strength
for survival—and a better year to come.

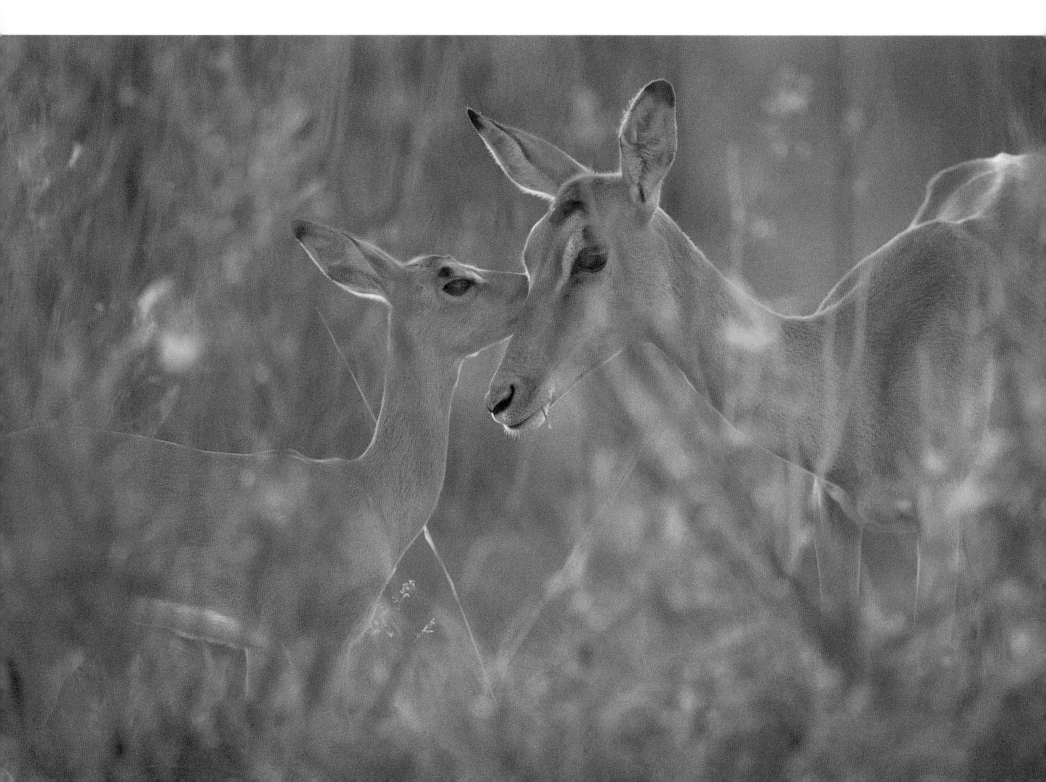

Adaptable ostriches
may nest year-round.
But whenever rain comes,
they lay eggs in a flurry.
Chicks are born after about six weeks,
in time to feed
on ripening seeds and berries.
In dry years,
hens are more likely to deposit
their eggs
in a communal clutch:
As many as 43
have been counted
in a single nest.

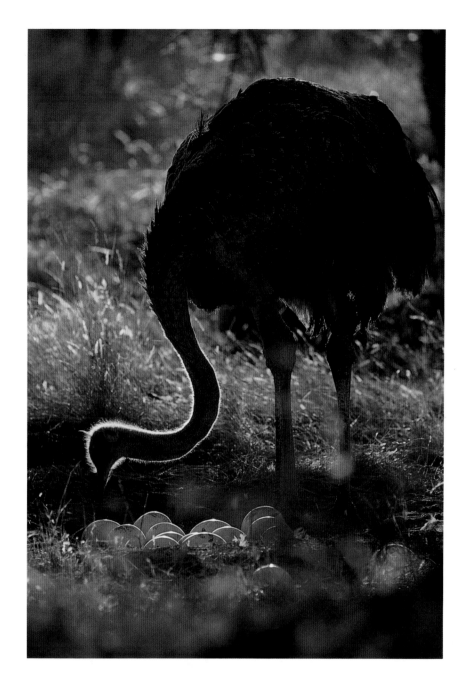

Radar ears perked high with curiosity,
a litter of bat-eared foxes
sunbathes
outside their burrow,
awaiting parents foraging nearby.
Like antelope,
most bat-eared foxes
are born at the onset of rain,
when the termites
and other insects
that form the bulk of their diet
are most plentiful.
Oversize ears enable them to detect
the subtle sounds
of insects underground,
and help radiate heat.

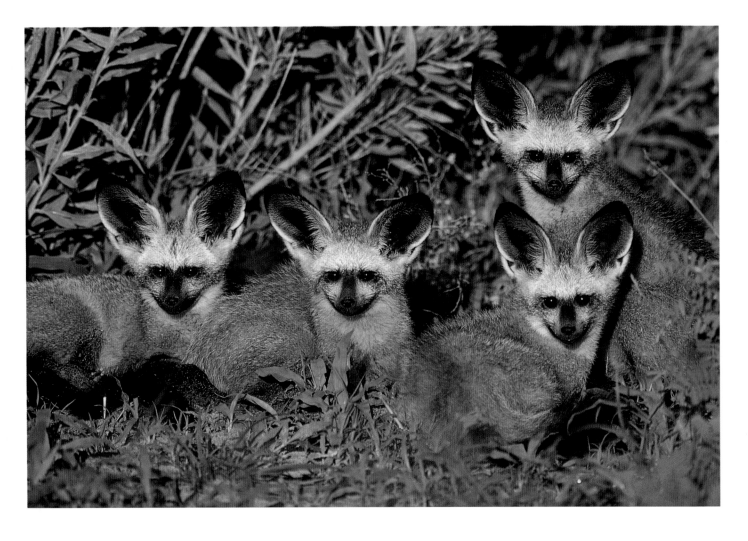

In dispute over a succulent patch of grass, warthogs drop to their knees and butt heads. It's hard to be objective about these pigs, which have been described as "incarnations of hideous dreams" and "the most astonishing objects that have disgraced nature." Despite such unfavorable reviews, warthogs are loved by everything with teeth and claws in the Kalahari. Lions are so fond of them that they will go to great lengths to try and dig them out of their burrows— with warthogs crouched inside, awaiting a chance to sprint away from imminent death.

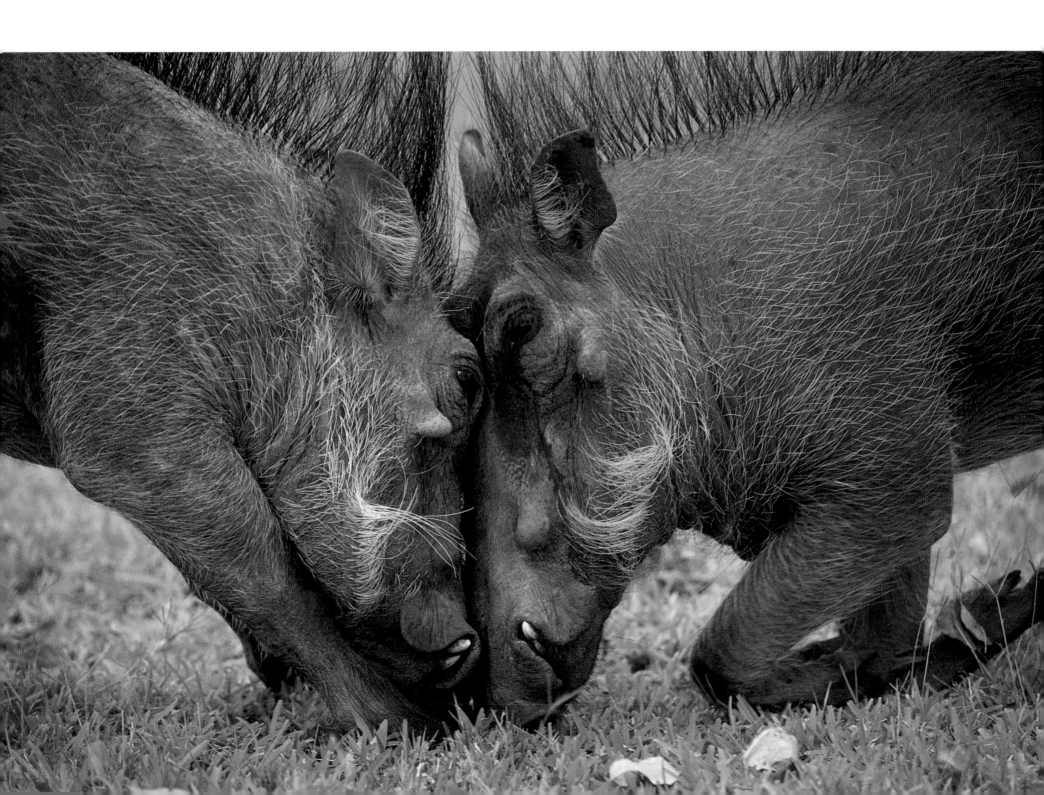

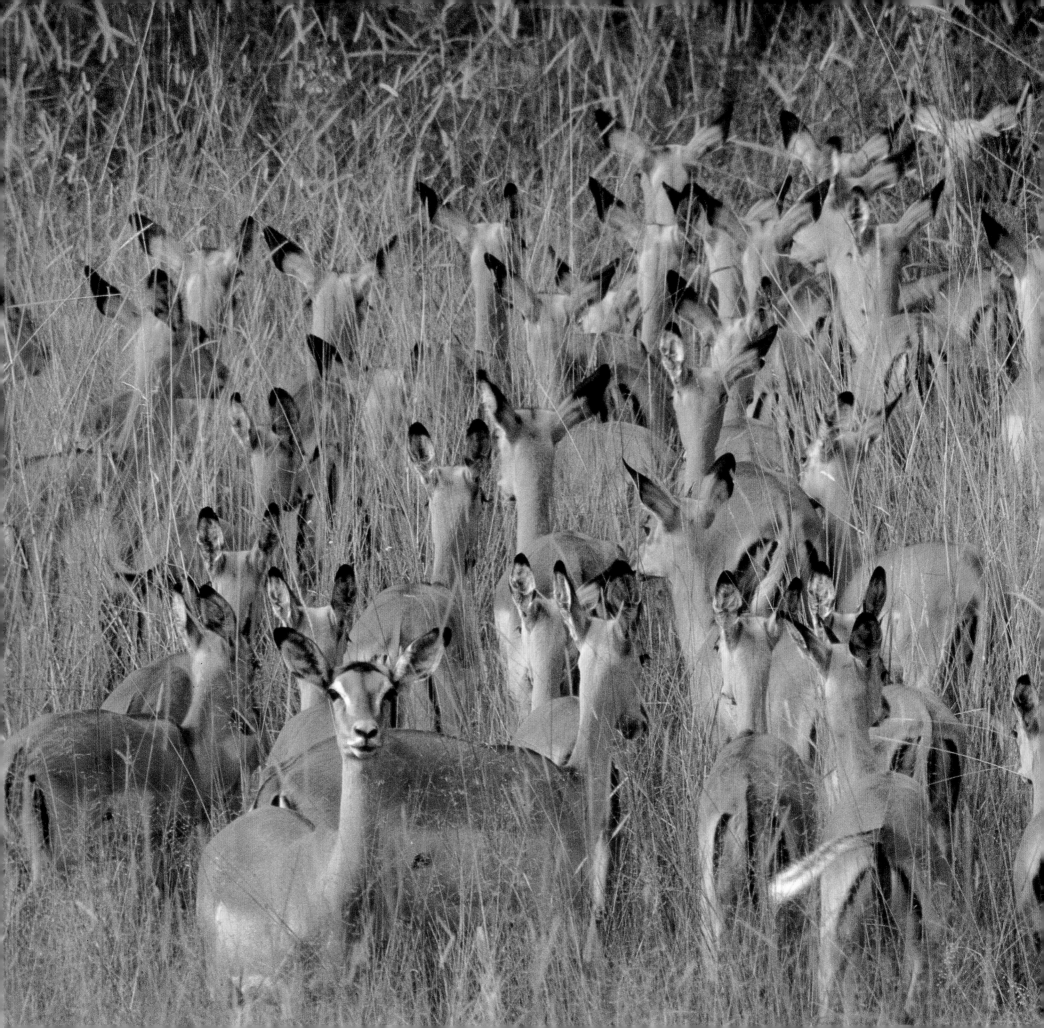

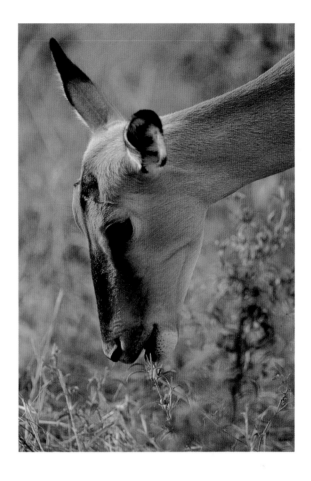

Impala does
peer through a screen
of late summer grass
on Chief's Island, in the middle
of the Okavango Delta.
Within a home range
of a few square miles,
these graceful gazelle live in herds
that move seasonally
between savanna and woodland,
eating grass after rain,
browsing when the land dries out.
Even their internal ecology
undergoes a seasonal shift:
As their diet changes,
so does the make-up of bacteria
that helps them digest plant matter.
As mixed feeders,
impalas are a symbol
for the mosaic of environments
found around the Okavango.
In this land of boundaries
between habitats ranging from
swamp to desert,
they are animals of the edge.

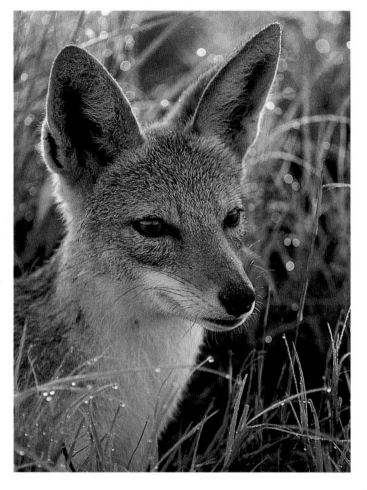

"Slyboots"
is just one of many names
for the jackal.
This African cousin
to the American coyote
is an omnivorous opportunist
who can get by
on almost anything.
In Kalahari Bushmen folklore,
it even fills the same role
as the coyote in
Native American tales—
that of the clever trickster
who gets tricked himself,
yet somehow always
pulls through.

A herd of tsessebe wades through dewy savanna
in the Okavango, where grasses mellowing to gold
mark the wane of the rainy season.

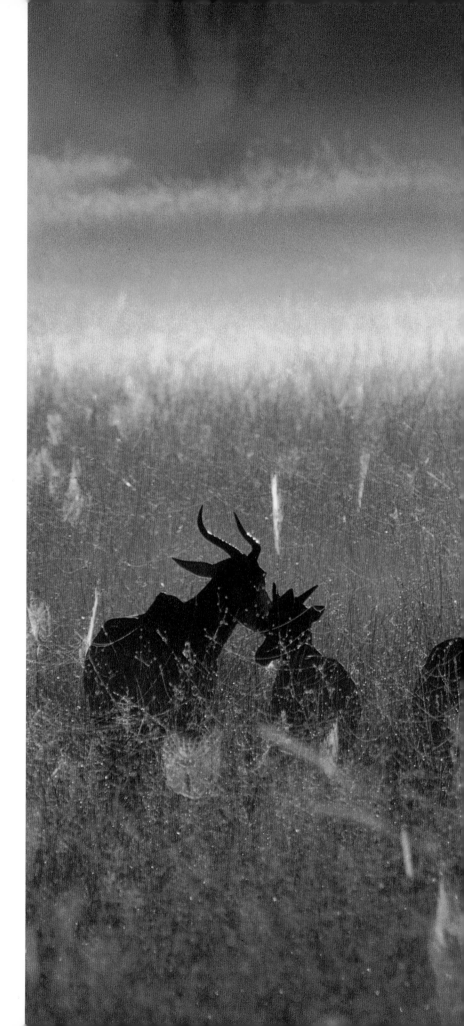

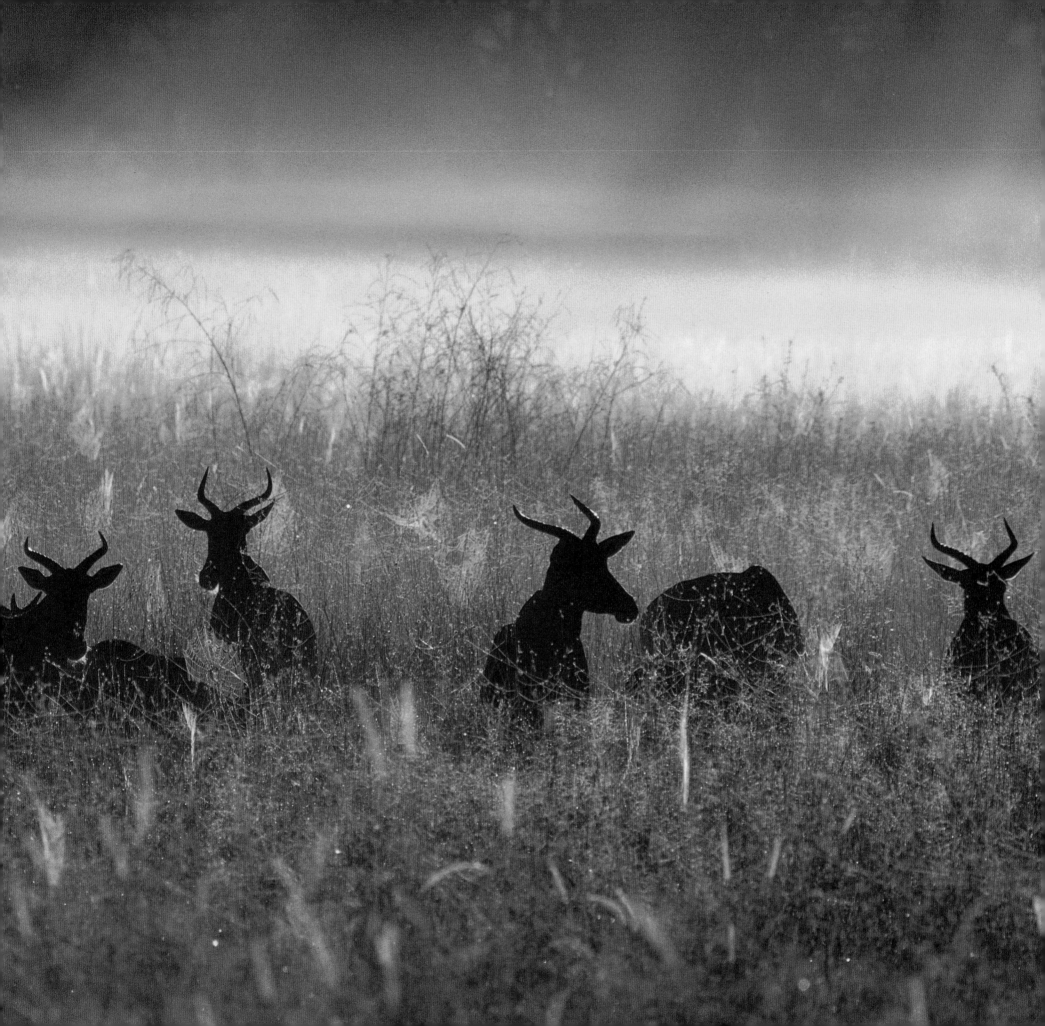

With his tail flared, his tongue flicking, snorting as he goes,
an impala buck sprints to demonstrate his prowess to a challenger
of his territorial claim. At the end of the rainy season,
bucks flex their muscles: They've built strength on the bounty of summer —
conditioning they need to establish and defend territories
where they guard harems of does and try to keep them from drifting off
to a rival's terrain. A buck's role is so physically demanding,
and his dominance so constantly threatened,
that most don't last more than one or two seasons
before they're replaced by younger males.

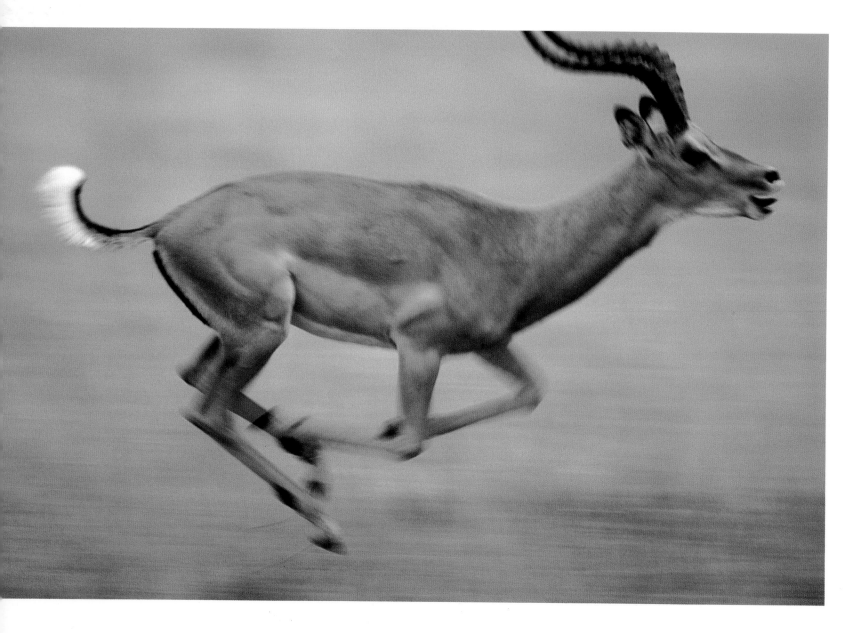

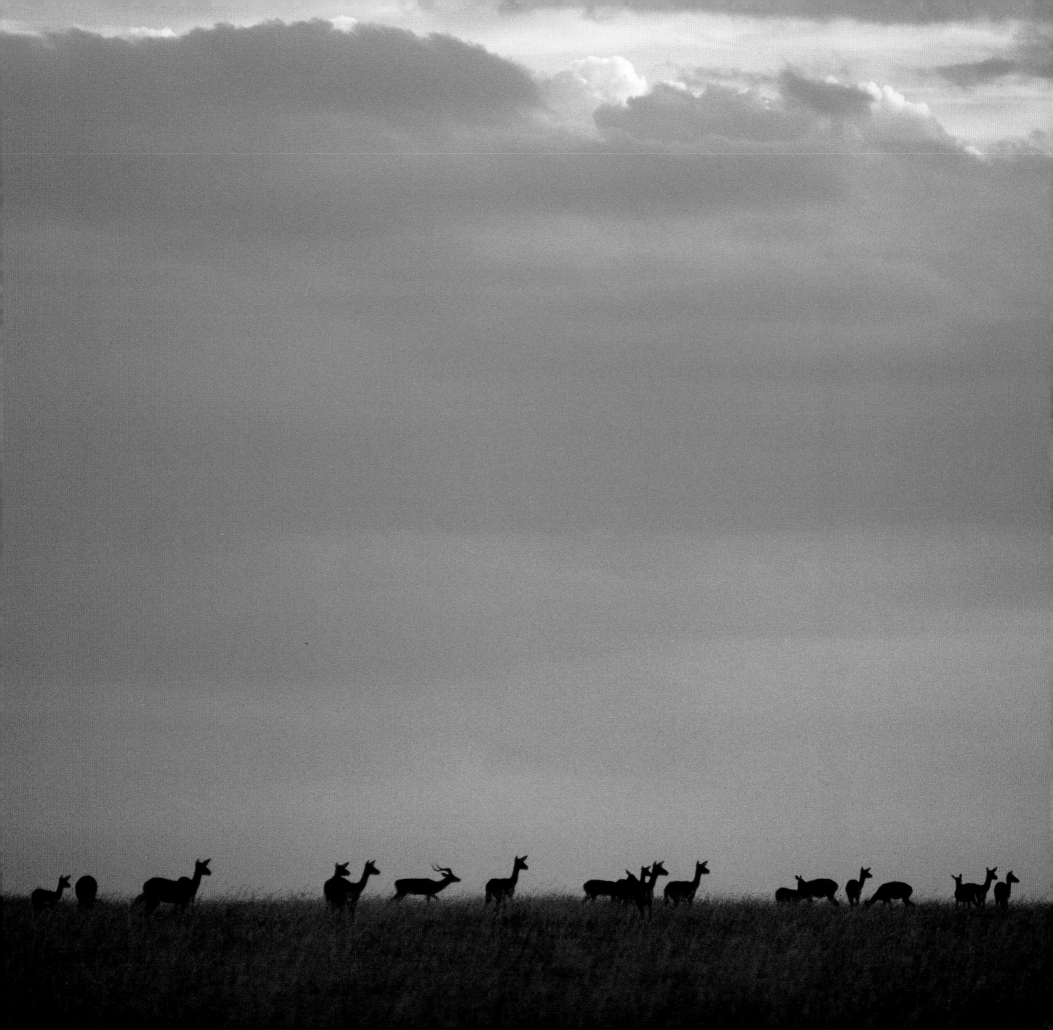

AFRICAN NIGHT

Into the Heart of Darkness

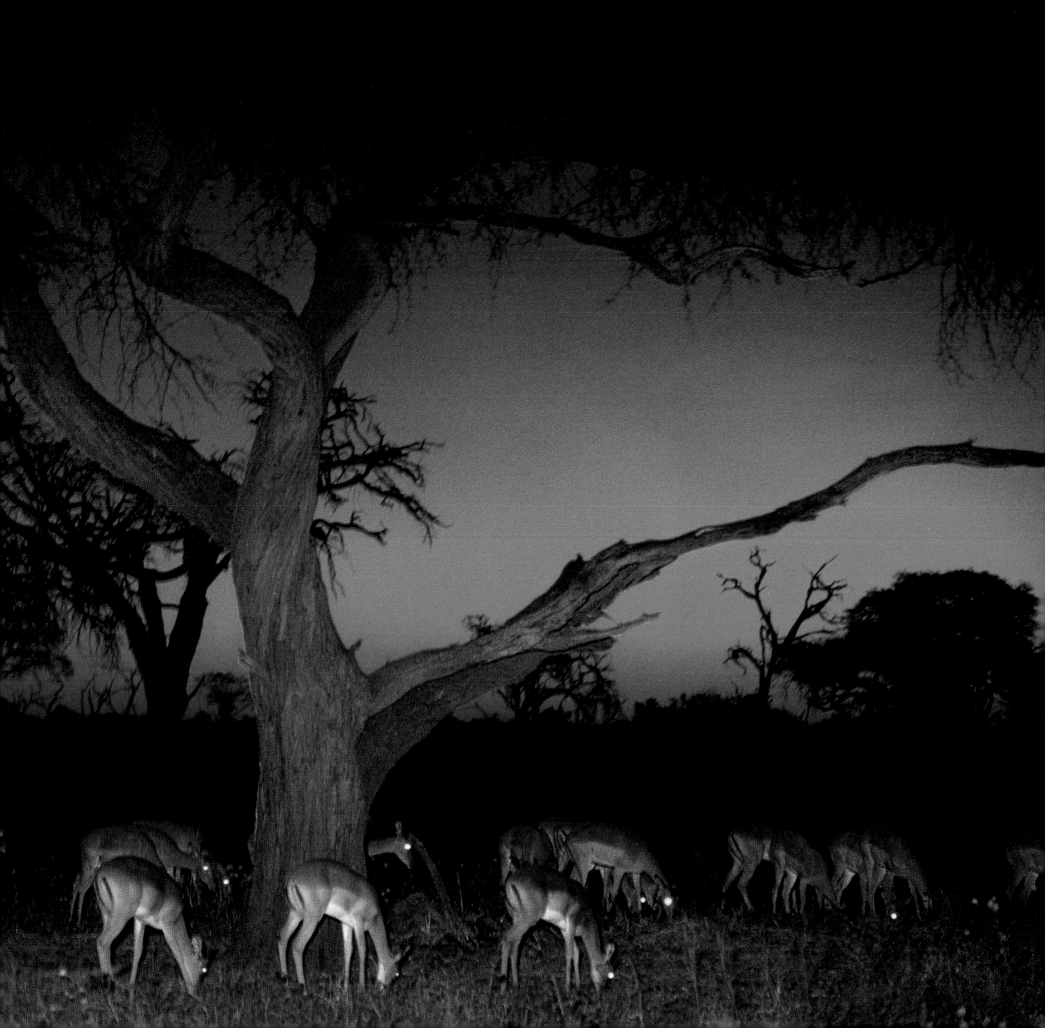

She rose and fixed her eyes on a distant point in the dark.

Only her tail twitched. I followed her gaze and listened. Nothing. No wind. No clues came from the night. Just the moon and a blaze of stars against a velvet night sky. What did she sense? The other seven lionesses lay sprawled on the ground where they had slept for hours, but now they too stirred. Every one of them turned in the same direction and froze, listening in silence. Then they stretched, got up and walked off in ragged file. I had been living with this pride for several weeks now and knew their habits well. Something was different tonight.

I followed them from behind, as I had many times before when they wandered across the darkened plains. The cats would stop often to get their bearings, listening for leads among the sounds of the night. But this time there was no hesitation. They moved with purpose, picking up speed as they went. As they came to the edge of a woodland, they broke into a trot and I lost them in a dense tangle of mopane scrub. But then something else led me on.

I smelled the elephant before I saw it, a bull that had fallen to its death in a clearing. Anarchy reigned around the carcass. My spotlight caught the glowing eyes of dozens of hyenas trying to fight off the lions, who with bold lunges and frightening growls pushed their way into control of the dead elephant. The hyenas lost confidence and skulked away, whooping while their enemies ate until their bellies couldn't hold any more. For two days the pride stayed around the elephant, moving only to drink. To this day I don't know what clue led the lions to the carcass. Did they catch a scent in the air? Or was it one faint hyena whoop that carried across 5 miles of bush draped in darkness?

The African savanna has always been a place of suspense, but generations of visitors have taken some of that edge away. However, when night settles over the land, familiarity fades and another world emerges—one where everything seems less certain. I was attracted to this realm of darkness but never quite freed of a sense of unease. Perhaps it goes back to our own species' beginning on the African savanna, to an ancient fear that leads us to stay close to the fire and shun the dark.

◄ *Overleaf*
The eyes of impalas grazing at dusk reflect my lights,
giving new meaning to these gazelle's scientific family name,
Antilopinae, or "bright-eyed."

Night closes in
from the shadows,
swallowing all
but my vehicle's
narrow beam of light
advancing through
the bush.

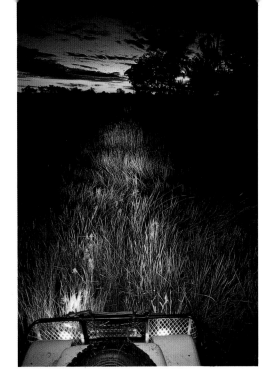

My guides to this nocturnal frontier were eight lionesses, who had hunted together for a decade as an all-female pride on the plains of Savute. For one intensive four-week period I turned my life upside-down to fit in with their rhythms; I slept by day and, like them, awoke at dusk. I trailed behind in a truck to give them room to hunt, cutting my engine when they needed to listen. We'd sit together in darkness, the cats and I, soaking up a silence punctuated by slight sounds—a half-heard rustle, a distant howl. In their company I experienced a privacy unlike any I had known before, an aloneness alternately terrifying and exhilarating.

They became used to me quickly and tolerated me being close, but I could never let my guard down. More than once when I had left my vehicle to crawl up to one cat for a more intimate perspective, I would turn around to find another one stalking me. Test or play? I never strayed far from that metal box on wheels that shielded me from true fear.

No two nights were the same, and chance as much as skill made the difference between feast and famine. Sometimes the cats would sweep the plains in a random search, covering nearly 20 miles without ever finding an opportunity to pounce. Other nights the action was swift and stark. When the pride sensed prey ahead, walking would become stalking. The lions would fan out, some hanging back, others easing out to the fringes, in an effort to surround their unsuspecting victim. I'd watch them slide through the grass, muscles taut, heads low to the ground. Focused as only cats can be, they'd slink away from view. Silence. Sometimes for minutes, other times for what seemed to me an endless hour. Then chaos. The drumming of hooves. Shrieks. I would flip on my spotlight and with luck, at the edge of my vision I'd witness that awesome strength lions reserve for the brief burst of a charge. Hit or miss, it would all be over in seconds.

Many people think of lions as the top predators of the African plain, the kings and queens of the animal kingdom. I came out of the night with a different perspective, with an admiration for their skills, but also with a deepened sense of how precarious their lives are. I saw them hunt with deadly precision, acting in perfect synchrony on clues I could not detect, but they also failed at opportunities that appeared to me, the novice, impossible to miss. Such, perhaps, are the vagaries of a hunter's life. But on another level questions remain.

Some nights the lions roamed for only a few hours before they lost concentration and went to sleep, leaving me to wonder when they might rise again. On one such night I had dozed off myself, with the pride lying in front of me. When I awoke, the lions were gone. I drove around in the dark to find them, but couldn't get my bearings and gave up. Tired and frustrated, I climbed on top of the truck and laid down on the roof. Heat lightning flickered on the horizon as I drifted to sleep. The next thing I knew, the vehicle resounded with a deep vibration. I bolted up to see all eight lionesses, sprawled around me, roaring in unison. They had come back and were asserting their claim right here at the truck to the open plain that stretched for miles in every direction. It was still dark, the lions were not more than shades of gray, but from the east, color was seeping back into the land.

There was a time when we thought of wild animals as lesser creatures governed only by instinct. We are broadening our interpretations now, to a more dignified view of their lives. But have we come any closer to understanding what goes on in a lion's mind when it wanders the African night?

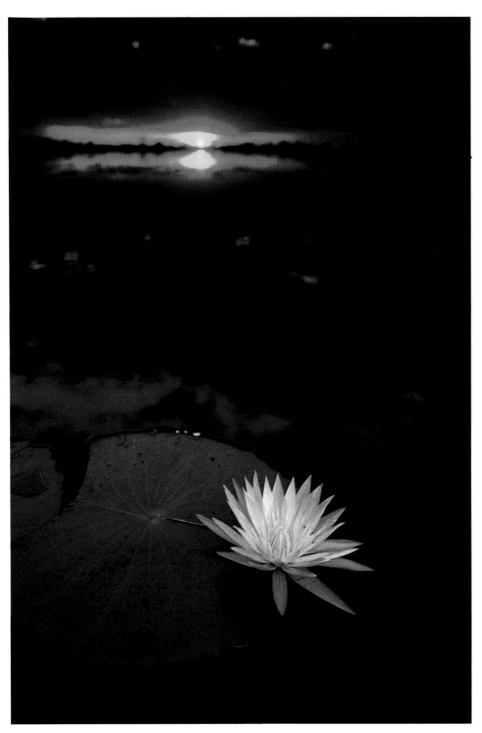

On a delta lagoon,
day's end begins
with a subtle change in shifts.
As a day-blooming lily closes,
the petals of night lilies nearby
are just beginning
to open.

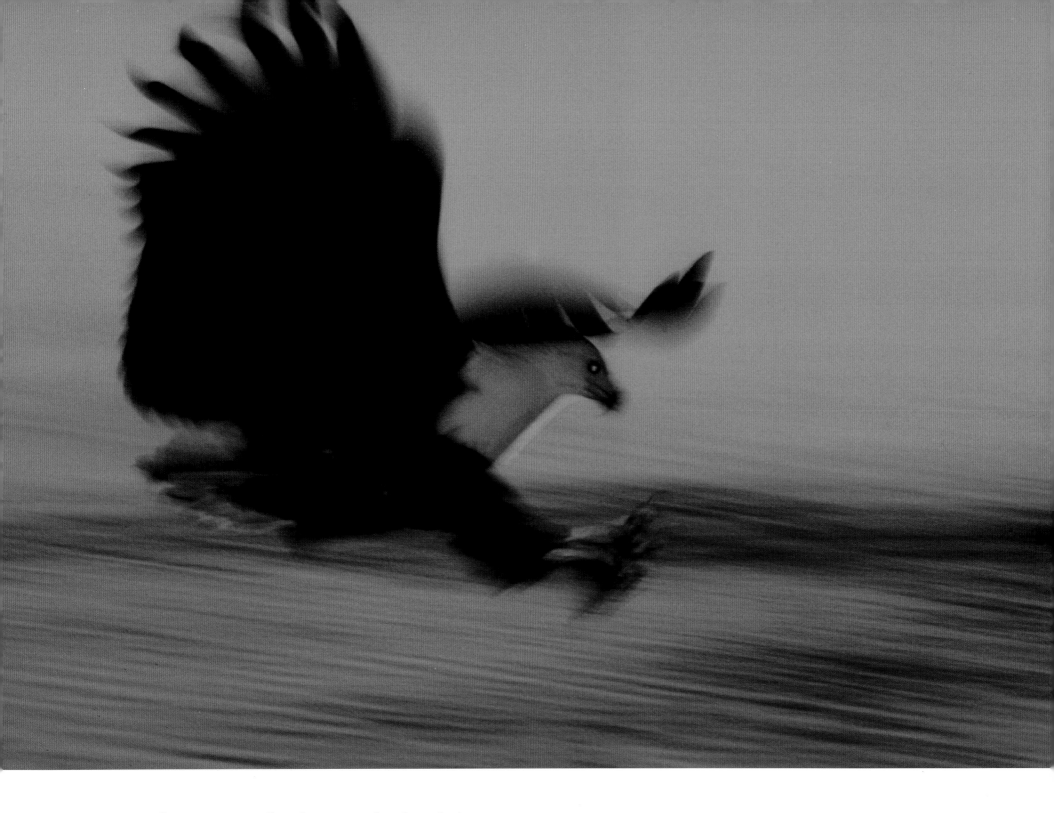

Talons stretched to grab the fish it spotted as a ripple in the water, an African fish eagle swoops down for the last catch of the day. After sunset its domain is taken over by a silent hunter, Pel's fishing owl, which pinpoints prey in total darkness.

A rush of wings is all a flock of sacred ibis reveals

as it passes
in waning light,
headed for the protection
of a swamp island thicket
where the birds
will settle until dawn.

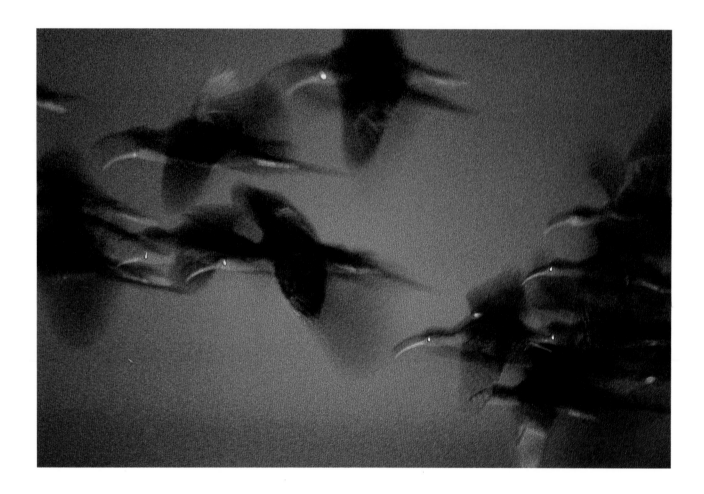

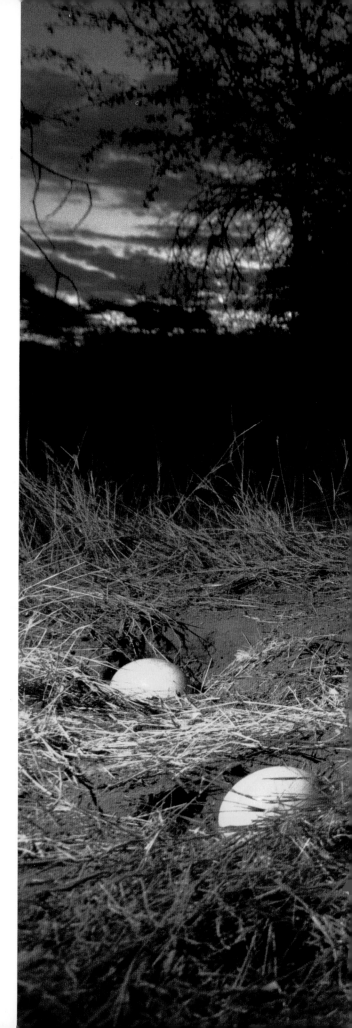

More eggs
than she could handle
are scattered around an ostrich
sitting atop a pile of eggs
laid by herself
and several other hens.
But in a break with convention,
it was she
and not her black-plumaged mate
that kept nest duty
through the night.
I approached her with great caution,
remembering the story
of an ostrich slicing
the belly of a hyena with one kick
of its powerful clawed feet.
My stomach
never left the ground.

A pod of hippos
comes alive at twilight,
sounding hilarious grunts
like old men laughing.
After dark, they all lumber
out of the water
to graze through the cool
of the night.

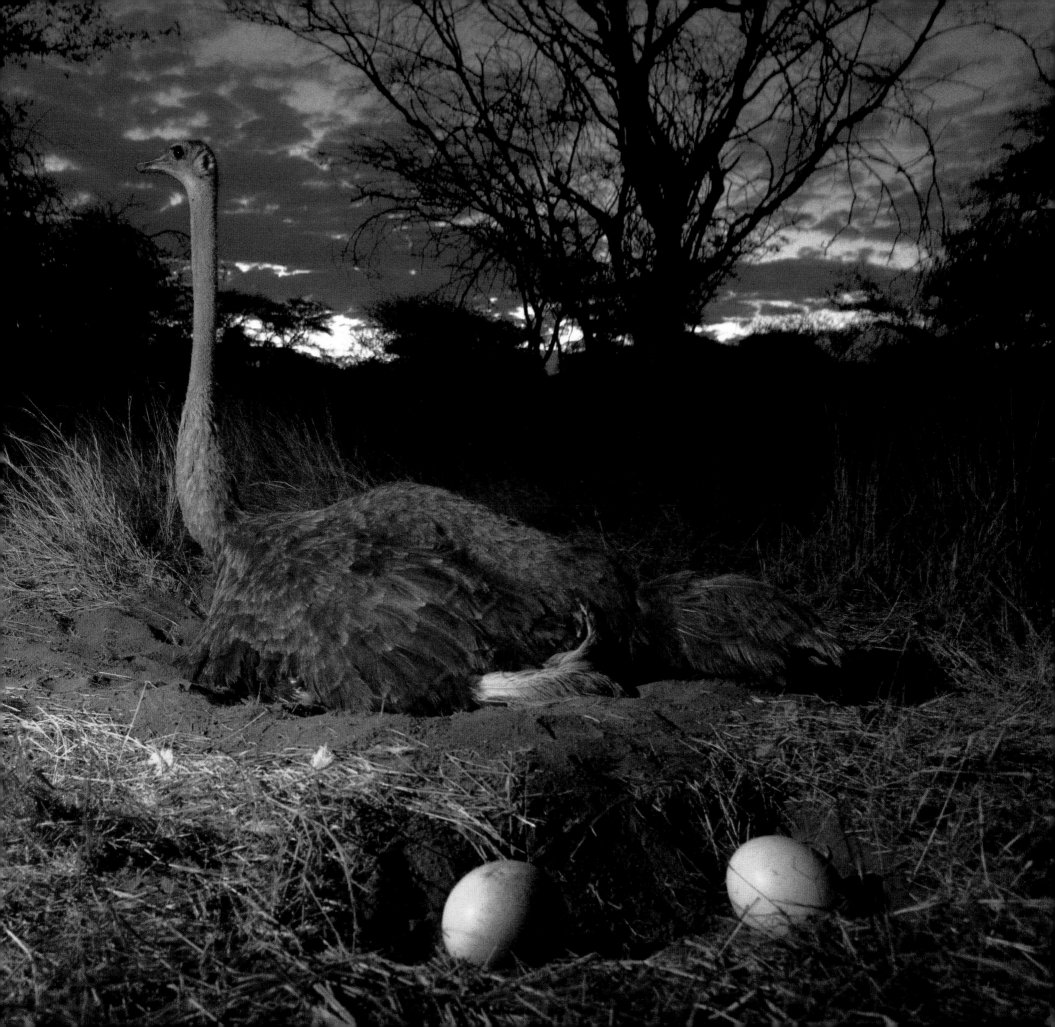

Buffalo leave the forest
that shaded them
during a searing day
to graze in the Chobe floodplains
through the breezy hours
of evening.

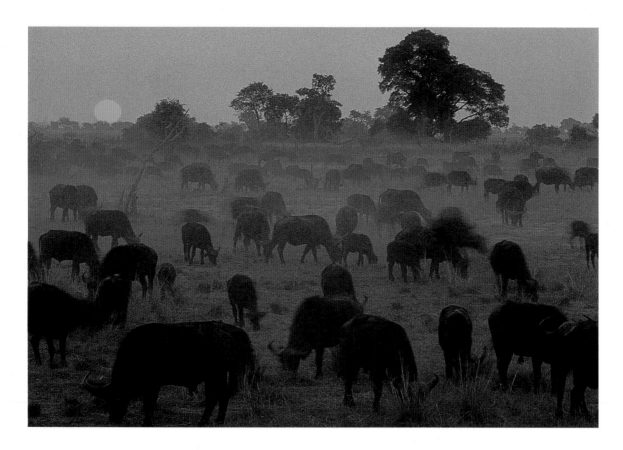

An elephant the color of dusk fades into a darkening sky.

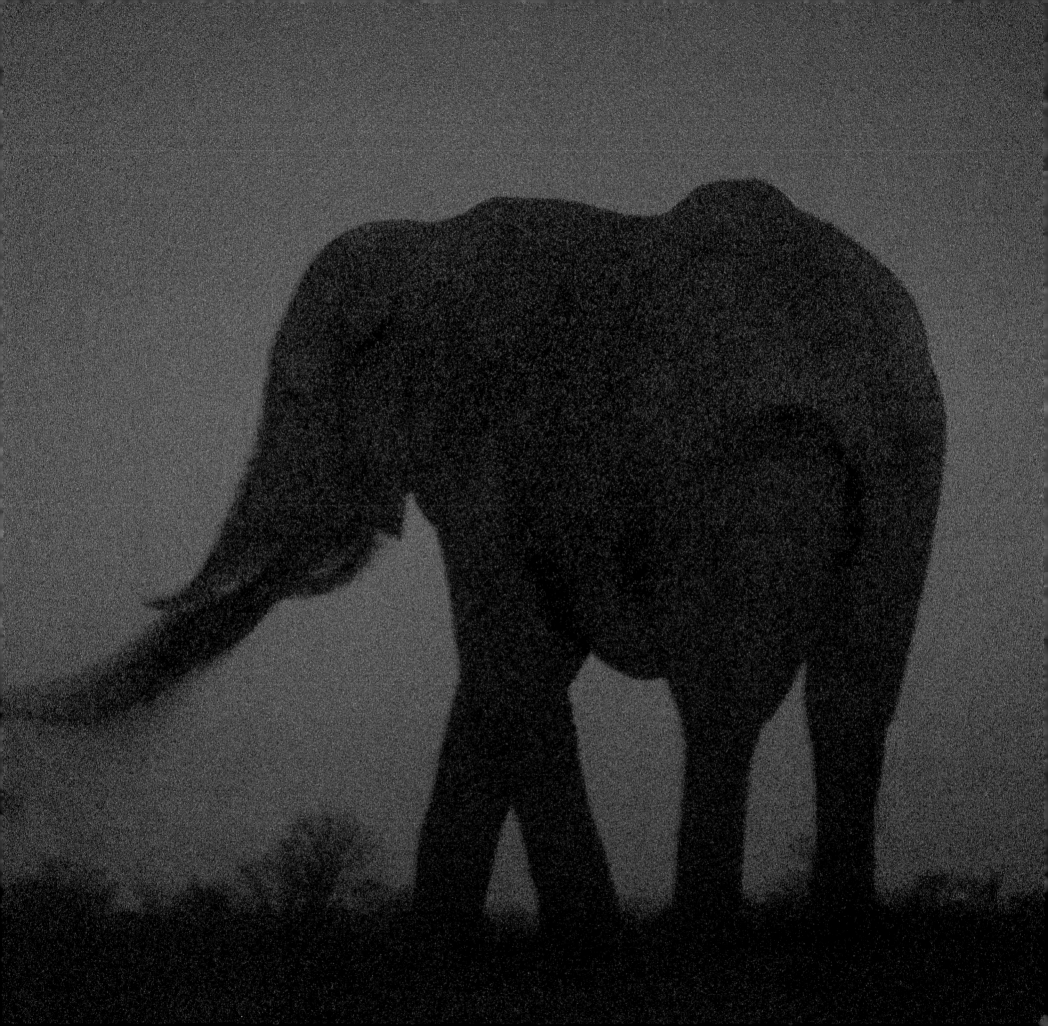

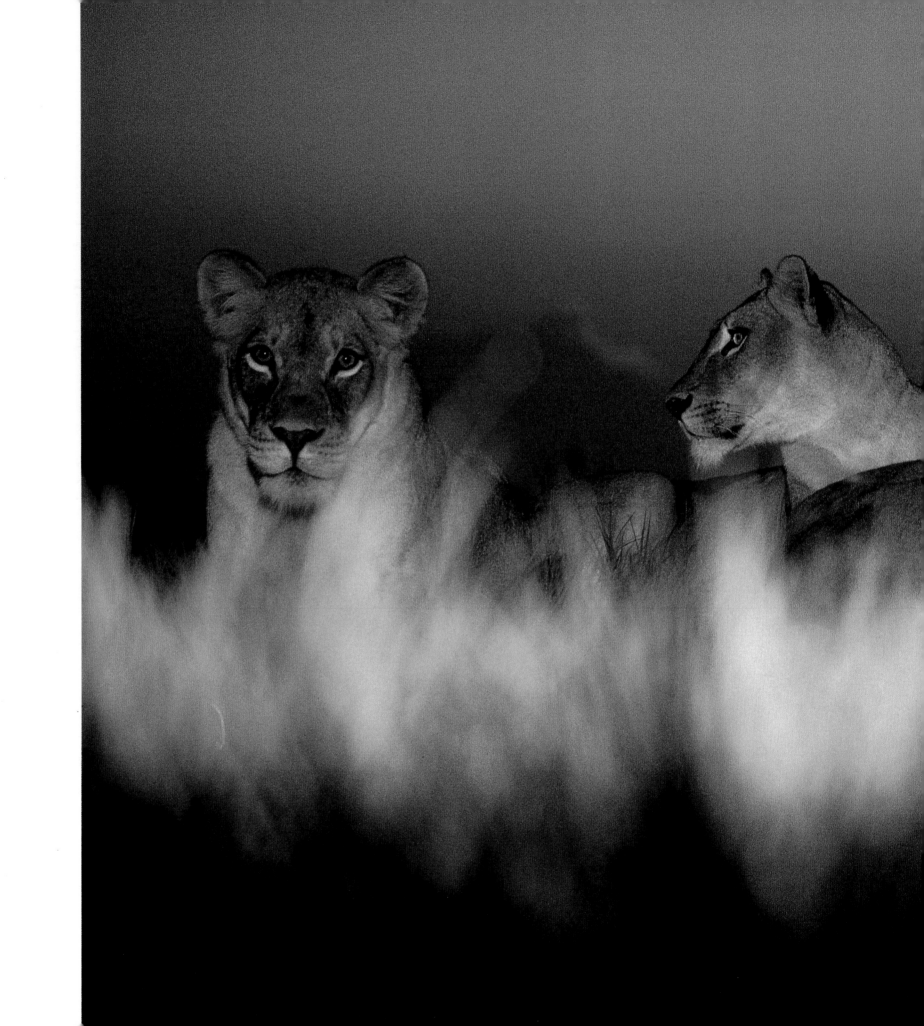

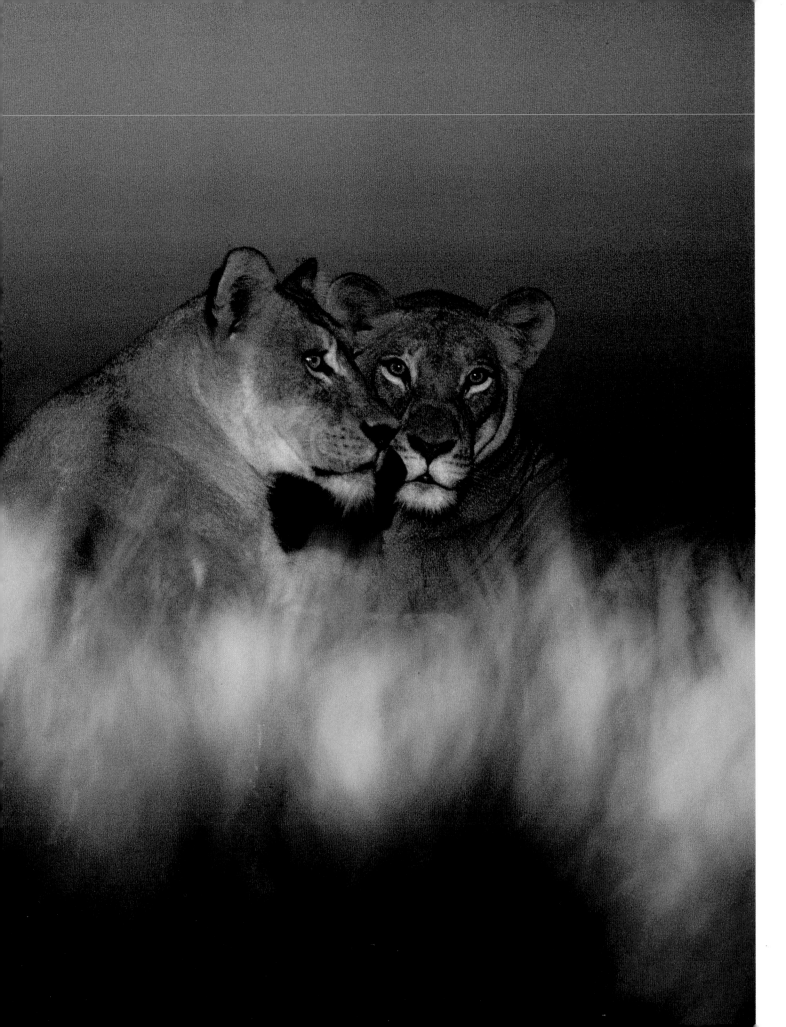

With eyes
and ears scanning the bush,
a pride awakens,
ready to hunt.

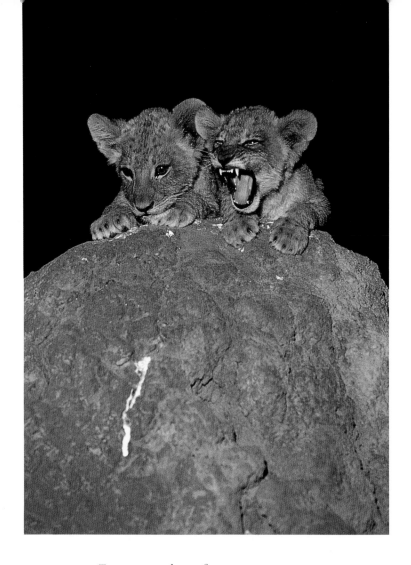

Too young to know fear,
two lion cubs left by a mother
doing double-duty
spend a vulnerable night on top of a termite mound.
Alternating between hunting and parenting,
their mother joined her sisters
on most nights, then returned
to nurse her offspring.
But one night the cubs disappeared,
perpetuating the sad record
of this pride.
In ten years' time,
they have yet to raise one cub
to independence.

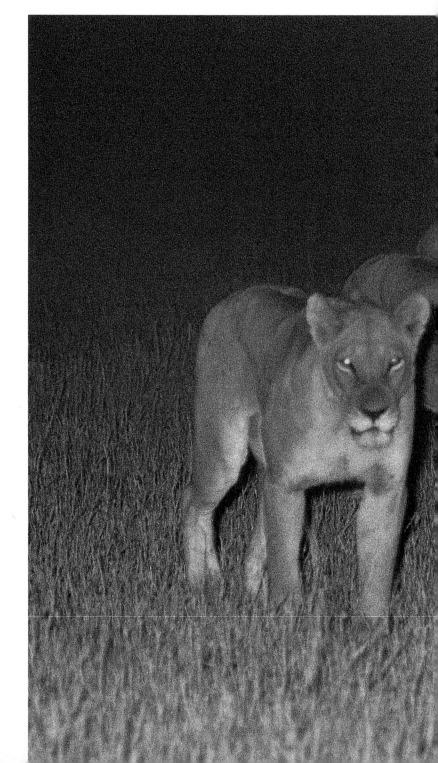

An advancing front of lionesses bound by sisterhood and hunger
moves through the night.
I watched them wander
in lethal procession, night after night,
and could imagine no sight more fearsome.
But hunting is a hard way of life even for these seasoned cats,
who have patrolled the same range together for a decade.
Many nights they roamed without luck —
or the heart for a chase.
I saw their bellies grow flat.

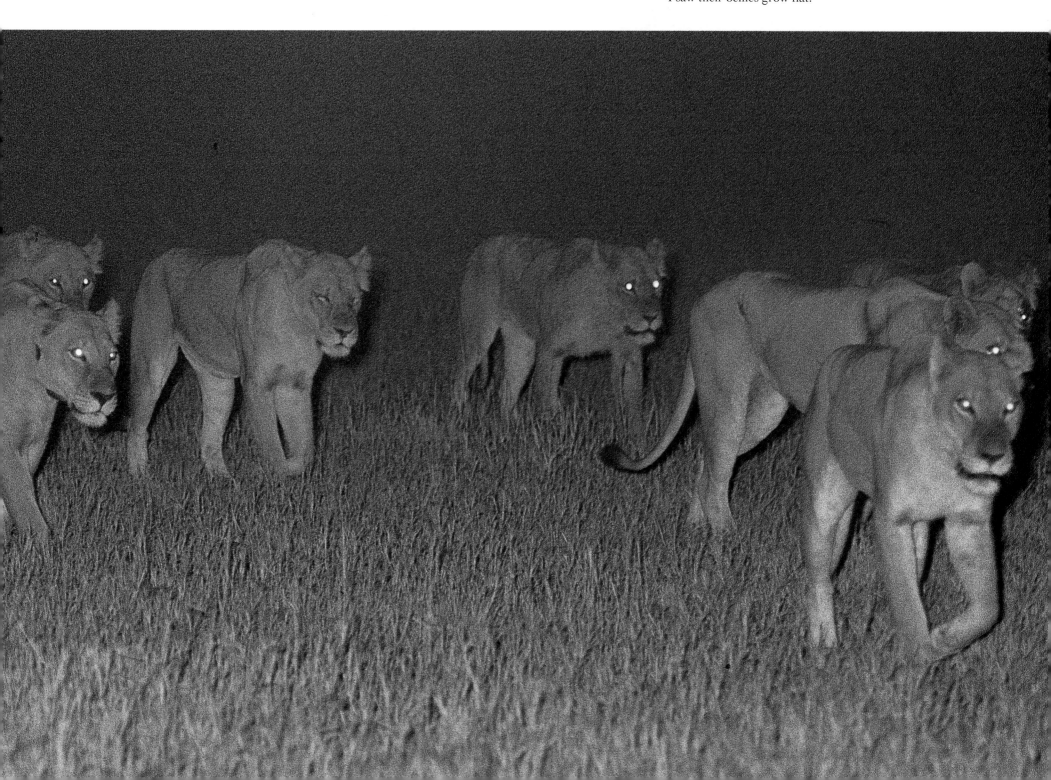

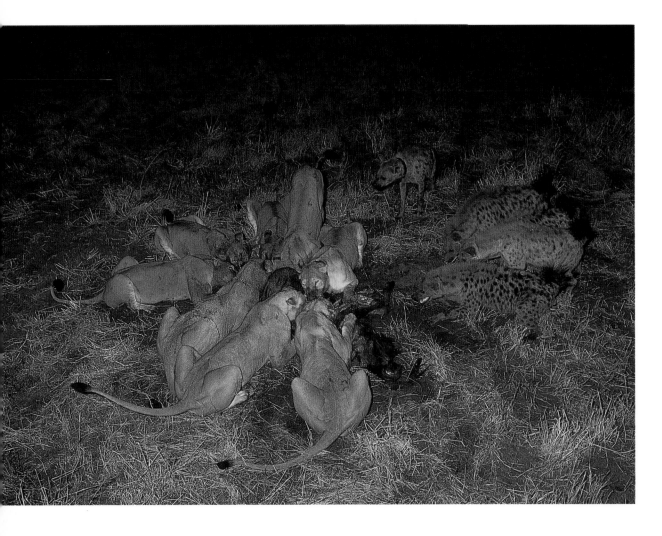

The end was brutal
but swift for a wildebeest
ambushed one night.
But without males among them
whose greater strength adds security,
this all-female pride
often loses kills to neighboring
clans of hyenas,
who are masters at exploiting weakness.
Supremacy can slip away
in an instant during naked battles
between killers and scavengers
who reverse roles,
time and again.

Even a feeble moon
can take the edge of surprise
away from cats on the prowl;
the darker the night,
the better the hunt.

To a hungry lioness
who hasn't eaten
for several nights,
even a tiny plover will do
as a meal.

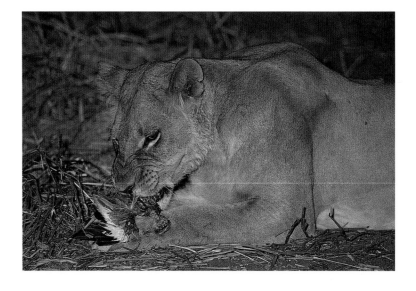

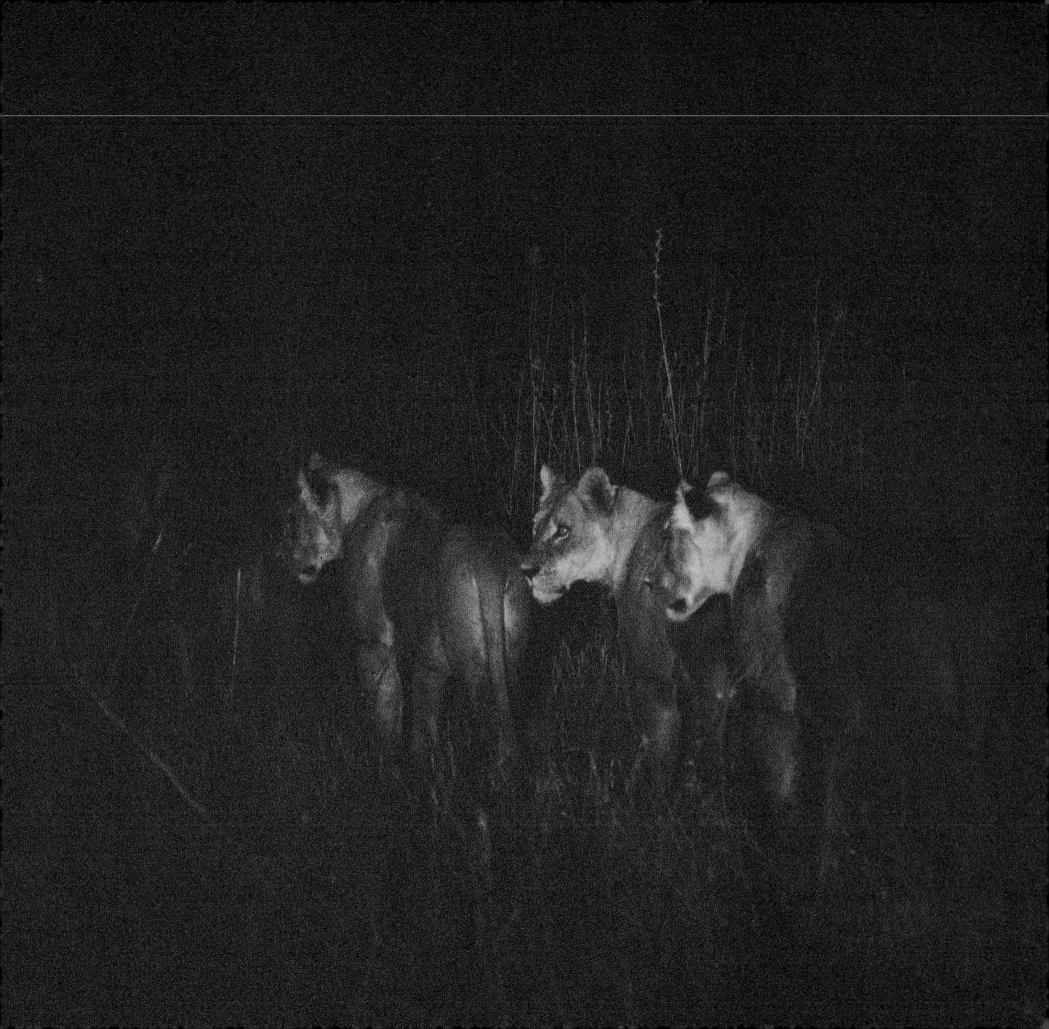

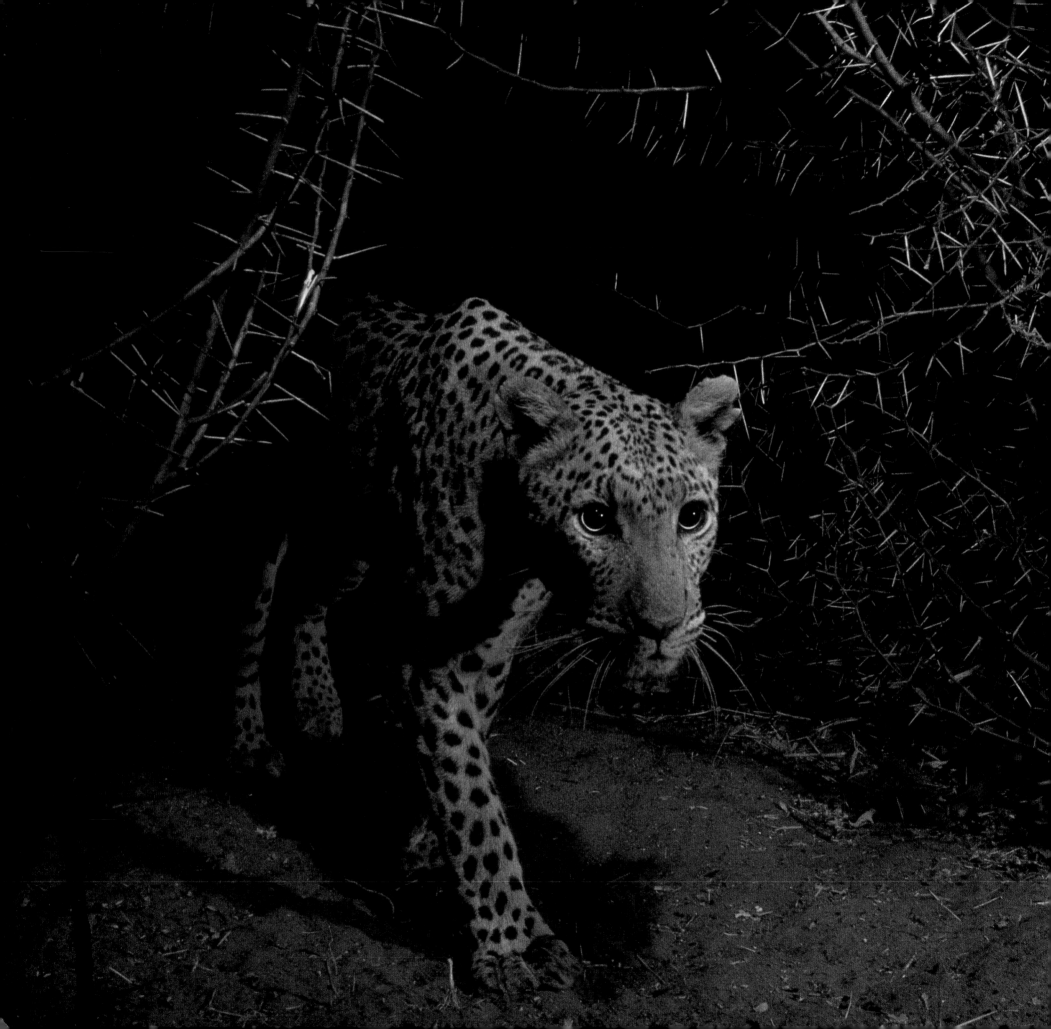

A robot camera
triggered
by an infrared beam captured
the stealth of a leopard
I never saw myself,
and produced
a chilling portrait
of a wild animal unvarnished
by the presence
of a human.

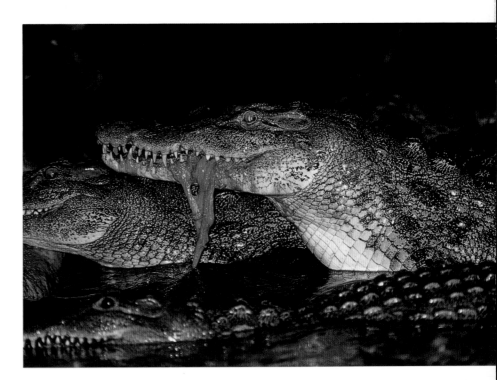

In a feeding frenzy,
crocs slither over each other
and onto a hippo carcass
in the Linyanti swamp.

The sight of springhares

bouncing like tiny kangaroos
along the side
of a sandy track
provides a counterpoint
to the tension
of the night.
They have reason to run;
springhares figure
in the diet
of almost every carnivore
in the Kalahari.

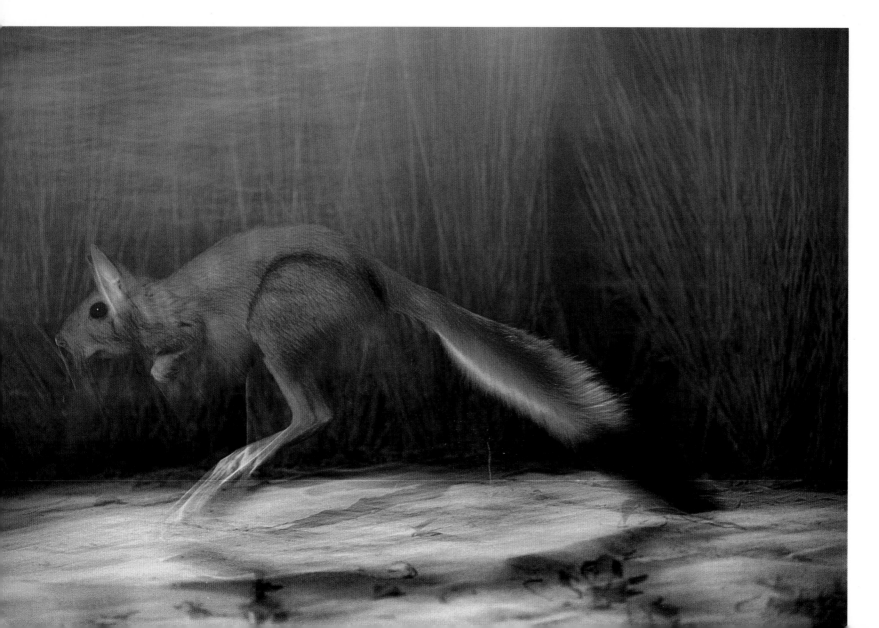

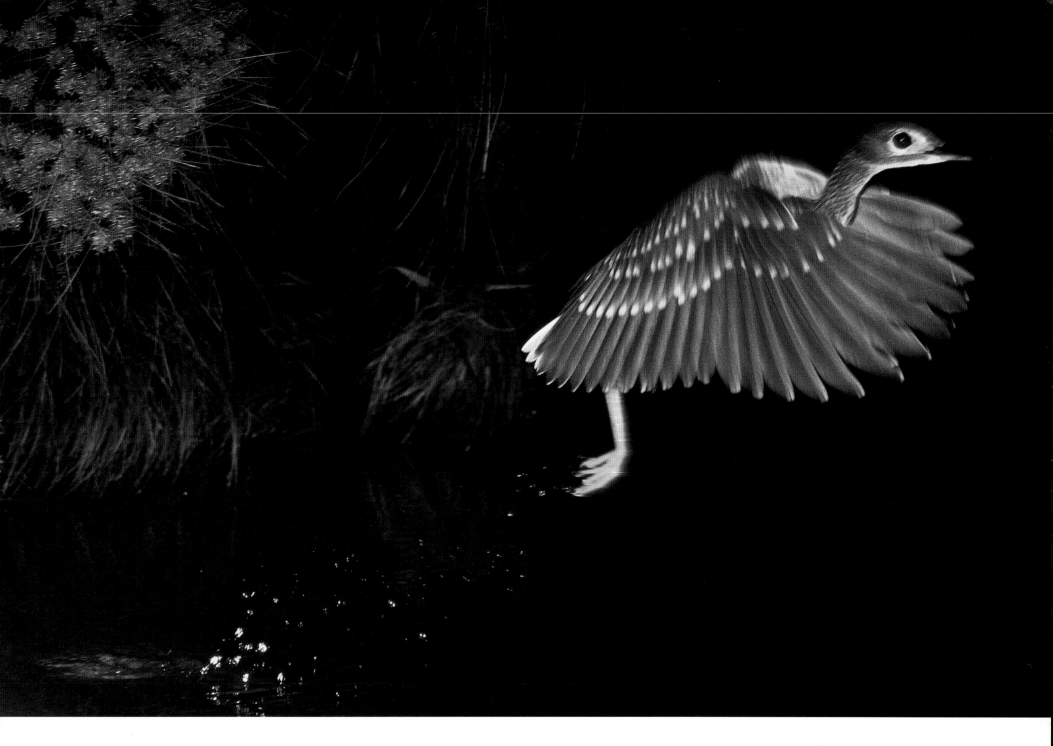

A mutual start
marked my encounter with a rare
white-backed night heron,
who flapped up from a beach
in the swamp
when I drifted past
in a canoe.

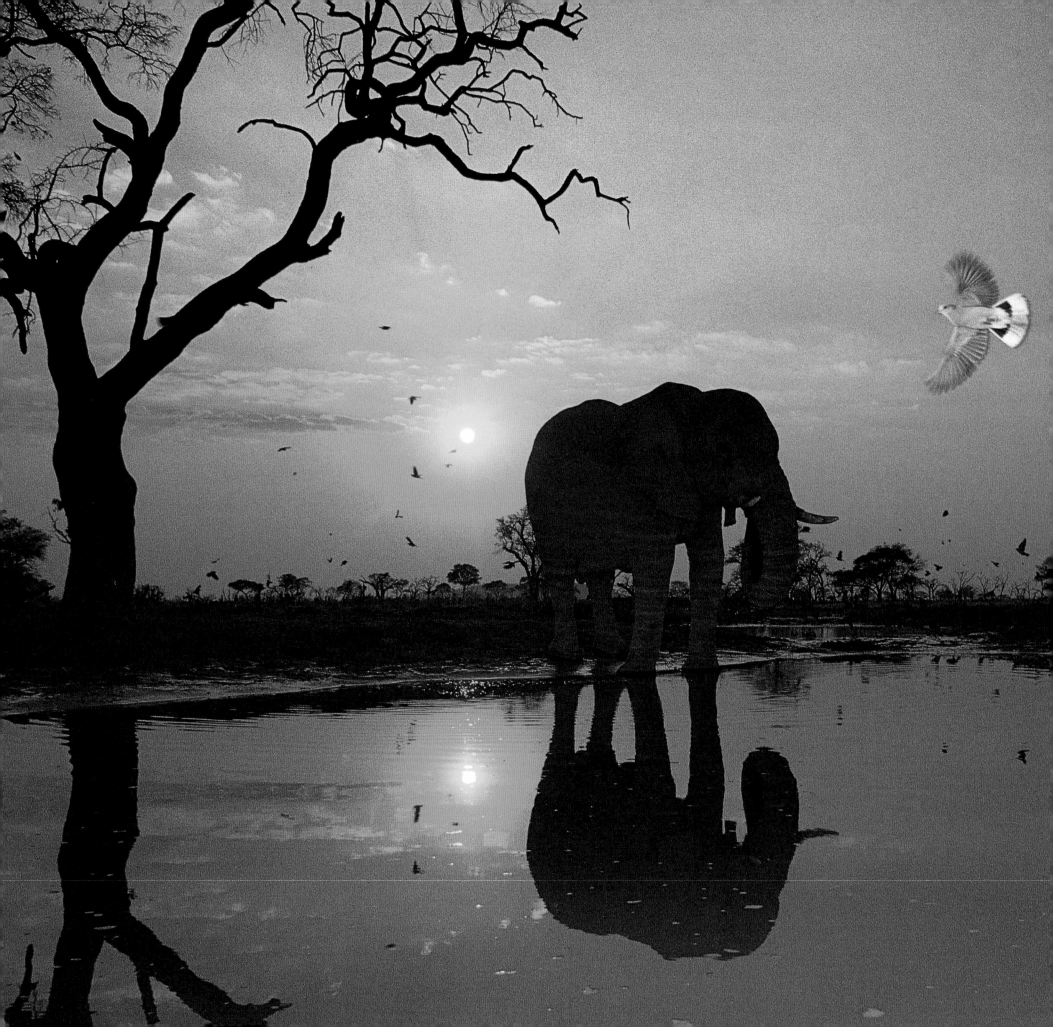

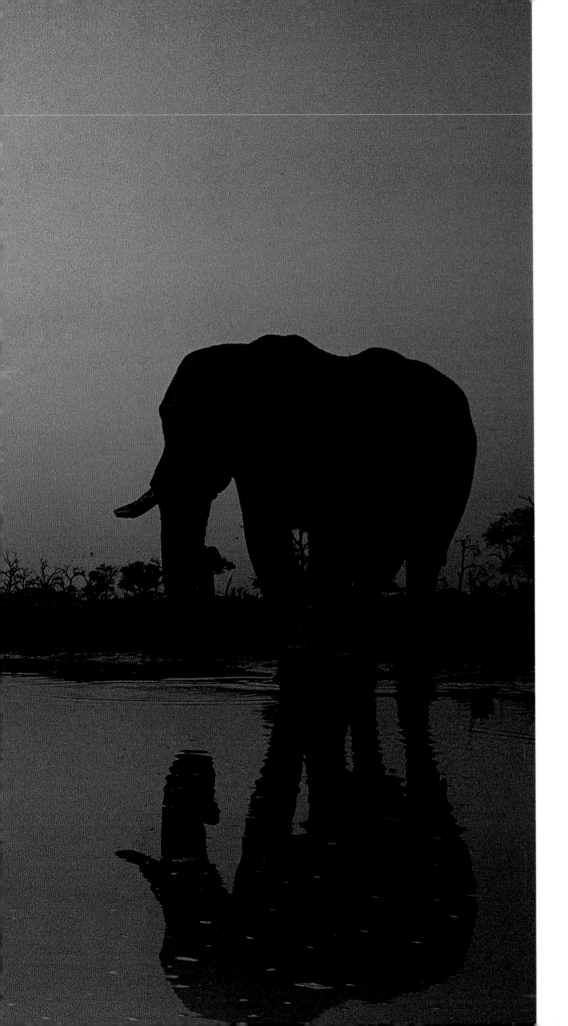

As light seeps

over the eastern horizon,

familiarity returns

to the land; the harsh contours

of the night

and its black-and-white drama give way to the color

and definition of the day.

Bleary-eyed

after a night of work,

I watch the arrival of a morning shift

at a water hole

where a dove heralds the dawn

with a flash of wings.

ELEPHANTS

Twilight of the Giants

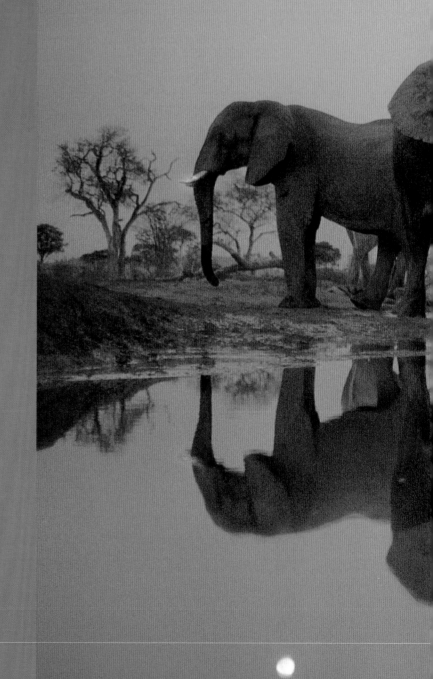

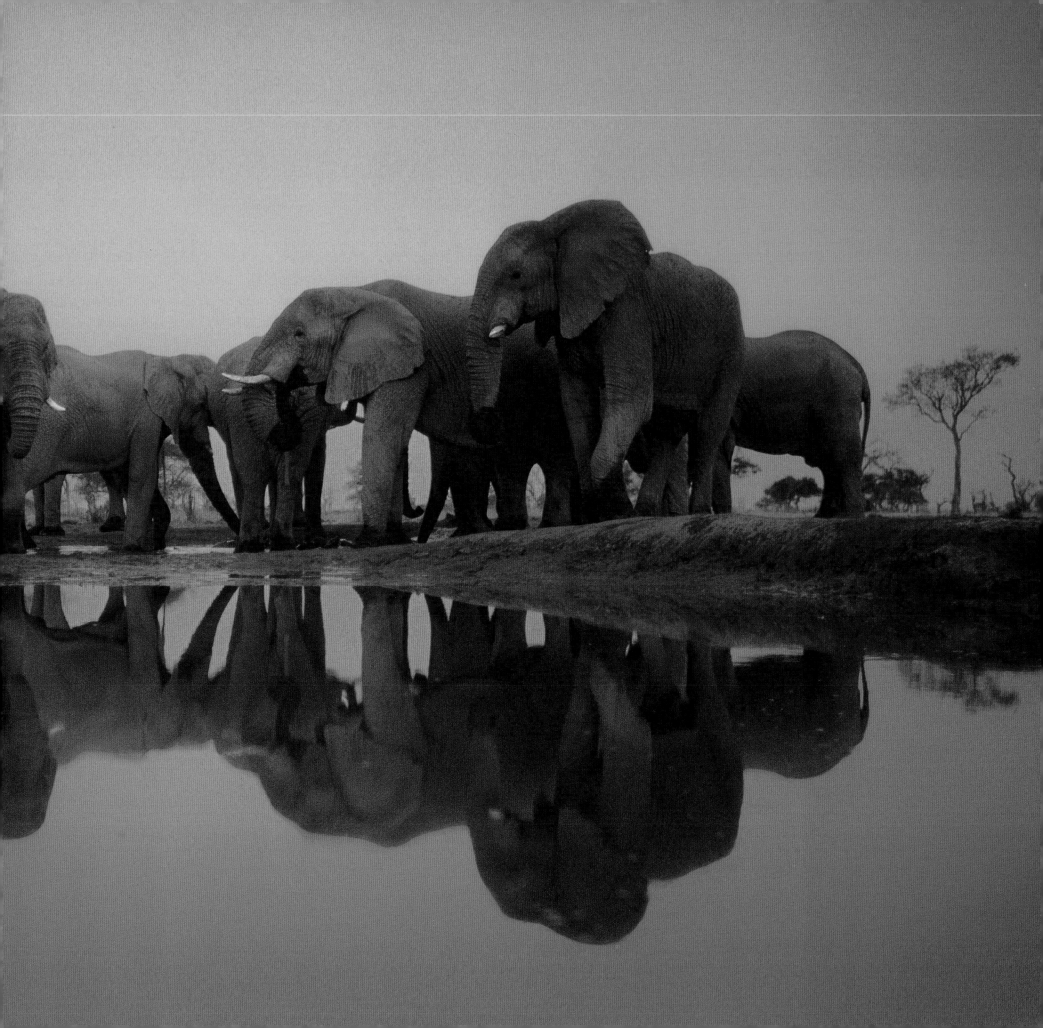

Only their trunks were visible, undulating along the surface

of the water. It was a family of elephants, cows and calves, swimming across the Chobe. The smallest ones were corralled in the center of the herd, the cows keeping them afloat as they made their way back from a feeding trip on the opposite side of the river.

I watched this moving raft of pachyderms from a small boat in the middle of the Chobe, the broad river northeast of the Okavango that forms part of the border between Botswana and Namibia's Caprivi Strip. In the dry season, elephants converge on the Botswana shores of the Chobe. Their numbers build to an awesome concentration in October, when along a 60-mile stretch of river, tens of thousands can be counted—the greatest gathering of elephants left on the face of the earth.

Their impact on the landscape is like that of a hurricane. Trees lie snapped in half. Others are stripped of leaves and bark; branches litter the ground. Riverbanks have been pounded to bare dust. But on the Namibia side of the Chobe, tall grass sways on floodplains where few wild animals roam. Wildlife in that area has been decimated by poaching over the past decade. Many elephants have been killed and others have fled—most to Botswana. Poaching pressure is lower here, and the government has imposed a moratorium on elephant hunting. The elephants know they are safe. In the past decade, their numbers have been augmented by herds from Zambia and Zimbabwe—refugee elephants escaping both illegal hunting and official culling conducted to control their impact on farmland and parks. The result is that northern Botswana is now host to more than 60,000 elephants, the largest unharassed population left in the world. For some of them, the temptation of all that grass in Namibia is too great to resist. But they are loathe to go there by day. They wait till darkness. Then they leave the trampled shores of Botswana and swim across the Chobe to Namibia to feed at night—and return to Botswana with first light.

◄ *Overleaf*
Bulls gather at a water hole under an October moon.

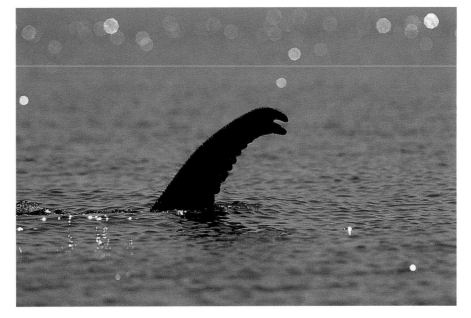

An elephant snorkels
across the Chobe River.

It is no secret that elephants understand demarcations humans draw on the land. A bull in East Africa pursued by hunters walked nonstop for two days—straight to the border of a park. Many parks in Africa have literally become refuges for elephants escaping areas where they clash with growing human populations. No animals have had more impact on the African landscape than elephants and humans, and it is the elephant, more than any other large animal on the continent, that competes with the interests and needs of people. Elephants need space. Unrestrained, they range over huge areas. In earlier days their trails crisscrossed the African continent. Elephants occupied virtually every environment, from rain forest to savanna, swamp to desert. Wherever they roam they leave their mark. But in their passage, they also create opportunities for others. Some animals feed on elephant leftovers; others follow trails they plow through dense bush or graze in the clearings they open. During dry times, these soft-footed giants remember the location of former watercourses and return to them. In northern Botswana they dig holes in dry pans and sand rivers, creating seeps on which other animals survive as well.

Elephants are picky eaters. They consume grass in the rainy season when it's succulent, then switch to browse in dry times when leaves are reaching their palatable peak. They will pull down whole trees just to get to a few desirable branches in the crown. In the mopane woodlands of northern Botswana, the crackle of trees being felled by elephants is a common sound, not unlike firearms discharging. Some bulls seem to push trees over not just for food but to show off their strength, or to vent frustration. But in areas where too many herds are crowded together, the end result is a landscape dominated by elephants. Their droppings, their trails, their wreckage, are everywhere.

Unless you have surveyed an elephant-battered land, it may be hard to understand the voices that call for culling in an effort to bring about a balance between elephants and the environment that we at present think is proper. But the dilemma is easy to see, because elephants, to many people, are not like other animals. Outside the family of great apes, there is no other creature on earth that allows for such opportunities to anthropomorphize. Despite the obvious dissimilarities between us, we recognize in elephants a kindred spirit—whether it's the intricacy of their social lives, the nurturing they receive in extended childhoods, the long life spans so like our own, or, on a simpler level, the unabashed pleasure they seem to take at just messing around in water. Stories about elephants have been main fare around campfires and villages in Africa for generations. According to one, elephants ingest one pebble a year to keep track of their age. Other stories are now beginning to garner scientific credibility. It has long been suspected that there was more to elephant communication than met the eye or ear. That has now been borne out by findings that their rumblings below the threshold of our hearing carry information between herds many miles apart.

Perhaps no story better shows our implicit acceptance of elephants as cognizant beings than the old tale about elephant graveyards, reputed to be sites where elephants go to die. Although we know they attend to bodies of deceased family members, nudging them in an attempt to stir them to life, lingering by them for days and walking off with bones, no one has ever really found an elephant graveyard. But the story refuses to die. Is it because we want to attribute to them impulses or motivations that go beyond sheer survival needs, such as altruism, or a sense of death? What we read into elephants is a reflection of ourselves—of the things we deem important, the things that move us. But our knowledge and appreciation of elephants seem to grow as fast as our inability to live with them. It remains to be seen which force will overcome the other.

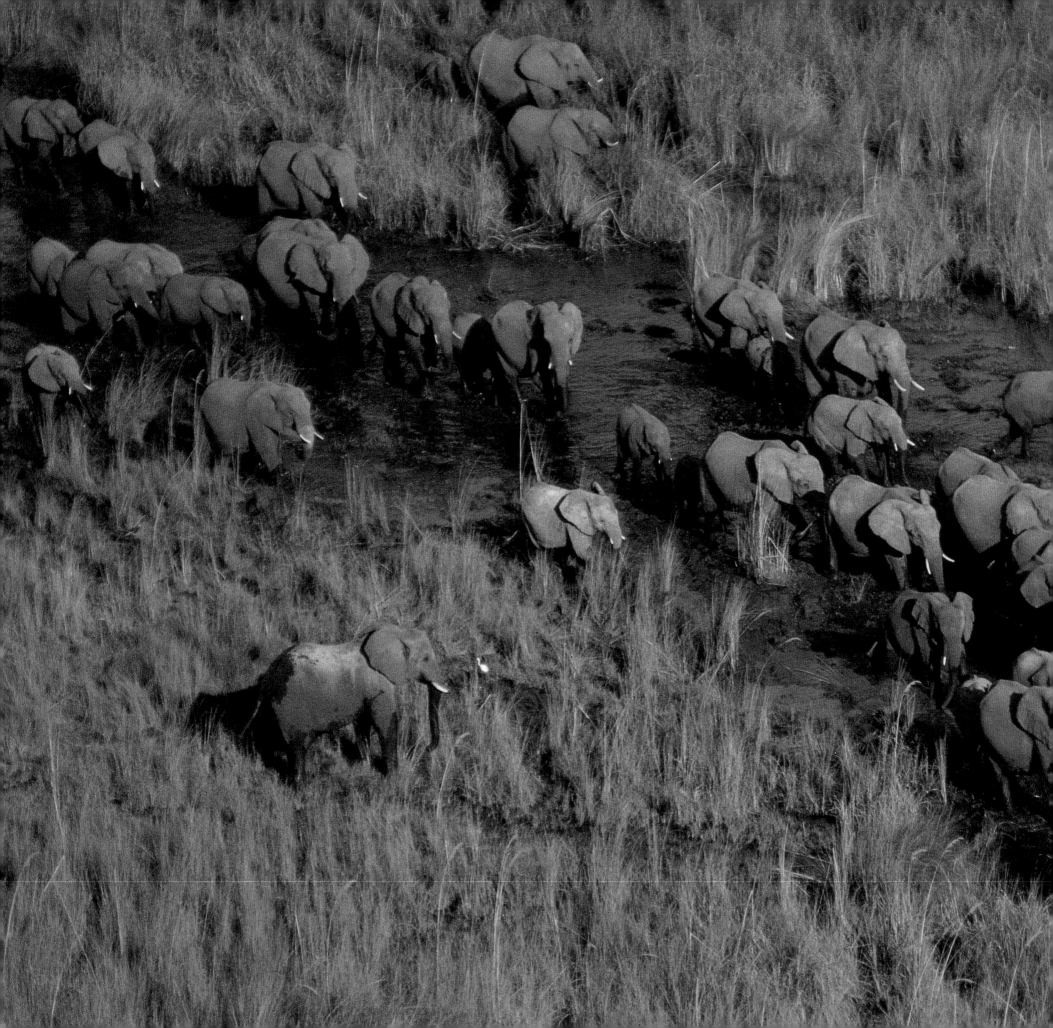

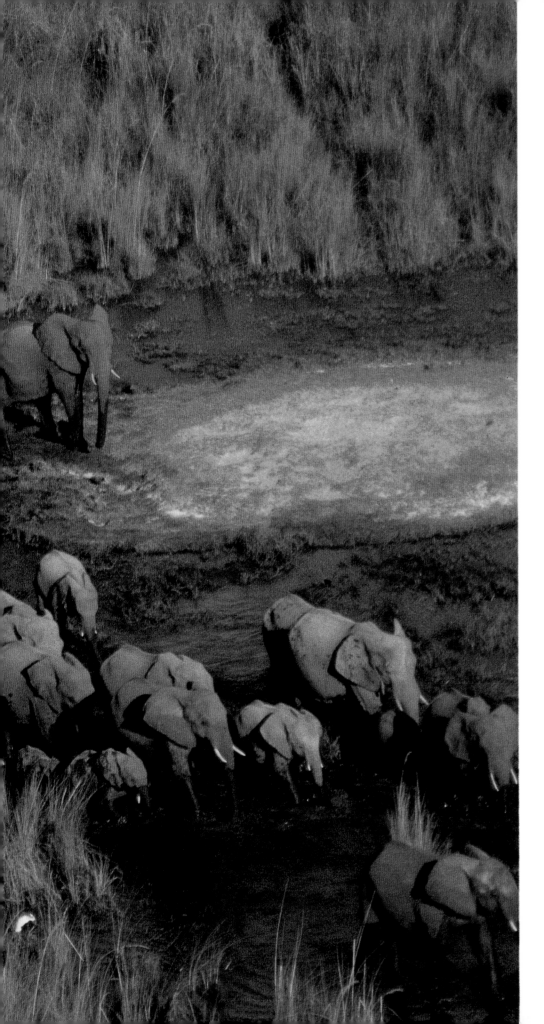

A procession of elephants

plows a path
through the Linyanti swamps,
a dry season destination
for tens of thousands of elephants
scattered widely across
northern Botswana
at other times of the year.
Family groups consisting of mothers
and their offspring
led by a matriarch cluster together here
in large aggregations,
occasionally joined
by lone bulls.

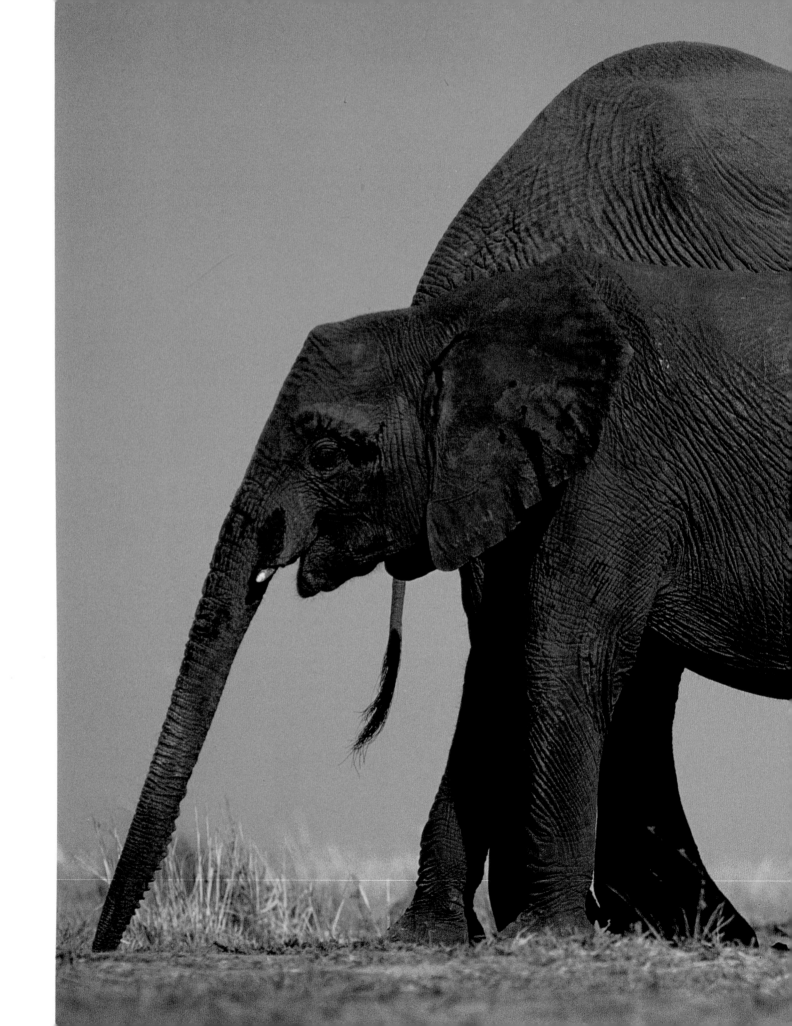

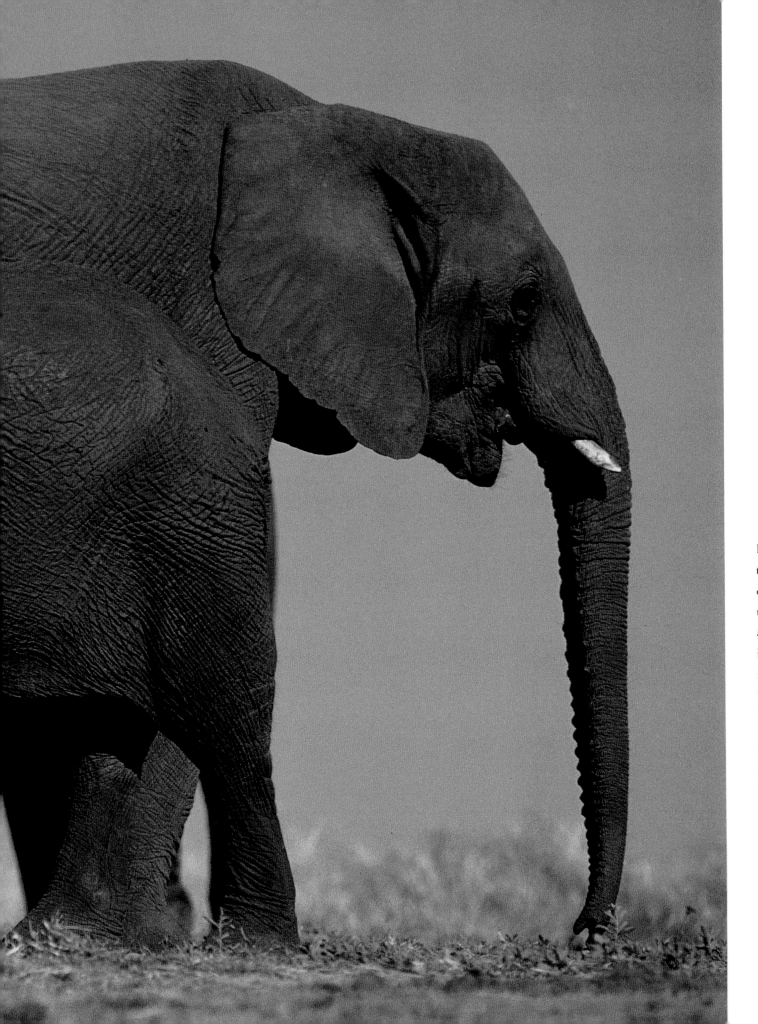

Elephants are
the last living representatives
of the distinguished lineage of *Proboscidea*,
the trunked beasts that arose
50 million years ago and evolved
into more than a hundred species including
mastodons and mammoths.
Today only two members of that
ancient order survive—
African and Asian elephants,
the largest land animals
on earth.

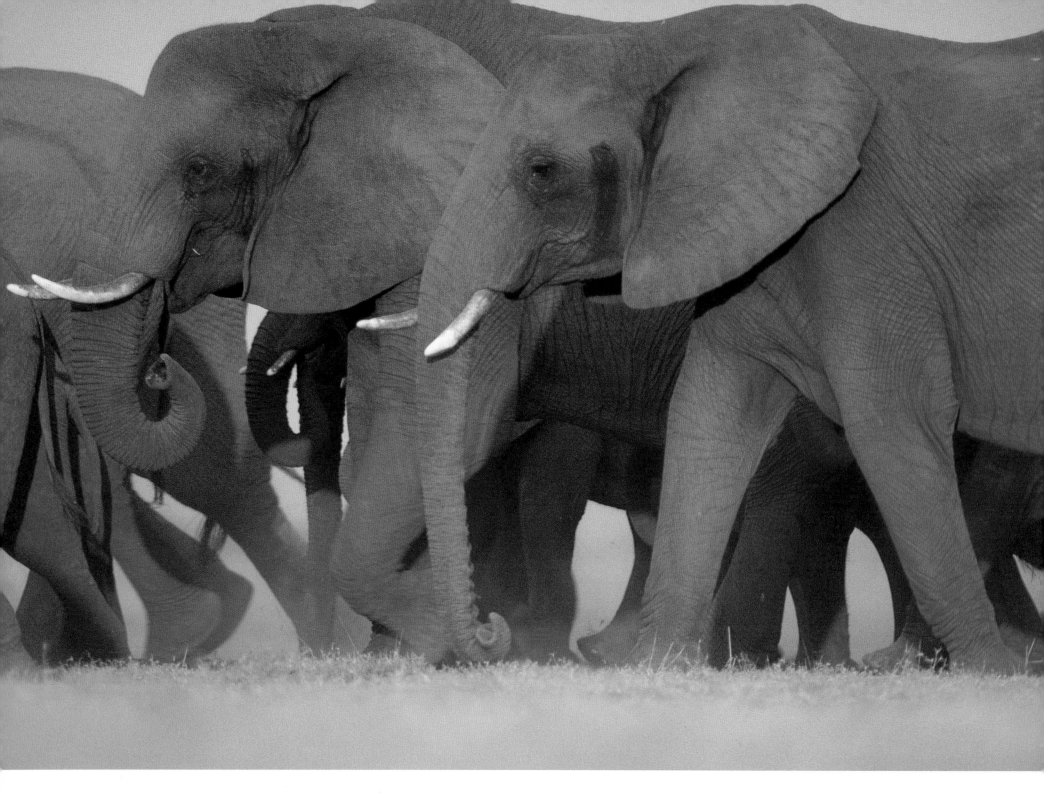

By nature, elephants are wanderers.

In northern Botswana, families cover an annual circuit
that may be as long as 300 miles. Their knowledge
of routes as well as the location of crucial features such as
water seeps in sand rivers is part of a family's
collective memory.

Born after a gestation period
of nearly two years,
a newborn elephant is nurtured
within a close-knit family
that includes aunts
who help share the burdens of raising young.
Like humans, elephants have
a lengthy childhood
during which they learn to function
properly in the complex network
of elephant society.
From day one, babies are on the move,
but families adjust their pace
to the speed of the slowest.

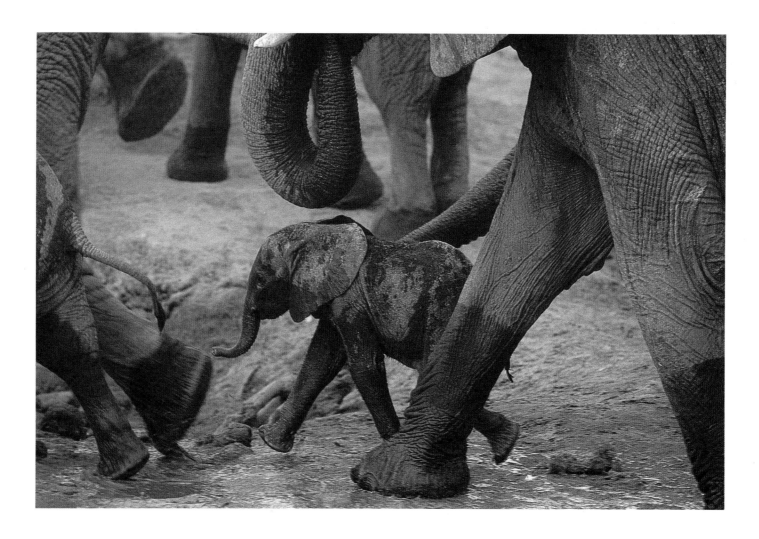

A bull elephant meets my gaze

and raises himself
in a show of strength.
His reactions to me,
lying prone and vulnerable
at the edge of a water hole,
ranged from
angrily tossing his head
to blowing a trunk full of water
or dust my way.
But he refrained from the ultimate —
a full-on charge.
He was testing my resolve,
and I gambled
on his mood.

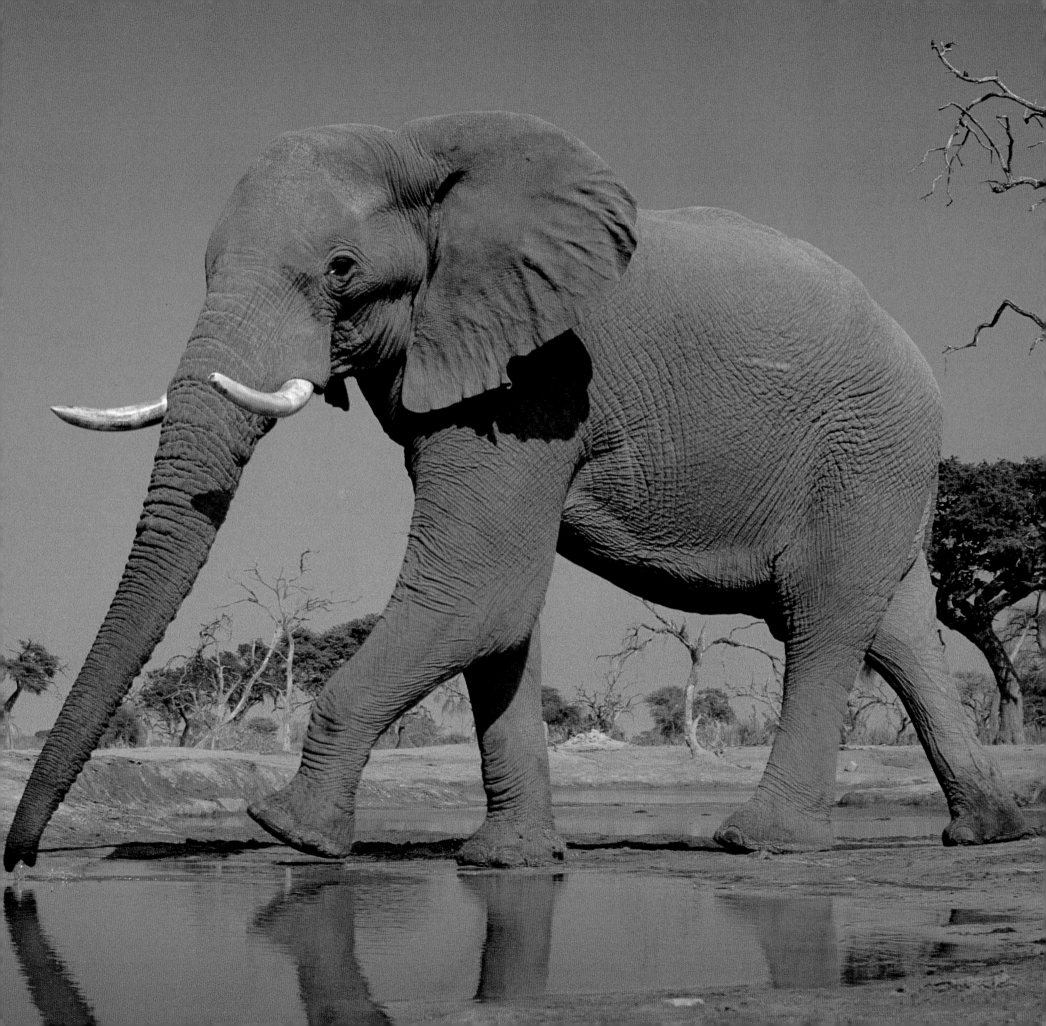

Lined up along the shores of the Chobe River,

a herd draws deep drafts of water.
If it's available,
an elephant will consume
30 gallons a day through its trunk.
A fusion of nose and upper lip
that lacks bones or cartilage,
an elephant's trunk
contains some 40,000 muscles.
It's not just a nose,
but serves as a hand, arm, taster,
trumpet, and spritzer.
It's strong enough to pull down trees,
yet sensitive enough to doodle
in the sand or fondle infants.

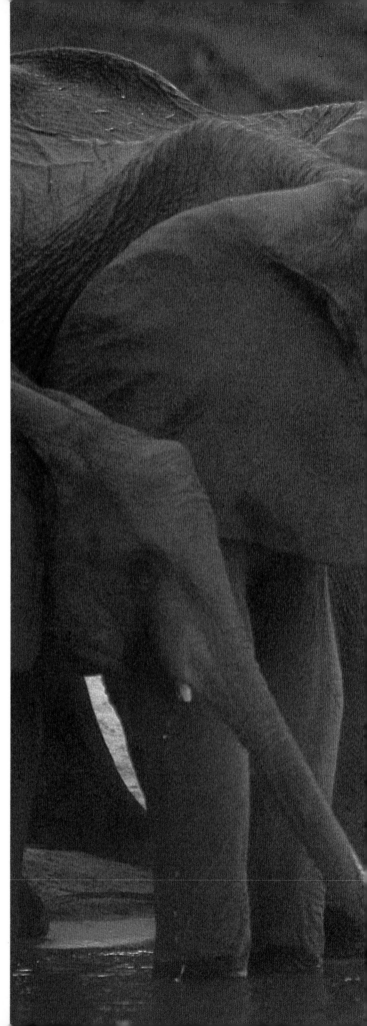

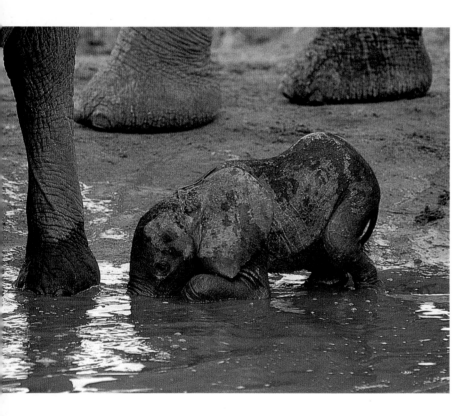

Newborn calves wear their trunks
like wobbly rubber hoses
over which they have little control.
It takes them several months to master the skill
of drinking through their trunks.
Until then, they bend down and slurp water
through their mouths.

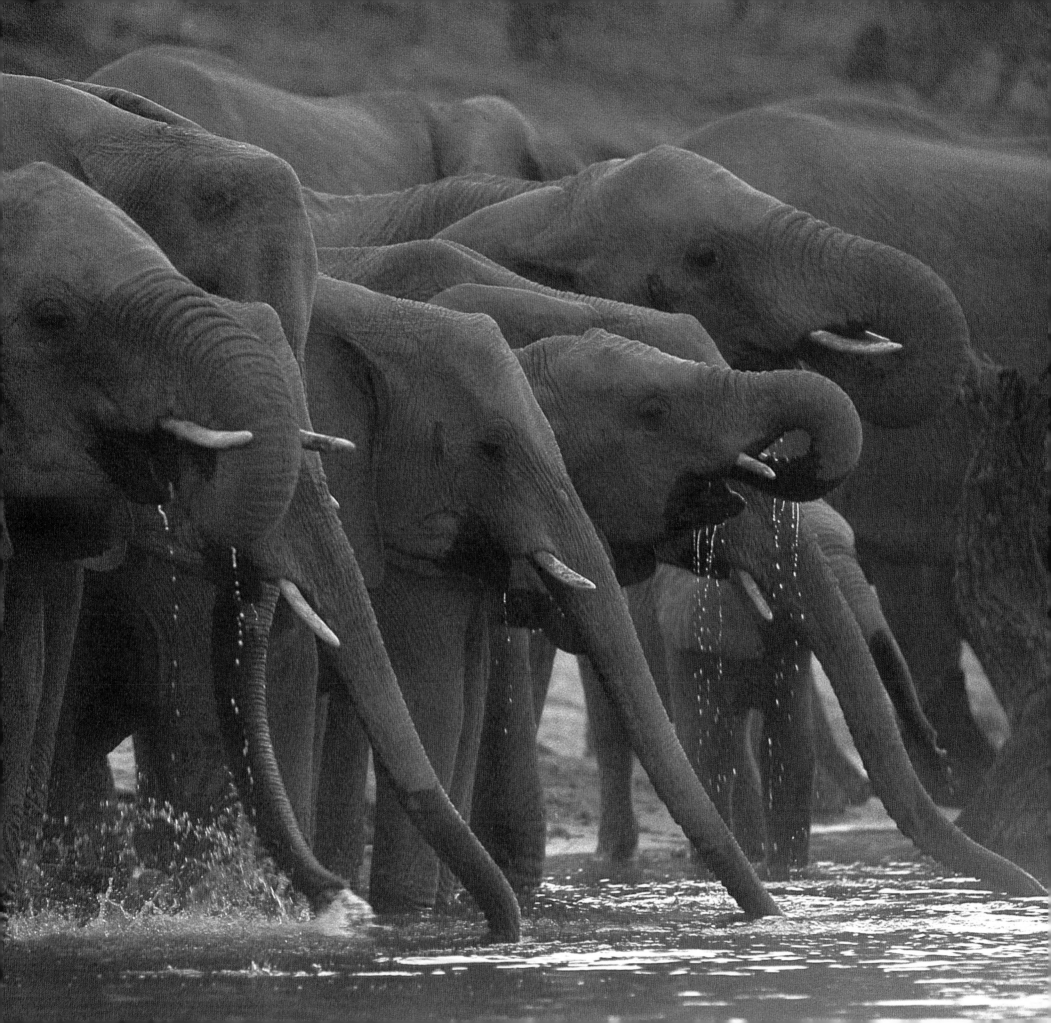

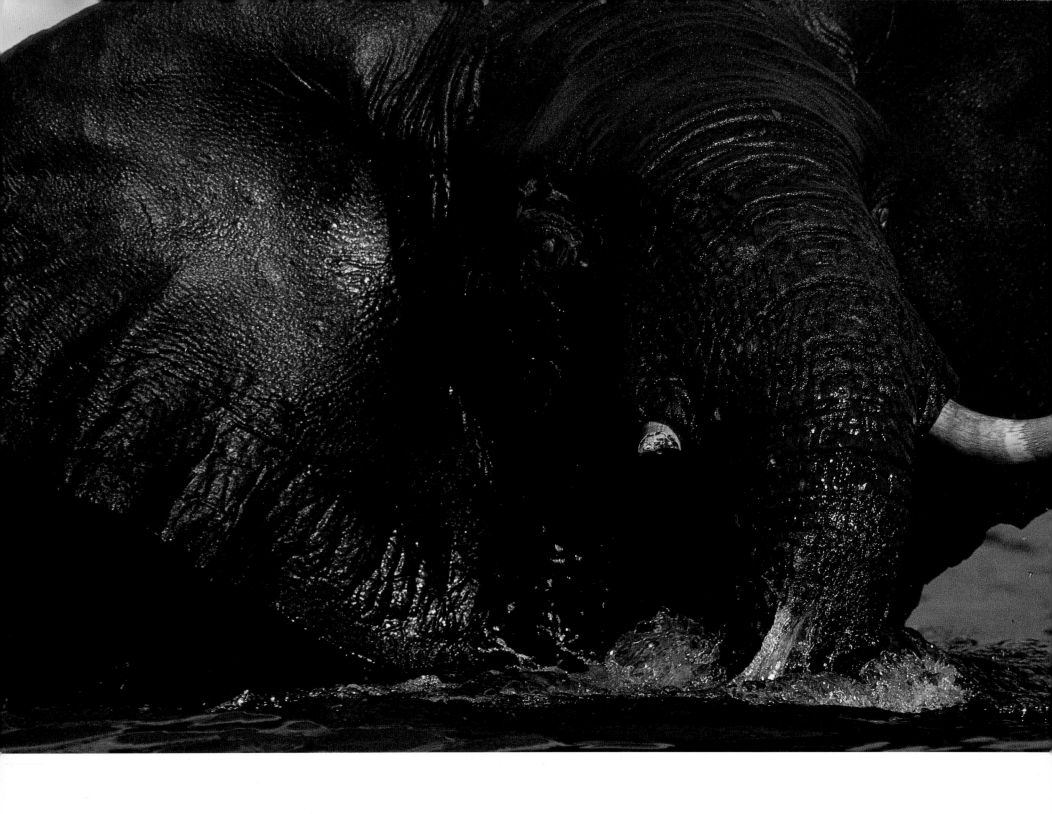

The obvious enjoyment
that elephants
derive from water
goes far beyond the satisfaction
of physical needs.
Sometimes they're so eager to get to it
that they'll break into a dead run
to cover the last hundred yards
to a river or water hole.
At first, they just drink.
But then they loosen up and wade in
just to slosh around,
or go for a bout of sparring
like these two young bulls.

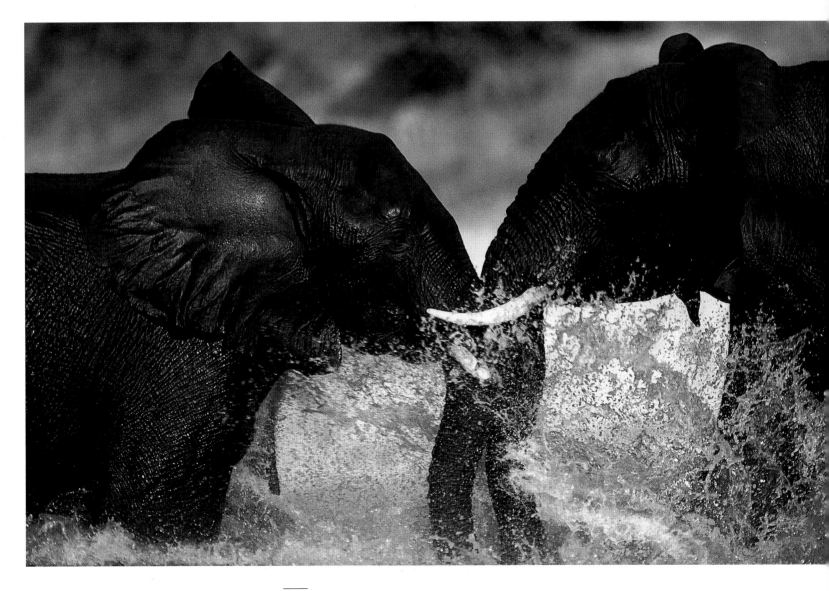

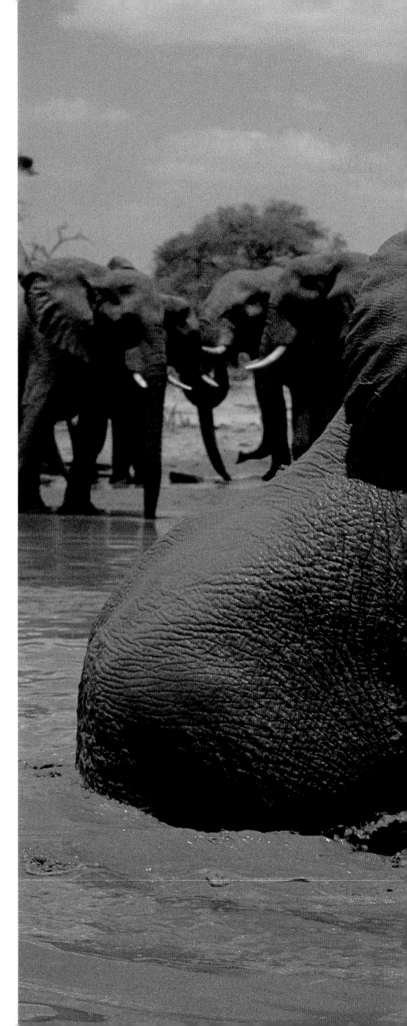

Buoyed by water,
one young bull
attempts to mount another
in ponderous play
at a Savute water hole.

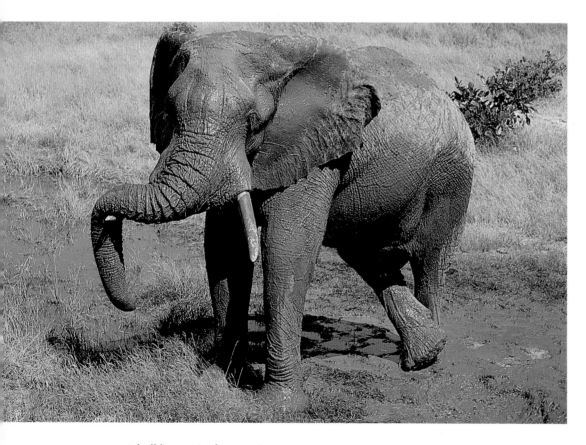

A bull lingers in the sun
after a soothing
mud bath.

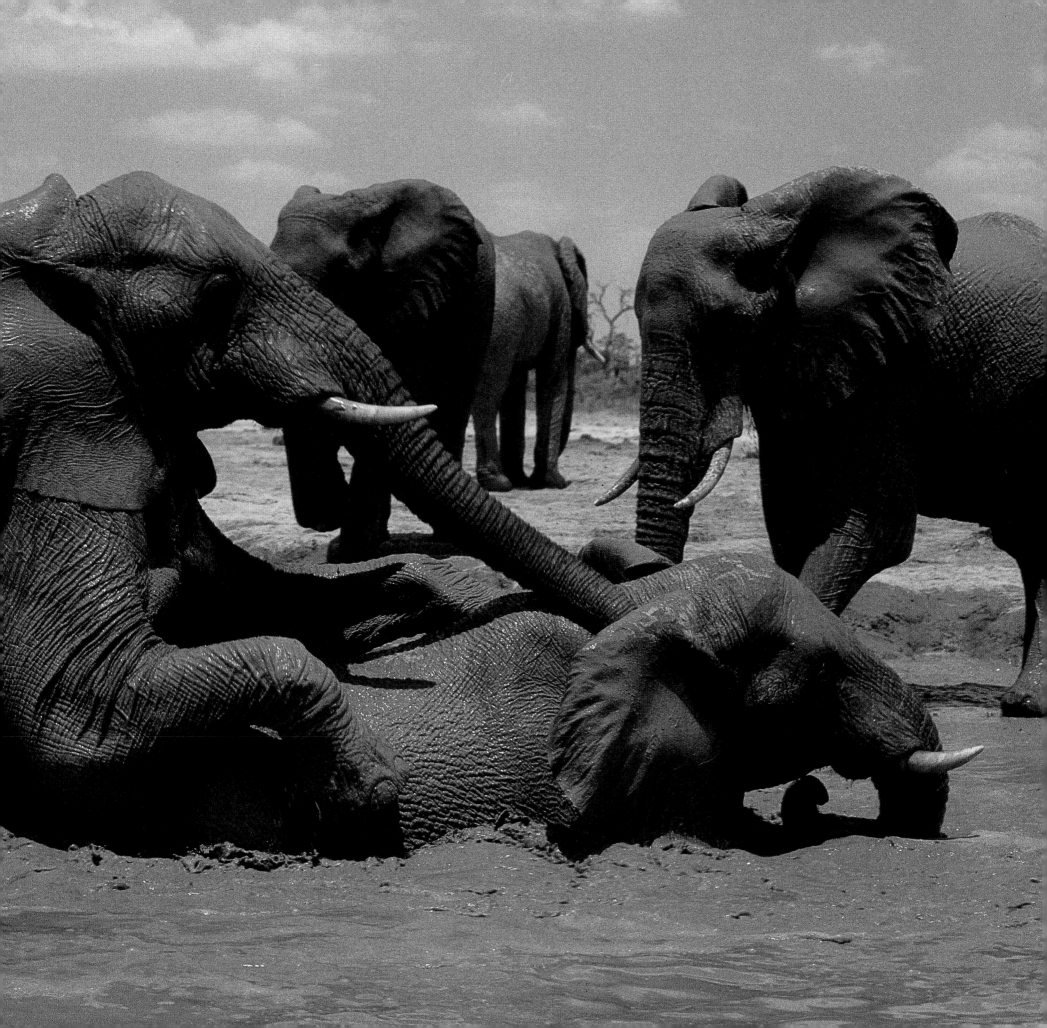

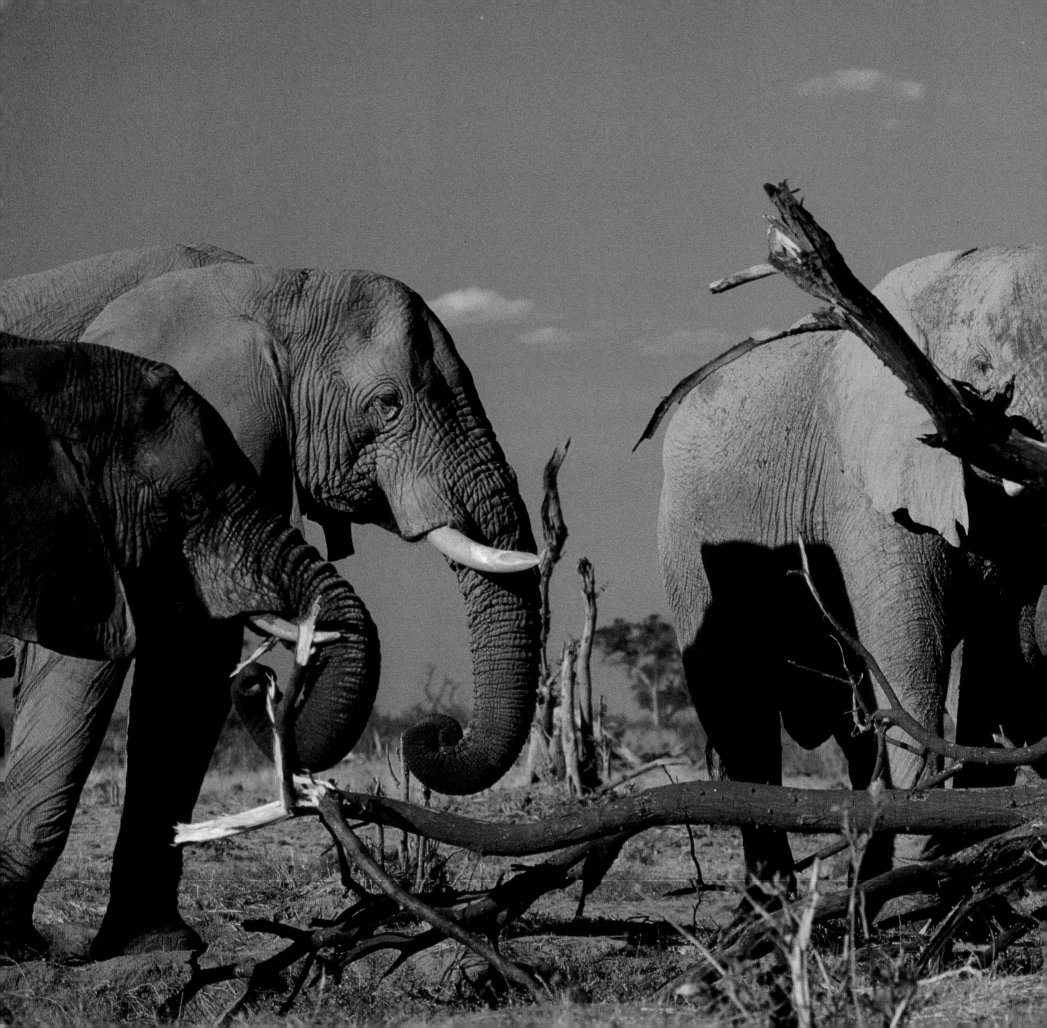

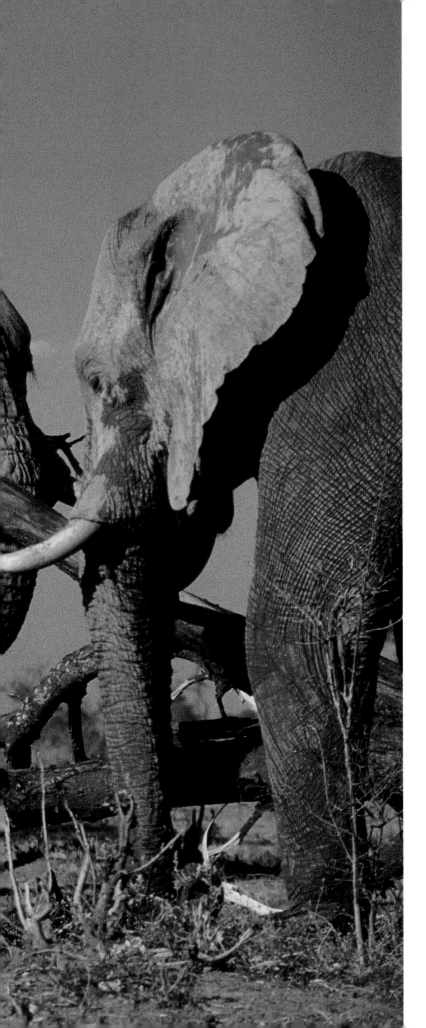

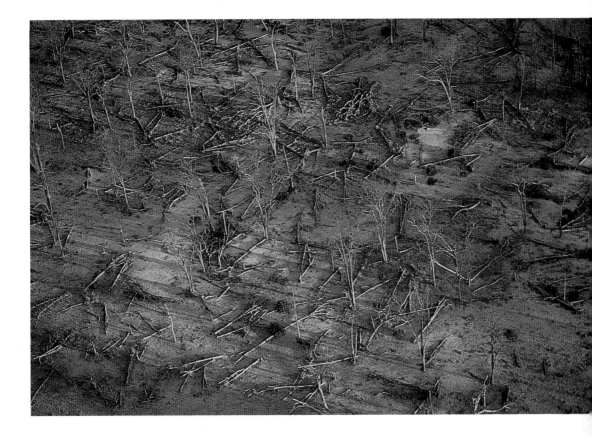

The colossal appetite of an elephant
requires between 300
and 500 pounds of food per day.
Along with grass, browse,
and fruits, elephants devour
the bark of trees. This woodland
of young mopane trees
downed by elephants in a dry year shows
the extreme effect they can exert
on a landscape. Elephants
are agents of change:
They knock down swaths of forest,
which opens up areas for savanna
communities to prosper,
and disperse in their droppings
the seeds of new growth.

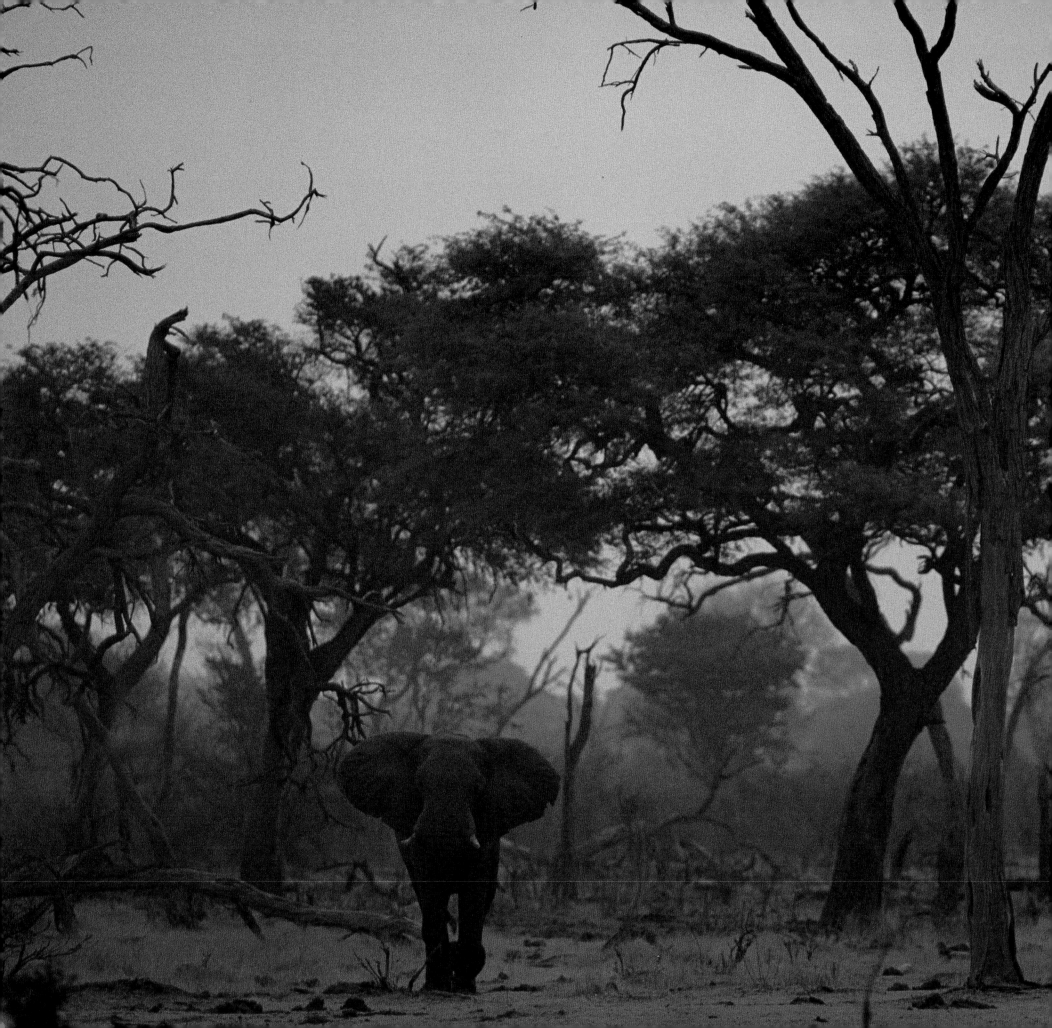

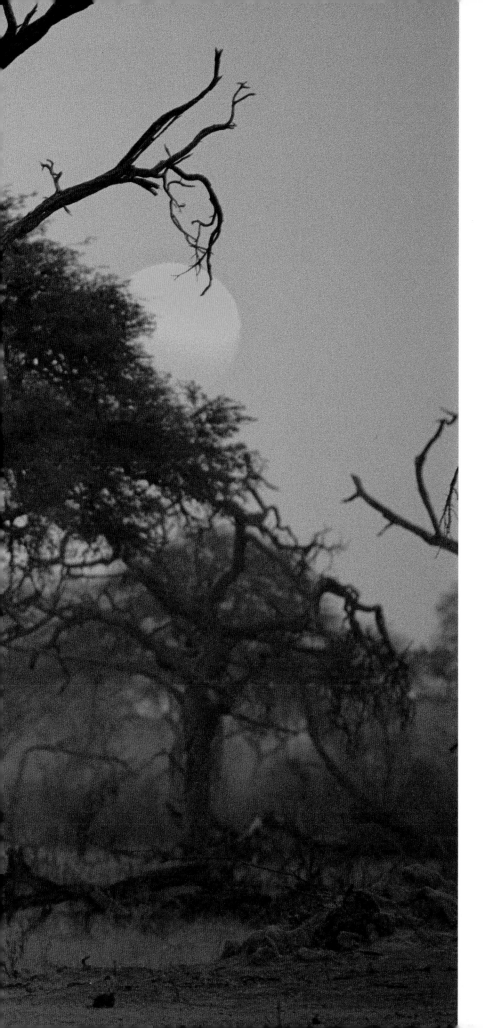

A lone bull ambles

through a heavily browsed woodland,

a landscape broken by elephants.

In the wilderness

of northern Botswana,

only one factor

shapes the look of the land

more than the presence

of elephants—and that is pula,

the force of water.

BEYOND EDEN

An Epilogue

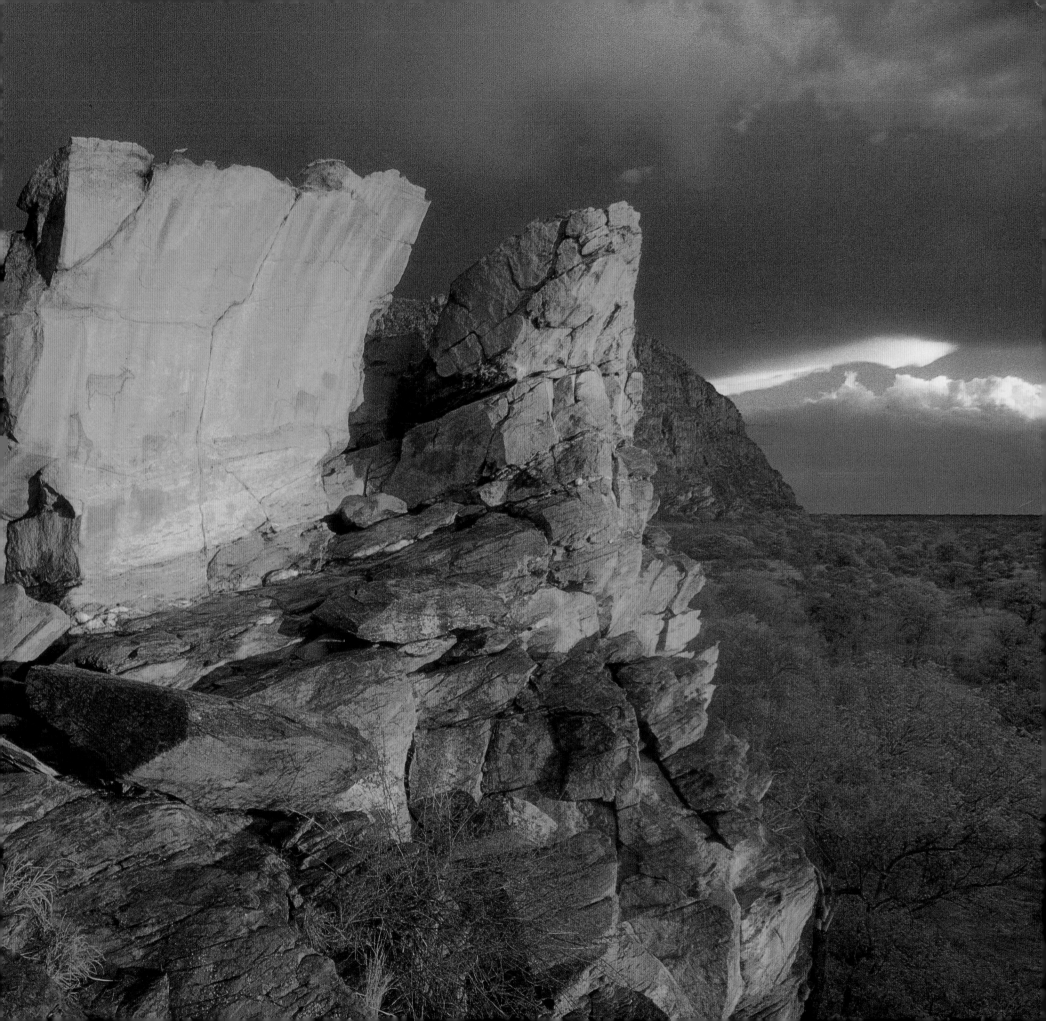

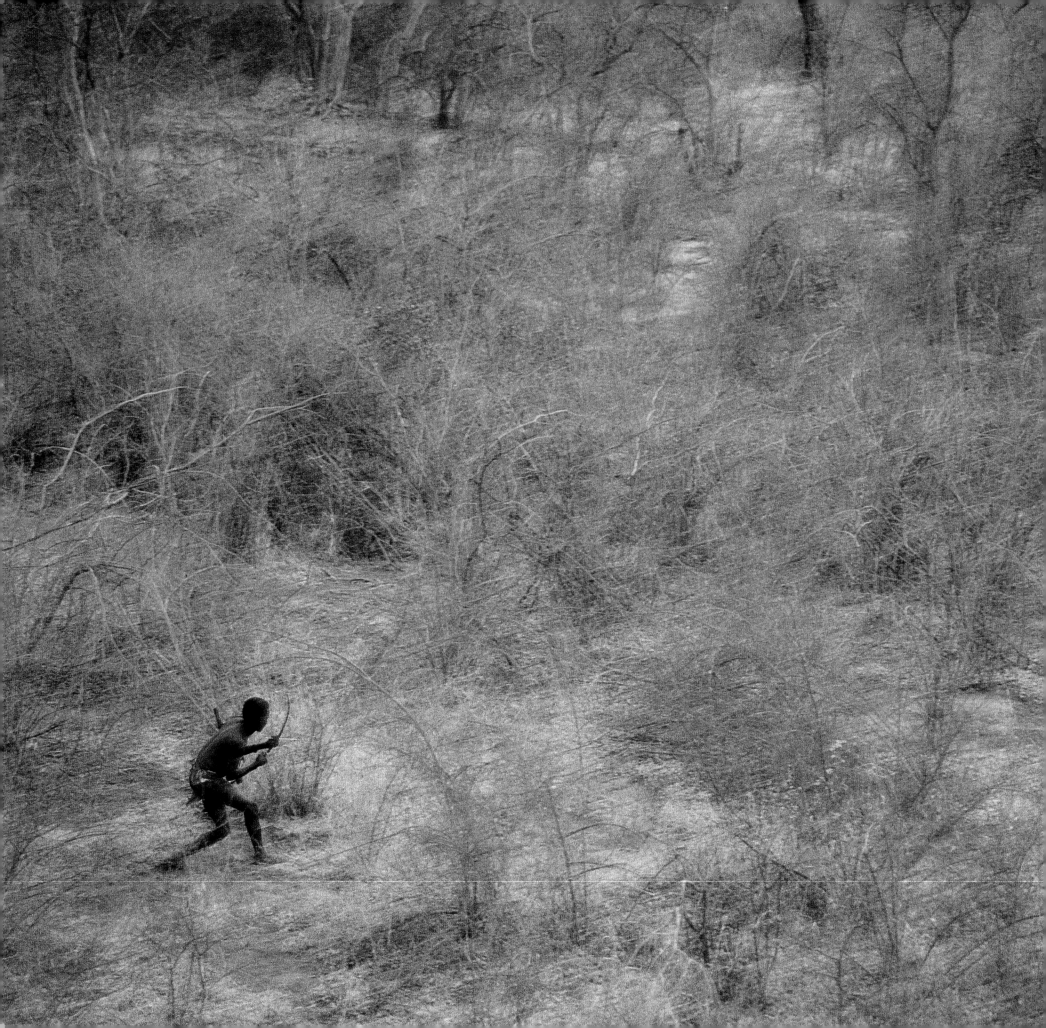

West of the Okavango the Kalahari bush stretches unbroken for hundreds of miles. The most prominent feature of this level country is a group of four rounded hills, worn by time. The granite they consist of has been dated at well over a billion years old. Collectively, these outcrops are known as Tsodilo Hills, and they hold one of the richest repositories of rock art in southern Africa. Almost 3,000 paintings have been identified here, ranging from faded smudges to articulate shapes drawn with great artistry and understanding. They depict the animals that roam the area and the people who once lived among them. The artists are believed to have been ancestors of the Bushmen, the people who call themselves San. For thousands of years their hunting and gathering way of life was the only one in this part of the world. It was an existence utterly dependent on the cycles of water and the movements of animals. A small band of these shy hunters still camps in the shade of Tsodilo. When pressed by visitors, who often ask such questions, they have remarked that God used to live at Tsodilo, but that he left because too many people were now coming.

More people did indeed come. Recent archaeological digs at Tsodilo indicate evidence of cattle in the area as far back as a thousand years ago. Domestic animals certainly came along when haMbukushu people followed the Okavango River into northern Botswana in the mid-eighteenth century. They settled along the western edge of the delta, not far from Tsodilo. In one of their stories, Tsodilo is a place of origin, where their God lowered them into this world on a rope dangling down from heaven.

Other people came, called baYei, who, according to one story, followed their great hippo hunter, Hankuzi, from the north. The baYei were river people who mingled with, and eventually overcame, the now-vanished tribe of baNoka, or River Bushmen, who lived in the Okavango. From the south, other Bantu-speaking people pushed into the desert, including the baKgalagadi, whose name became the word for the land, Kalahari.

In 1849, life around the delta changed forever when David Livingstone arrived at Lake Ngami, on the southern edge of the Okavango. His accounts of bountiful wildlife soon spread. Stories went around of a land so rich in game that cattle kraals were made of ivory tusks. They lured hunters and traders bent on commercial exploitation, and a slaughter

In the Kalahari,
a few bands of Bushmen still
stalk game the old way.

◄ *Overleaf*
Ancient paintings of giraffe and eland
glow in storm light at Tsodilo Hills.

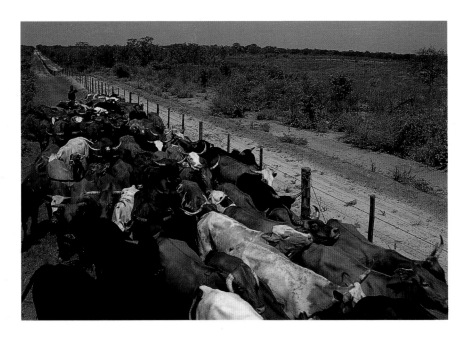

Cattle are herded
along the Buffalo Fence
near Maun.

began. In 1867 alone, the tusks of 12,000 elephants were sold. A few years later, in 1885, the political no-man's-land of the Kalahari became the British protectorate of Bechuanaland, and remained so until 1966. In that year, the independent nation of Botswana was created in a transition remarkably free from the tribal strife and colonial trauma that has torn apart many other regions in Africa. After diamonds were found at Orapa in 1967, Botswana set off on a course of rapid economic development, but the northern part of the country was relatively unaffected. It remained a sparsely settled wilderness unsuitable for agriculture, with a frontier economy dominated by cattle herders and game hunters.

The latter had drifted in from East Africa in the 1960s, and started hunting safaris that catered to sportsmen from Europe and America who paid royal fees for the privilege of hunting big game. They operated in hunting concessions leased from the Botswana government that covered thousands of square miles of wilderness, including the very heart of the Okavango. The overall effect of trophy hunting on the land was minimal, and it can be argued that this brand of wildlife utilization prevented other developments: In the interests of maintaining good populations of game, and exclusive access for their clients, professional hunters kept virtually everyone else out of large areas. But a lot of people will concede that for many years, one small insect has done more than any protective measure to keep the Okavango unaltered: the tsetse. This black fly with a nasty bite has been called "Africa's best game warden." It transmits sleeping sickness to cattle and people, but doesn't affect wildlife. Tsetse has been responsible for keeping places like Tanzania's Serengeti and Zambia's Luangwa Valley free of the livestock that competes with wildlife for fodder and space in many parts of Africa. And in Botswana, a country where cattle outnumber people three to one, tsetse has saved the Okavango from becoming a cow pasture at a time when few people could have, or would have, objected.

Tsetse was a scourge in northern Botswana. In the 1940s it killed 2,000 of 11,000 cattle in the district of Ngamiland—which includes Okavango—and sent hundreds of Maun residents to hospitals. Early efforts to control the fly were brutal in their consequences. The theory that eliminating its host would get rid of it resulted in an outright game eradication program, and dozens of hunters were employed full time to shoot wild animals on sight. More than 60,000 were killed this way over a period of 25 years. So hated was the fly and so little value was placed on the bush in those days that a scorched earth practice of destroying woodlands that provided essential cover for tsetse was also applied. In some areas in the Okavango, stands of skeletal trees still testify to this unfortunate era.

Botswana's cattle economy received a great boost in 1975 when the European Economic Community, in a generous gesture, agreed to buy beef at a preferred rate of up to four times the world price; it now purchases half of Botswana's beef exports. But the EEC insisted that Botswana adhere to European health codes which require prevention from contamination of beef with hoof-and-mouth disease, known to exist in certain populations of wild herbivores. As a result, some 1,500 miles of fences designed to separate wild animals from domestic stock have been set up in the past 20 years. In 1982, the so-called Buffalo Fence was built along the southern rim of the delta in a 150-mile-long crescent. It was erected to keep wildlife away from cattle, but its unintended effect became to keep livestock out of the Okavango. During the severe drought of the mid-1980s, which killed 700,000 domestic animals throughout Botswana, there was great

Fine baskets featuring traditional geometric designs are woven from palm leaves by haMbukushu women in Etsha, a village west of the delta.

Hunters are reflected
in the eye of a zebra killed
minutes before.
Over 2,000 game animals are shot
legally each year by foreign sportsmen
as part of a controlled
hunting program, in addition
to a much greater take
by local residents with licenses.
Illegal hunting is
a growing problem.

pressure to cut portions of the fence and allow cattle access to the water and grazing of the delta. But the barrier stayed, and has taken on more protective importance in recent years, when the Okavango was finally cleared of tsetse with a massive aerial spraying program. Together, the unlikely trio of hunting, tsetse, and fences have contributed in a backhanded way to help keep the Okavango wild.

The Okavango's survival into the 1990s as a virtually intact ecosystem has had more to do with fortuitous circumstances than with careful planning. But time is catching up with the region. During a safari in 1977, writer Peter Matthiessen and his party could still claim to be the only foreigners traveling in northern Botswana. In the late 1980s, more than 30,000 visitors were drawn to this part of the world, most because of the wildlife. Maun has become a boom town, and its demand for water is growing fast. Then there is the thirst of agricultural interests and the need of the large diamond mine to the south at Orapa, which provides much of the nation's wealth. Over a billion dollars' worth of diamonds have been taken from the ground there in good years, but this extraction requires great amounts of water. Plans for diverting water from the delta had been tried out before, but had always run afoul of engineering problems and logistical obstacles. But in 1991, a plan to dredge a portion of one of the Okavango's main channels, the Boro, in an effort to sluice more water to Maun for a reservoir came very close to driving a thin wedge of development into the delta's southern wetlands. The plan had been approved and bulldozers were ready to start dredging when a wave of international publicity crested with the opposition of local citizens. In the best of Botswana's democratic traditions, a town meeting known as a *gotla* was held in Maun. By custom, gotlas are conducted outside, under a big tree, and every adult citizen is given a chance to express an opinion. The Boro plan was discussed as well in the international press, but only after the people of northern Botswana spoke out with a resounding "no" did the government reconsider and eventually shelve the plan.

The Boro episode is but the latest manifestation of another attitude in Botswana, one that recognizes the value of wild land and wildlife. Early on, land was set aside in natural reserves. In 1963, in an enlightened move, the baTawana people established protection for a crucial part of the Okavango by allotting a portion of tribal land to a reserve now named Moremi. A tract of adjacent land that reaches all the way to the Zimbabwe border became incorporated as Chobe National Park. To the south, a huge area of 20,000 square miles had already been set aside as the Central Kalahari Game Reserve in 1961, to serve as a homeland for Bushmen living as hunter-gatherers. Altogether, Botswana has committed 17 percent of its land to parks and reserves, a percentage as high as that of any other nation. But the boundaries were drawn in earlier days when fewer factions were laying competing claims on wild land, and less knowledge existed about the movements of animals.

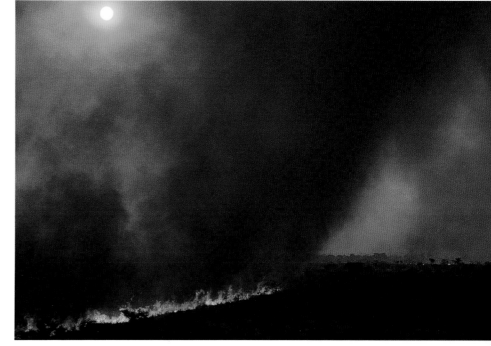

Bush fires deliberately set have long been used throughout southern Africa by hunters flushing out game and cattlemen encouraging fresh growth for their herds, but they burn more than half the delta's vegetation each dry season.

The most crucial issue for wildlife in this arid land is unimpeded access to water. In times of drought, which have come before and inevitably will come again, the wild herds of northern Botswana shift their range. When that happened in 1983, cattle fences prevented the movement of wildebeest to permanent water at Lake Xau. As a result, tens of thousands died. The population has not recovered. The number of wildebeest in the central Kalahari was once estimated at more than a quarter of a million; today, fewer than 10 percent survive, and several other species have suffered a comparable decline. The central Kalahari is becoming silent—the land overgrazed, the remaining wildlife overhunted. But northern Botswana is still replete with great herds of game, and the country is in the fortunate position of being able to learn from past mistakes before it is too late.

In Botswana, the interests of cattle are the basis of most land-use decisions. Cattle are not just a source of wealth, but the heart of a culture. They bring social prestige and power. But with diamonds, Botswana struck it rich. They have brought prosperity, a rare thing among African countries, and that has bought the country the luxury of time and the

privilege of choice. The choices ahead are real, but if they are not faced soon, the opportunities will dwindle. Until recently, Botswana was focused on its twin assets of cattle and diamonds, but it is now beginning to realize the importance of another major resource, its bounty of wilderness and wildlife. And the Okavango may well turn out to be the biggest diamond of all.

Northern Botswana is on the brink of a new era. A paved road will soon bring the once-inaccessible bush within a smooth, one-day drive by car from the urban centers of Gaborone and Johannesburg. It will increase development, and more people and more interests will lay claim to the land. At the same time, the international community is discovering Botswana. Keenly aware of the irretrievable loss of intact ecosystems in the northern hemisphere, people from the developed world turn ever more to great wilderness areas like the Okavango, which are rapidly becoming icons in a global natural heritage. But it is clear that what has survived in Botswana to the present day in part by benign neglect can be safeguarded for the future only with careful planning and vigorous protective measures.

When a large diamond is found, the experts look at it, and then decide how to cut it into four or five smaller ones, which are more marketable and can be sold at a greater profit. The Okavango faces a similar situation. In the years ahead, people will further chip away at the edges of the great wild range of northern Botswana for the sake of private gain and public good. There's one difference, however. There may still be diamonds in the ground larger than any that have ever been found, but there will never be another Okavango.

Tourists cruise toward
an elephant drinking at sunset
along the Chobe River.

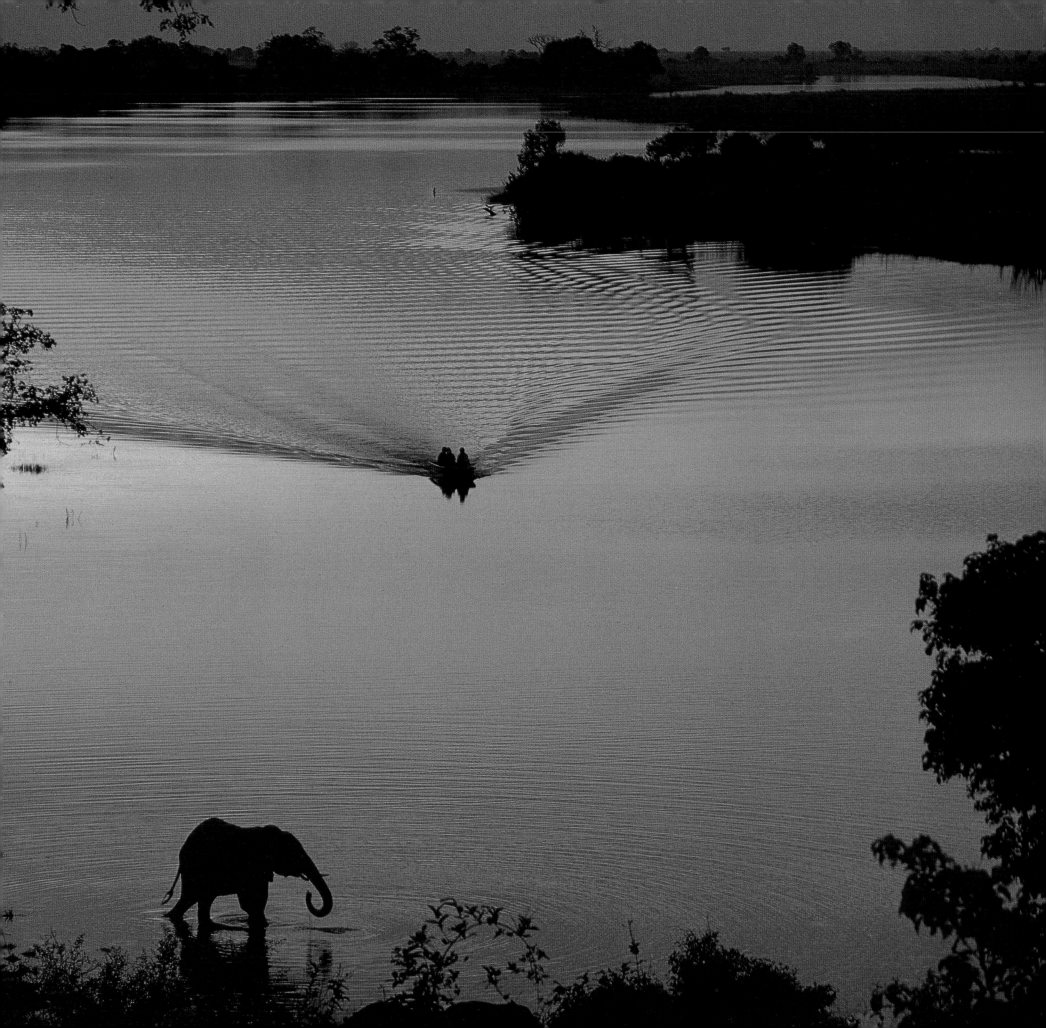

Bibliography

Beard, Peter. *The End of the Game*. 1963. Reprint. San Francisco: Chronicle Books, 1988.

Butler, David and Guy, eds. *Out of the African Ark*. Johannesburg: Ad. Donker (Pty) Ltd, 1988.

Estes, Richard Despard. *The Behavior Guide to African Mammals*. Berkeley: University of California Press, 1991.

Forrester, Bob, Mike Murray-Hudson, and Lance Cherry. *The Swamp Book: A View of the Okavango*. Johannesburg: Southern Book Publishers (Pty) Ltd, 1989.

Iwago, Mitsuaki. *Serengeti*. Tokyo: Asahi Shimbun Publishing Company, 1984.

Lewis-Williams, David, and Thomas Dowson. *Images of Power: Understanding Bushman Rock Art*. Johannesburg: Southern Book Publishers (Pty) Ltd, 1989.

Livingstone, David. *Missionary Travels and Researches in Southern Africa*. London: John Murray, 1857.

Maclean, Gordon Lindsay. *Roberts' Birds of Southern Africa*. Cape Town: The Trustees of the John Voelcker Bird Book Fund, 1985.

Main, Michael. *Kalahari: Life's Variety in Dune and Delta*. Johannesburg: Southern Book Publishers (Pty) Ltd, 1987.

Marais, Eugène N. *The Soul of the White Ant*. 1937. Reprint. London: Jonathan Cape, 1971.

Matthiessen, Peter. *The Tree Where Man Was Born*. 1972. Reprint. London: Picador/Pan Books Ltd in association with William Collins Sons & Co. Ltd, 1984.

————. "Peter Matthiessen's Africa: Book One, Botswana." *Audubon*, Vol. 83, No. 1 (January 1981), 69–81.

Moss, Cynthia. *Elephant Memories: Thirteen Years in the Life of an Elephant Family*. New York: Fawcett Columbine/Ballantine Books, 1989.

Owens, Mark and Delia. *Cry of the Kalahari*. Boston: Houghton Mifflin Company, 1984.

Owen-Smith, R. Norman. *Megaherbivores: The Influence of Very Large Body Size on Ecology*. Cambridge: Cambridge University Press, 1988.

Ross, Karen. *Okavango: Jewel of the Kalahari*. London: BBC Books, 1987.

Selous, Frederick Courteney. *A Hunter's Wanderings in Africa*. 1881. Reprint. Alberton: Galago Publishing (Pty) Ltd, 1985.

Sinclair, A.R.E., and M. Norton-Griffiths, eds. *Serengeti: Dynamics of an Ecosystem*. Chicago: The University of Chicago Press, 1979.

Smithers, Reay H. N. *The Mammals of the Southern African Subregion*. Pretoria: University of Pretoria, 1983.

Spinage, C. A. *The Natural History of Antelopes*. London: Croom Helm, 1986.

Van der Post, Laurens. *The Lost World of the Kalahari*. 1958. Reprint. San Diego: Harcourt Brace Jovanovich, 1977.

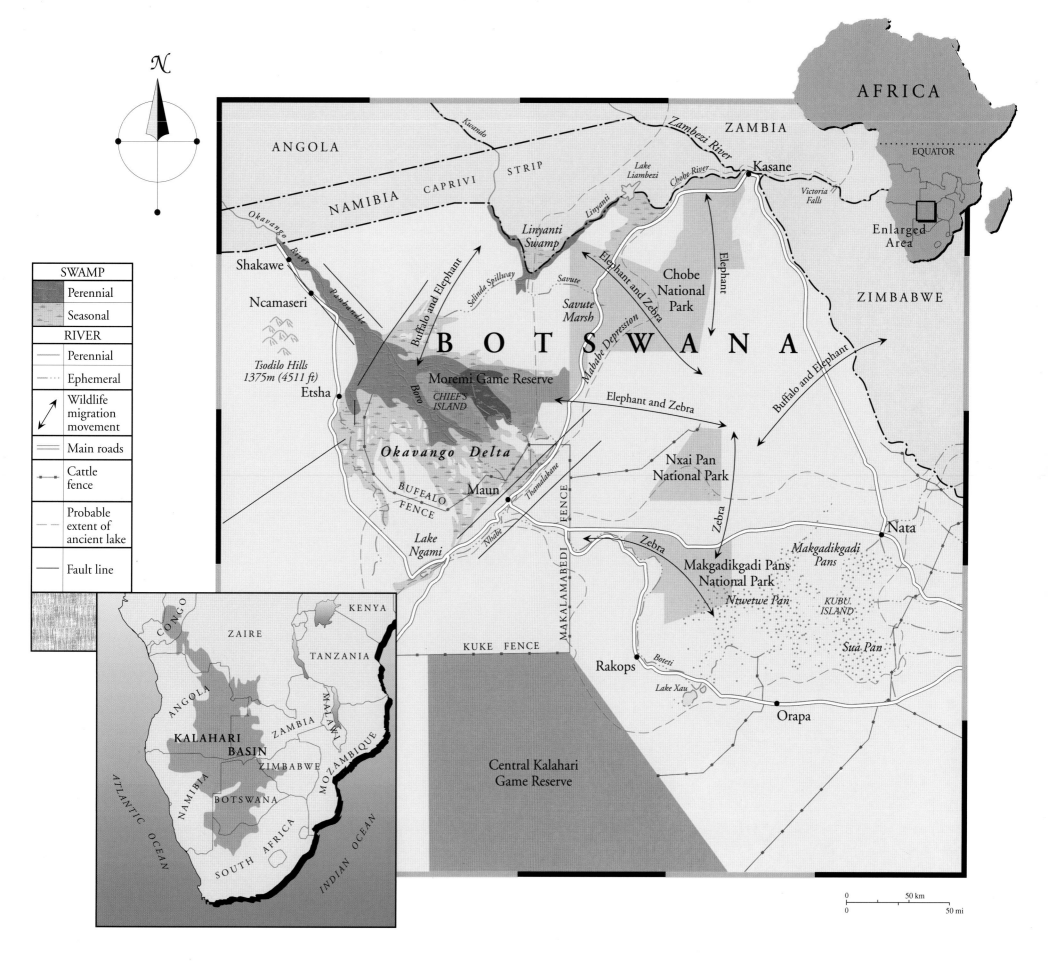

SWAMP
- Perennial
- Seasonal

RIVER
- Perennial
- Ephemeral
- Wildlife migration movement
- Main roads
- Cattle fence
- Probable extent of ancient lake
- Fault line

AFRICA

EQUATOR

Enlarged Area

ANGOLA

NAMIBIA CAPRIVI STRIP

ZAMBIA

Kwando

Zambezi River

Lake Liambezi

Chobe River

Kasane

Victoria Falls

ZIMBABWE

Okavango River

Shakawe

Ncamaseri

Panhandle

Tsodilo Hills
1375m (4511 ft)

Etsha

Boro

Linyanti Swamp

Linyanti

Selinda Spillway

Savute

Savute Marsh

Buffalo and Elephant

Elephant and Zebra

Elephant

Chobe National Park

Mababe Depression

B O T S W A N A

Buffalo and Elephant

Moremi Game Reserve

CHIEF'S ISLAND

Okavango Delta

Elephant and Zebra

Nxai Pan National Park

BUFFALO FENCE

Maun

Thamalakane

MAKALAMBEDI FENCE

Zebra

Zebra

Makgadikgadi Pans

Nata

Lake Ngami

Nhabe

Zebra

Makgadikgadi Pans National Park

Ntwetwe Pan

KUBU ISLAND

Sua Pan

KUKE FENCE

Rakops

Boteti

Lake Xau

Orapa

Central Kalahari Game Reserve

KALAHARI BASIN

CONGO

ZAIRE

KENYA

TANZANIA

ANGOLA

ZAMBIA

MALAWI

NAMIBIA

ZIMBABWE

MOZAMBIQUE

BOTSWANA

ATLANTIC OCEAN

SOUTH AFRICA

INDIAN OCEAN

0 50 km
0 50 mi

At twilight,
two young spoonbills
await the return
of parents with food
at a rookery in the middle
of the Okavango.

Photography Notes

Photography as a medium for chronicling the natural history of the African bush may appear to be a modern activity, but its roots go back to David Livingstone, who took a camera along on his expedition to the Zambezi in 1858. Innovations such as telephoto lenses and flash powder, which allowed the photographic penetration of the African night, were brought into the field shortly after the turn of the century. But it wasn't until after World War II with the mobility afforded by 35-millimeter SLR cameras that wildlife photography in Africa truly came into its own. The proliferation of images from Africa in the last decade tends to overshadow the fact that for many years our view of this continent's wildlife stemmed from the efforts of a very small group of cameramen and women. The images of these pioneers have been a source of inspiration for mine.

Recent improvements in camera and film technology allow a greater range in expressive possibilities than ever before. The current options in equipment—and especially the availability of fast, long lenses with their amazing optical quality—along with the improvement in film emulsions, facilitate the making of photos in situations where until recently, one could only watch. For my work I used Nikon cameras and lenses. My camera of choice was a simple (by today's standards) motordriven Nikon FE2. My lenses ranged from 18-millimeter to 500-millimeter; the longer lenses were sometimes used in combination with a TC 14 extender. I often mix artificial with ambient light. Simple but indestructible Vivitar 285 strobes performed no matter what. For long-range flash work I used strobes of the Metz 60 series with a fresnel device to extend the reach. I used a variety of film emulsions, from fine-grained to high-speed; each has its own strength and I tried to use them accordingly. Fujichrome, Ektachrome, and Kodachrome were all exposed in copious amounts.

This project took nearly a year of field time spread over 1988 and 1989. For an undertaking of this magnitude I leave home with an embarrassing mountain of gear, not because I like to, but because swamps and deserts are hard on cameras and from the heart of the Okavango it is a long way to the nearest photo store. I double up on all essential gear, so that I can work without worrying about taking cameras into the kind of extreme situations that would horrify the engineers who put these delicate machines together. To me, cameras are tools. They are a means to an end; important, but not worth thinking too much about. Wildlife photography in Africa is part natural science, part bush skills, part hunting, part storytelling—and that is just how I like it to be.

Conservation

The future of the Okavango is by no means secure. The following organizations are actively involved in the issues that affect the region. I urge anyone with an interest to become involved by contacting them for further information, and to offer support for their work.

Kalahari Conservation Society
P.O. Box 859
Gaborone, Botswana
Telephone: (267) 374-557
Fax: (267) 314-259

Conservation International
Okavango Program
P.O. Box 448
Maun, Botswana
Telephone: (267) 660-017
Fax: (267) 661-798
E-mail: cibots@info.bw

Chobe Wildlife Trust
P.O. Box 55
Kasane, Botswana
Telephone: (267) 650-516
Fax: (267) 650-223

African Wildlife Foundation
1400 16th Street N.W., #120
Washington, D.C. 20036
Telephone: (202) 939-3333
Fax: (202) 939-3332
Website: www.africanwildlife.org

World Wildlife Fund USA
1250 24th Street N.W.
Washington, D.C. 20037
Telephone: (202) 293-4800
Website: www.worldwildlife.org
E-mail: wwf@us.org

WWF International
Avenue du Mont-Blanc
CH-1196 Gland
Switzerland
Telephone: (41) 22-3649111
Website: www.panda.org

On a misty winter morning,
palms line a stretch of
the Boro River that was
to be dredged —
a plan that was tabled,
for the time being.

Acknowledgments

The common view of a wildlife photographer is of someone who does his work alone. Nothing could be further from the truth in the case of this project in Botswana, which took two calendar years and the help of hundreds of people to complete. I owe gratitude to many, and along with sincere apologies to those not mentioned, I extend my heartfelt appreciation to those listed here.

In Botswana
Drew Allport
Joseph Barati
Isaac Barnard (RSA)
John Benn
P. J. and Barney Bestelink
Ralph Bousfield
Jeffrey and Judy Bowles
George and Brodie Calef
Alec Campbell
Bruce and Claire Cantle
Heather and Pat Carr-Hartley
Clem Coetsee (Zimbabwe)
Joe Coogan
Susan Cooper
David Dugmore
Jonathan Gibson
Mike Gunn
Leo van der Heiden
Nigel Hunter
Ian Khama
Bernadette Lindstrom
Tim and June Liversedge
Michael Main
Susan Masson
Steve Mbingamo
Glen Merron
Fred and Pam Mitchell
Janis Mullan
Glen Munger
Mike Murray-Hudson
Peter Nelson (RSA)
Elias Nkwane
The Oakes family
Lionel Palmer
Neville Peake
Willy Phillips
Barry and Elaine Price
Cecil Riggs

John Seaman
Gabriel Seelotso
Harry Selby
Mike Slogrove
Pete Smith
Malcolm Thomas
Mark and Sandra van der Walle
Mike and Suzie Watson
Douglas and Diane Wright

Botswana Government
I am thankful to the Office of the President, the Department of Wildlife and National Parks and the Office of the District Commissioner in Maun for their support and permission to work in their country.

In the United States
Jim Brandenburg
John Bulger
Kate Glassner
Bill Hamilton
Robert Hitchcock
Eric Hoffman
Roger Luckenbach
Diana McMeekin
Nick Nichols
Galen Rowell
Shawn Sandor
George Steinmetz

At the National Geographic Society
Sergio Ballivian
Leah Bendavid-Val
Nelson Brown
Neva Folk
Will Gray
Robert Hernandez
Ann Judge
Larry Kinney
Kent Kobersteen
Phil Leonardi

Robert Madden
Al Royce
Susan Smith
Joe Stancampiano
Jonathan Tourtellot
Charlene Valeri
Jane Vessels
Kenji Yamaguchi

Special thanks
At the National Geographic Society to editor Bill Graves, former editor Bill Garrett, Tom Kennedy and Mary Smith for their trust and support; Douglas Lee for sharing the passion; Larry Minden, and at Minden Pictures: Chris Carey and Stacy Frank for their dedication; and in Botswana, for providing a home away from home and a shoulder to lean on: Paul Sheller, Tim and Bryony Longden, June and Lloyd Wilmot, Ewan Masson, Dereck and Beverly Joubert, Karen Ross, Rodney Fuhr, Dan and Paula Rawson, and the late Jack Bousfield.

For help with making this book possible
Nicholas Callaway, Todd Foreman, Charles Melcher, Bernard Ohanian, Susan Powell, Alan Ritch, Isabel Stirling, Lucille Tenazas, Antoinette White, Siegfried Woldhek and staff at WWF Holland

In a class by herself
Sandy Arrowsmith

Colophon

This book was produced by Callaway Editions under the direction of Nicholas Callaway and Charles Melcher.

The photography was originally commissioned by the National Geographic Society.

Christine Eckstrom collaborated on the text with Frans Lanting.

Alexandra Arrowsmith was project editor.

Antoinette White was editor at Callaway Editions.

True Sims was production director, with assistance from Toshiya Masuda and Ivan Wong.

Caroline Herter supervised the publication of the book at Chronicle Books, with assistance from Fonda Duvanel.

The book was designed by Lucille Tenazas of Tenazas Design, San Francisco, with assistance from Todd Foreman. Typeset in Cochin.

The map was produced by Eureka Cartography, Berkeley.

Larry Minden and Patti Richards coordinated the publicity and promotion of the book.

The figures reproduced in the chapter openings are drawn from rock art found in southern Africa. The oryx on page 14, the vultures on page 62, the impalas on page 84, and the leopard on page 106 were drawn by Lindy Huggins. The cobra on page 36 was drawn by Sue Ross. These drawings were originally reproduced in *Out of the African Ark*, edited by David and Guy Butler (Johannesburg: Ad. Donker (Pty) Ltd, 1988), and are reproduced here with the kind permission of the publisher.

The elephant on page 130 and the Bushmen on page 152 were drawn by Thomas Dowson. These drawings were originally reproduced in *Images of Power: Understanding Bushman Rock Art*, by David Lewis-Williams and Thomas Dowson (Johannesburg: Southern Book Publishers (Pty) Ltd, 1989), and are copyright © by Rock Art Research Unit, Department of Archaeology, University of the Witwatersrand, Johannesburg.

Scitex retouching for the front cover image was made by Repro-Media, San Francisco.

Okavango was printed and bound in Korea by Palace Press International.

For more information about Frans Lanting's work, please contact his studio:
Fax: (831) 423-8324
E-mail: info@lanting.com
Website: www.lanting.com

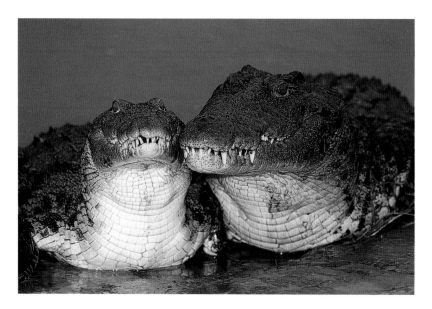

Crocodile farm, Maun.